Christ among Us

Christ among Us

Sculptures of Jesus across the History of Art

Joseph Antenucci Becherer

Henry Martin Luttikhuizen

William B. Eerdmans Publishing Company

Grand Rapids, Michigan

Wm. B. Eerdmans Publishing Co.
4035 Park East Court SE, Grand Rapids, Michigan 49546
www.eerdmans.com

Published 2022
Printed in Canada

28 27 26 25 24 23 22 1 2 3 4 5 6 7

ISBN 978-0-8028-7406-1

Library of Congress Cataloging-in-Publication Data

A catalog record for this book is available from the Library of Congress.

The authors and publisher gratefully acknowledge permission to reprint material provided by the individuals and institutions listed on p. 16 and pp. 123–36.

This book is dedicated to
Rose Antenucci
and her daughters: Joanne, Carmella, and Rita

and to
Dena Bakker van Luttikhuizen
and her daughters: Frances, Mary, Rebecca, Esther, and Sharon

and to
Margaret Hanes Scholten
and her daughters: Marian, Ardith, Karen, and Shirley

Acknowledgments

In many ways this book is a striking testimony to the great creative tension that exists between a problem posed and solutions nurtured among a peer group constantly asking questions and challenging assumptions. For many years a group of writers, philosophers, and academics have gathered weekly at the Cottage Bar in Grand Rapids, Michigan. As lofty inspiration, the group is a distant echo of the famed Inklings, whose literary and theological discussions in the 1930s and 1940s are now legendary. However, for the reverberations in late twentieth- cum twenty-first-century America, topics have often ventured beyond literature and poetry toward politics and religion—the latter both theoretically not to be broached in polite company. Art, too, is a common topic, as an art historian, or frequently two, are usually at the table. Revered publisher Bill Eerdmans was often at the head of the proverbial table and took delight in the conversations where the visual arts, history, and religion intersected and sometimes collided. This book and the journey leading to it are a result of several, and likely dozens, of those conversations. In truth, the project at large is indebted to those who have participated in these discussions.

The idea of a publication for an exhibition that could never be was foundational to the enterprise that resulted in this book. Over time, a theme involving currents of Christian faith traditions developed. As the aforementioned group is populated largely by those coming from Dutch Reformed or Roman Catholic traditions, there have always been lively dialogues and opportunities for deeper understanding. In terms of the visual arts, group discussions have proved there are equal measures of mystery and familiarity when devotional objects and religious subjects are encountered. Message and meaning for something as iconic as the famed and singular Jan van Eyck's Ghent Altarpiece in Belgium might command as much inquiry and attention as commonly encountered sculptural series known as Stations of the Cross in parishes all over town and, indeed, all over the world. Increasingly, what was woven into such discussions was the desire to produce a volume that would be valuable to art and culture enthusiasts yet welcoming to museum novices. From such circumstances, *Christ among Us: Sculptures of Jesus across the History of Art* was born.

As articulated in the ensuing introduction and catalog entries, this book is a joint effort of the two art historians noted above. At the time, Henry Martin Luttikhuizen, a scholar of medieval and Northern Renaissance art, was on faculty at Calvin University. Coauthor Joseph Antenucci Becherer, a renowned specialist in modern and contemporary sculpture but with an eye trained in the Italian Renaissance, was on faculty at Aquinas College, although he now serves as director of the Raclin Murphy Museum of Art at the University of Notre Dame and a concurrent member of the art history faculty.

Support for research and image rights and reproduction were absolutely essential to this project. The authors would like to express their deepest gratitude to the Center for Christian Scholarship at Calvin University and to John and Marilyn Drake of the Drake Quinn Foundation for their leadership role in this endeavor.

So too, the authors would like to thank those at the Barnabas Foundation and the MSJ Foundation for their support. At Calvin University, Susan Felch, Michaela Osborne, Betty Sanderson, and Dale Williams are gratefully acknowledged for their guidance. Also, at Aquinas College, Stephen Schousen, Amanda Lahikainen, Stephen Barrows, and President Kevin Quinn offered direction and guidance. At the University of Notre Dame, gratitude is owed to Maura Ryan; Rev. Austin Collins, CSC; Rev. Daniel Groody, CSC; Rev. Robert Dowd, CSC; Laura Rieff; and Charles S. Hayes.

The authors thank Adrienne Lambers and Paula Manni Pohler, our research assistants, and, most assuredly, Suzie Tibor, who were instrumental in acquiring high-resolution photographs and permissions. A special note of thanks is offered to Joe Baptista of Pace Gallery and Zhang Huan Studios, Dietrich Klinge, Mimmo Paladino, Maurizio Lanzetta and Flavio Arensi, Jaume and Laura Plensa, Jay Hall Carpenter, Jonathan Borofsky and Jeremy Rutkiewicz, Elisa Veschini, George Tatje, Julia Manzù, Cristopher Canizares, Gina Costa, and Matt Cashore.

Finally, the authors recognize the labor of copyeditor Victoria Jones, proofreader Tim Baker, and several people at Eerdmans Publishing—David Bratt, Alexander Bukovietski, Lydia Hall, Jennifer Hoffman, and Kristine Nelson—for their gracious efforts in transforming a manuscript into a book. Bill may have passed away before seeing this project come to completion, but we are sure he would join us in singing your praises.

Although the two authors grew up in different subcultures, each was raised by extended families with intelligent and caring women, who arguably have displayed more patience than Job in waiting for them to mature. Respective mothers, aunts, and grandmothers have offered unconditional love, even at moments when it was seemingly the least deserved. Both of us have been blessed with exceedingly good mentors throughout our academic training, but these are the women who have taught us as young men how to read, look, laugh, and pray. So, with deepest gratitude, this book is dedicated to them.

Joe and Henry

Introduction

At a gathering of colleagues from across a variety of academic disciplines, renowned publisher Bill Eerdmans challenged the two art historians present—one from a Roman Catholic institution, one from a Protestant institution—to produce a catalog for an exhibition that could never happen, even if cost were not a factor. He wanted the subject to be one that offered significant common ground between the faith traditions but that also opened up different trajectories of understanding and meaning. He also expected that works by leading artists from across history should be employed. Canonical works should be reexamined, but lesser-known examples could also be considered. If the subject were to be profound, the scope of works should be vast.

Liberated from the obstacles inherent to mounting a physical exhibition, we delighted in the abundance of possibilities. Unlike many exhibitions devoted to contemporary art, exhibitions that include historical objects are fraught with frequently insurmountable difficulties. Foremost, issues related to conservation, the physical condition of objects, may prohibit or hinder the possibility that a work of art can travel. Collateral are challenges with insurance, which in a post-9/11 and, more recently, COVID-19 world, have become increasingly daunting. Of course, the sheer scale of some works of art is also a factor. Within this discussion, the art historians quickly advanced to some of the further obstacles scholars face in curating sculpture exhibitions in particular. In addition to the realities of conservation and insurance, all the issues associated with shipping, installing, and presenting art objects are vastly increased, and can be overwhelming, when those objects are three-dimensional. It is no surprise, therefore, that sculpture exhibitions are in the decided minority compared to those focused on two-dimensional objects, such as paintings, drawings, prints, and photographs. With this in mind, we thought that, for a catalog of an exhibition that could never happen, a focus on sculpture seemed noble and necessary.

Examining visual traditions that Catholics and Protestants share across centuries proved more complex than initially imagined. In European art, images of Mary and of the lives of saints persisted through the middle of the sixteenth century and exist in great abundance. But matters of patronage, presentation, and theological dogma greatly changed in response to the Protestant and Catholic Reformations that followed. Biblical subjects are frequently shared in Catholic and Protestant cultures, but variant interpretations prohibit the degree of focus across time that an exhibition, real or imagined, requires. However, what is shared in both theological cultures from the first centuries of the Common Era until today are images of Jesus Christ—as deity, savior, healer, and perhaps the ultimate humanitarian. Imagery of his early life, ministry, passion, death, resurrection, and eternal glory supply the sweeping thematic vista for which our wizened publisher was searching. This and the aforementioned decision to focus on sculpture coalesced in a topic that has not been adequately explored in a continuum from early Christianity through the present.

Images of Jesus, from his humble yet majestic birth to his harrowing death and miraculous resurrection, are unmatched in art history in terms of both number and aesthetic ingenuity and power. No single figure has been featured with greater frequency in Western art than Jesus Christ, despite the fact that his early life is not

concisely noted and his public ministry was measurably brief. Some of the many artworks depicting Jesus remain in the context, frequently religious, for which they were created, while others are now in museums or private collections; even today, masterpieces from earlier centuries still come on the market and make for brilliant museum acquisitions to be enjoyed for generations (see fig. 1). Still others are public monuments that preside over cities or that live in natural environments.

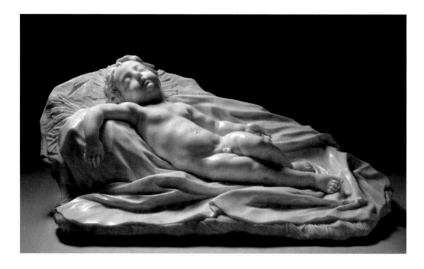

Figure 1

Among the most extraordinary recent acquisitions of a sculpture representing Christ by an American museum is the Cleveland Museum of Art's *Sleeping Christ Child* (1675) by Filippo Parodi. Although the reclining form most immediately calls to mind the Gospels' infancy narratives, it also foreshadows the mature Christ's death and burial.

All in all, two-dimensional works are more familiar to, and, by extension, more comfortably encountered by, the Christian faithful and art enthusiasts alike. Sculpture, or three-dimensional imagery in general, can be challenging, as it occupies space and is physically measured not only by height and width but also by depth, mass, and volume. Sculpture is like us and in our world in ways that even the most compelling paintings, drawings, and prints are not. Even relief carvings possess a physical presence that enters our space in ways flat images can't. No matter how expert an illusionist a painter, draftsperson, or printmaker may be, the three-dimensionality of sculpture possesses a unique power that even the most casual of viewers perceive. Sculptures are entities with us.

In addition, two-dimensional images are more commonly encountered. For example, most people have some experience living with things hung on their walls. Most of these may be images of family or picturesque scenes rather than images by famous artists, but the physical and perceptive experience is the same, and it tends to be more passive—the image is over there, on the wall. Far fewer people live with sculpture beyond that which fits the confines of a coffee table or a curio cabinet. There is generally a heightened sensory experience when one encounters a substantive sculpture because that object is not just physically present but also a less familiar spatial experience. Thus, viewing sculpture is a more active experience— the image is in the space with us. If that image happens to be religious in nature, it may very well elicit spiritual and psychological responses within the viewer.

Comfort and familiarity with two-dimensional works of art is furthered by the multitude of readily available reproductions. An original painting or print can be easily and successfully reproduced, as the format remains two-dimensional. Many people own and display copies of original paintings and enjoy the experience. Far

fewer people have copies of sculpture. Any major art museum shop, for example, will offer vast quantities of poster and postcard reproductions of paintings and prints but never more than a shelf, or possibly two, of sculpture reproductions. In regard to Christian imagery, reproductions of well-known paintings and prints have long illustrated family Bibles, calendars, and prayer cards and, more recently, greeting cards and even stamps. Such familiarity with imagery that penetrates deeply into popular culture beyond strictly devotional functions does not extend widely to sculpture. In other words, one could find innumerable quality reproductions of Leonardo da Vinci's *Last Supper* and struggle to find anything that suggests the measurable strength and presence of Michelangelo's *Pietà*. As for images of Jesus, a few exceptions persist in popular devotional culture today: sculpted figures in nativity sets or crèches, as well as crucifixes, easily come to mind. While the former is more universal across Christianity, the latter is a tradition more widely embraced in the Catholic world, although such objects are gaining popularity among Protestants too.

In terms of art history, another reality to consider is that both scholarship and the art market have historically favored two-dimensional art. As a case in point, early twentieth-century American industrialists imported legions of paintings in comparison to the occasional sculpture. Samuel Kress, for example, was among the most enthusiastic American collectors of Renaissance art, yet his painting acquisitions vastly outnumber his sculpture acquisitions (see fig. 2). So too, tremendous amounts of research and publication around painters and paintings exist in comparison to that on sculptors and sculptures. If we were to look specifically at artists with a significant repertoire of religious imagery, the numbers for painters and paintings only increase.

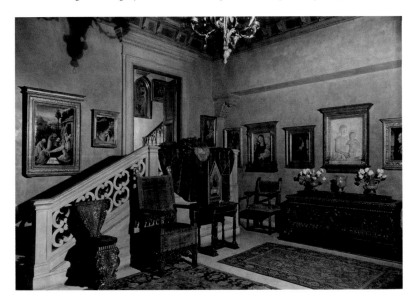

Figure 2
Interior of Samuel Kress home. One of the greatest art collectors of the twentieth century, Samuel H. Kress (1863–1955) amassed more than three thousand works, which, like many private collections, generally favored Renaissance and Baroque paintings. A philanthropist of extraordinary measure, he gifted works to more than ninety American institutions in thirty-three states. Note that there is only one sculpture, a relief, hung amidst a sea of paintings.

In addition to the wide access to two-dimensional artworks granted through reproductions, the relative ease of documentation, transport, and installation also tends to make them more desirable than works in three dimensions. Owing to their physicality, works of sculpture can be tricky but not impossible to photograph and highly challenging to ship and install. Then there is what we think of as the art market—the buying and selling of works of art. Until the last two decades,

sales for works of sculpture in general have been vastly outpaced by painting sales. All of the aforementioned shows why the consideration of sculpture, specifically carved and cast images of Christ, is very much in need, even if in the printed format of a book—an exhibition that could never be.

This book acknowledges the power and presence of sculpture as well as offers hope for a greater understanding of and an increased familiarity with three-dimensional imagery. In this sense, it is an art book. But with attention on works in the round and on reliefs visualizing the life, suffering, death, and resurrection of Jesus Christ, this book also acknowledges more than just art and art historical needs. It attempts to clarify the particular visual and emotive strengths of the Jesus narrative through forms that share our spaces and that are physically among us in ways that two-dimensional imagery, no matter the degree of illusion, are not. In this way, this is also a book about Christian devotion. Because artworks from the third century to the twenty-first have been considered, this volume is decidedly vast in breadth. The fifty-two catalog entries that follow, presented in chronological order, are an attempt to reach and inform a broad and diverse audience— religious or secular, Catholic or Protestant, art-aware or novice. As requested, the book represents a kind of carefully curated exhibition of masterworks that could never come together en masse as a singular presentation in one space or, truthfully, even in a series of smaller displays.

Whether in marble or bronze, wood or clay, sculpted images of Jesus operate within two important visual modes. First, there is the broader mode of the history of art—meaning that such images are a part of and reference millennia of art making and visual interpretation in general. In other words, an image of Christ exists as a part of the long story of art and will share bonds with a myriad of images that came before and will come after it, from across a variety of religious and secular traditions. There are many times when a representation of Jesus must be seen in relation to images of power, rulers, and deities, seemingly well beyond the boundaries of Christianity. For example, early Christian artists frequently looked to Greek and Roman models of Apollo/Helios (the sun god) and Zeus/Jupiter as they struggled to create some of the first images of Jesus. Second, sculptures of Jesus operate within a more focused mode in which Christian images are in dialogue with other specifically Christian images—generally those that precede them. A Baroque artist sculpting the crucified Christ may be looking at an example by a Renaissance master who was, in turn, considering a medieval tradition. The linkages have to do not only with forms but also with gestures and symbols, which together make up what we call iconography.

In many ways this book, a catalog for an imagined exhibition, is the result of two academics accepting a publisher's challenge. Yet the extensive research and thematic considerations that ensued revealed a need for both scholarly audiences and an enlightened general readership. *Christ among Us: Sculptures of Jesus across the History of Art* is a rare volume. Although the impetus for the project was a playful intellectual dare, the choice to pursue it to fruition, focusing on sculptures depicting Jesus Christ, is quite serious. Through the combined efforts of the authors, readers are offered a deeper look at the artistic nuances of sculptures designed to affect the religious beliefs and practices of those who encountered them.

Although an exhibition catalog for a nonexistent exhibition may initially seem strange, it is not unprecedented. Since the sixteenth century, publishers have produced "paper museums" consisting of reproductions of engravings—an exhibition, of sorts, in book format.[1] Furthermore, photography and, most recently, the internet have enabled people to visit "museums without walls."[2] The digital age and numerous online platforms give every user the opportunity to curate, in the loosest sense, images according to their liking. Globally, COVID-19 has taught museums much about crafting virtual experiences to satiate appetites for art until direct, in-person experiences can safely resume at full capacity.

In all the entries here, sculptures are regarded as agents that help shape what Christians do.[3] Rather than being passive illustrations of theological ideas, these objects have the powerful potential to direct the thoughts and behaviors of pious beholders. After all, sculptures, like other kinds of art, do not merely provide a map of religious sentiments; on the contrary, they are designed to move us physically, intellectually, and emotionally. Sculptures point and guide us toward something beyond the status quo.

Images of Christ in every medium are ubiquitous in the history of Western art, not to mention popular culture. Consider Warner Sallman's famous 1940 painting of Jesus (fig. 3), which has been reproduced over a half billion times, making it the most copied image of the twentieth century.[4] Although there are numerous sculp-

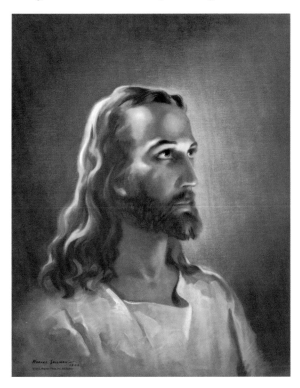

Figure 3

Warner Sallman, *Head of Christ*, 1940. Oil on canvas, 28¼ × 22⅛ in. (72 × 56 cm). Jessie C. Wilson Gallery, Anderson University, Anderson, Indiana. The ubiquity of this image in the twentieth century, hung in reproduction in homes, churches, and even secular venues around the globe, helped solidify an image of the Divine in the popular imagination.

tured crucifixes, they exist in many different styles and with variations, and thus there is no single three-dimensional work that equals the widespread popularity of the Sallman image. Perhaps the only sculptural form of Jesus that might place a distant second to Sallman's *Head of Christ* in terms of popularity is the standing

image known as *The Sacred Heart* (fig. 4). A Catholic subject that appears in some Anglican and Orthodox traditions, Christ with outstretched arms and exposed heart ablaze became a popular image in late nineteenth-century Catholic churches and homes. From smaller tabletop renditions to life-size installations in the outdoors, the image is still found in many Catholic sacred spaces.

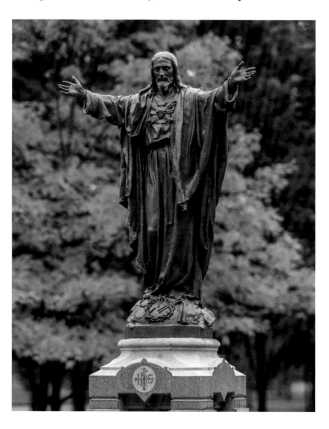

Figure 4
The Sacred Heart of Jesus, dedicated 1893. Bronze, height 90 in. (229 cm) (with base). University of Notre Dame, Notre Dame, Indiana. In combination with images of the Immaculate Heart of Mary, images of the Sacred Heart of Jesus became one of the most popular for Catholics over the course of the last two centuries. Conceptually, the Sacred Heart image type may derive from Bertel Thorvaldsen's marble *Christus*, which dates to 1821. See cat. no. 42.

In some ways, Christians' predilection for two-dimensional images is not surprising. There are historical dogmatic roots. Since 843 CE, Eastern Orthodox believers have consistently used painted panels called icons as a means to evoke the presence of the Divine. Two-dimensional images of Jesus and carved reliefs decorate Orthodox church interiors, and yet sculptural likenesses in the round are prohibited, linked to fears of idolatry. Flat icons are believed to function as sacred thresholds revealing holy persons and sacred events. The materiality of these works—typically pigment and wood—conceal themselves as they draw attention to divine figures and narratives. By contrast, sculptures in the round, it is worried, have a more difficult time denying their materiality. The artist's technical skill is usually readily noticeable, hindering sculptures from pointing beyond themselves to the sacred. In addition, a sculpture can closely resemble its prototype in physical shape, size, and features, leading to confusing scenarios in which the differences between real and ideal, between presence and likeness, are effectively foreclosed. Nonetheless, fears concerning the religious dangers of sculpture within Orthodoxy have focused on use in churches. Byzantine ivory figurines of the Theotokos (Mary as the Bearer of God) and Child were made for domestic devotion without any substantial concerns of misappropriation.[5]

In the West, Roman Catholics since the time of Charlemagne have often voiced apprehensions about the veneration of icons, preferring sacred relics over pictorial representations as manifestations or traces of the Divine. And yet, sculptures in the round typically have not posed a problem within Catholicism. One cannot but underscore the devotional intention of a great many sculpted works that depict Jesus Christ. Such works offer a meaningful focus but can also launch an imaginative spiritual journey for the faithful. This registers clearly with representations of the Crucifixion but also in images of, for example, the infant Christ in the manger, or of Jesus's lifeless corpse on the lap of his mother, as found in Pietà and Lamentation scenes. In addition to devotional images of Christ, narrative scenes in particular offer themselves as instructional to the faithful. What is presented visually can be of great assistance in guiding one through the Jesus narrative as well as establishing parameters for defining one's faith tradition. Certainly the instructional value of images is obvious in societies where literacy is low, but the reality is that from childhood onward, all human beings are visual learners.[6]

All Christians believe in the Incarnation—that God became flesh—but they have not always agreed on how this is made manifest. In Catholicism, the real presence of Christ occurs in every celebration of the Eucharist; once consecrated, the bread and wine become Christ's body and blood. During the late Middle Ages, altars across Europe were increasingly decorated with carved altarpieces.[7] This additional liturgical furniture was not necessary, but it offered an effective means to communicate church doctrines and to awaken the religious sentiments of viewers, helping to persuade them of the proximity of the Divine. In their celebration of the Eucharist, Lutherans and Catholics are quite similar. Already in the early sixteenth century, Martin Luther's close friend, the painter Lucas Cranach the Elder, and his workshop produced large altarpieces for Protestant churches in Schneeberg (1539), Wittenberg (1547), and Weimar (1555).[8] However, none of these monumental triptychs from Cranach's workshop include sculpture. Although some Lutheran churches have altarpieces with carved panels in relief, this is a rare phenomenon.

Meanwhile, the followers of Karlstadt, Zwingli, and Calvin actively stripped altars bare, destroying liturgical paintings and sculptures in the name of religious purity.[9] Images, they believed, could distract worshippers from hearing God's word. In some instances, Reformed Christians complained that the money used to produce these images would be better spent on the impoverished, but this objection does not fully explain their iconoclasm. They could have simply stopped commissioning ecclesiastical art and redirected church funds elsewhere.[10] Fears of idolatry and the inherent dangers associated with any efforts to localize the Divine appear to be among the primary concerns of the Protestant iconoclasts. Liturgical images, moreover, were often closely linked to Catholic practices, such as relic veneration, Marian devotion, monasticism, and the doctrine of transubstantiation, which were also under attack. Of course, although numerous Catholic objects were destroyed in the Protestant war against idols, this did not stop Calvinists from generating new ecclesiastical images, ones that they could call their own, such as banners displaying biblical passages and/or theological symbols. Furthermore, the removal of Catholic imagery from confiscated churches was never complete. Stained glass windows, for instance, were often allowed to remain. Many elaborately carved altarpieces, however, have been lost.

Innumerable ecumenical efforts, made by many in recent generations, have sought to engage Protestants and Catholics together around shared beliefs, cele-

brations, and social justice causes. Nonetheless, this has not eliminated theological or liturgical differences. Generally speaking, many Catholics are surprised at the more minimalist interiors of Protestant churches. This holds true for Catholic visitors touring historical sites in northern Europe or a church by Christopher Wren, or stepping into any number of industrial-looking megachurches in suburban America. The absence of an architectonic altarpiece replete with saintly figures, or of Stations of the Cross lining the nave walls, might eventually be intellectualized by someone with a Catholic background, but the use of images of an empty cross rather than one with a corpus might seem insufficient, for it does not address Christ's suffering, nor his sacrificial death. Conversely (and excluding Anglicans, for the most part), many raised in Protestant traditions can be taken aback by the profusion of images inside Catholic church interiors. One need not travel to one of the great basilicas of Rome for a resoundingly bold visual experience; any number of parish churches in city centers and neighborhoods across the globe where Catholicism has spread will do.

Although Catholics who have grown up after the implementation of Vatican II may have less familiarity with the details of religious imagery than their forebearers, there tends to be a continuum of comfort with worship in a context where such imagery is present. Even in newer Catholic churches and chapels where the aesthetic is more restrained and fewer, even abstracted, images are installed, there is still a representational presence of Christ—most often in sculptural terms. The felt connection to such sculptural representations of Jesus fulfills and sustains part of what the renowned Catholic writer and priest Andrew Greeley articulated as the "Catholic Imagination."[11]

The majority of sculptures of Jesus are for interior spaces, religious or secular, and are of a scale in sympathy with the human figure, from the handheld to the slightly over-life-size, but there is a more recent tradition of working on a colossal scale in the outdoors. Beginning in the latter half of the nineteenth century, an increasing appetite for large outdoor figurative monuments led to the installation of colossal works of sculpture across Europe and America.

Many—like Bartholdi's *Liberty Enlightening the World*, commonly known as the Statue of Liberty —celebrate civic ideals, but there are several significant examples that focus on Jesus.[12] A nearly one-hundred-foot-high depiction of the resurrected Christ with outstretched arms, recalling his crucifixion and suggesting his desire to embrace humanity, stands at the crest of Mount Corcovado, dominating the skyline of Rio de Janeiro (fig. 5). *Christ the Redeemer* was commissioned by private donors to combat the city's "godlessness."

In 2007 the sculpture, made of reinforced concrete with outer coats of soapstone, was named one of the New Seven Wonders of the World—the only intentionally Christian monument with this distinction. Since then, colossal crosses, aspiring to attract pilgrims and tourists, have been commissioned elsewhere. Concrete crucifixes larger than *Christ the Redeemer* have been constructed in Encantado, Brazil; Cochabamba, Bolivia; and Świebodzin, Poland. Another monumental cross, aimed at being the world's tallest, is proposed to be built in Victoria City, Mexico. Although Rio de Janeiro's sculpture is no longer the biggest, it remains the most famous.

Recently, *Christ the Redeemer* has acquired additional meaning. Despite the Brazilian president's opposition to enforcing numerous health restrictions and

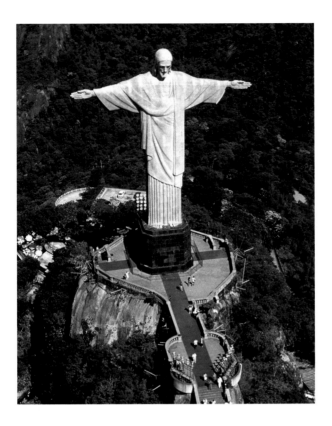

Figure 5
Paul Landowski, with Heitor da Silva
Costa, Albert Caquot, and Gheorghe
Leonida, *Christ the Redeemer*, 1922–1931.
Soapstone and reinforced concrete, height
98 ft. (30 m). This iconic work is the
only modern Wonder of the World to
address a traditional Christian theme.

his failure to offer incentives to produce and distribute vaccines in response to
the COVID-19 pandemic, the heroic deeds of the country's frontline healthcare
workers have not gone unnoticed. On Easter Sunday 2020, the archbishop Orani
João Tempesta performed Mass at the foot of *Christ the Redeemer* as large im-
ages of physicians and nurses donning lab coats, scrubs, and stethoscopes were
projected onto the figure, effectively conveying these workers' Christ-like efforts
in serving others. The figure was also periodically illuminated with flags from
different countries, including the United States, that continued to suffer fatalities
in large numbers. In multiple languages, words like "hope'" "thanks," and "stay at
home" also ran across the sculpture's surface.[13]

Although less famous, Marshall Fredericks's *Man on the Cross* (1959) also offers a
larger-than-life representation of Jesus (fig. 6). However, it does not overlook an ur-
ban landscape, nor is it made of reinforced concrete. Fredericks's cast-bronze sculp-
ture was commissioned to complement a new Catholic shrine located in Indian
River, a small resort town in northern Michigan. The scale of the cross was designed
to catch the attention of automobile traffic, encouraging those on vacation to visit
the shrine. Father Charles Brophy, the parish priest, said the woodland setting
reminded him of a tale about St. Kateri Tekakwitha, the Lily of the Mohawks,
a seventeenth-century Native American convert to Christianity. According to
legend, she often made little crucifixes, enshrining them in trees. Taken by the
story, Father Brophy envisioned a large crucifix for his forest parish, and he began
seeking donations for the project. The Danish American artist Marshall Fredericks
received the commission and designed a bronze figure of Christ to be placed on
monumental redwood beams. Wanting to emphasize strength and tranquility, the

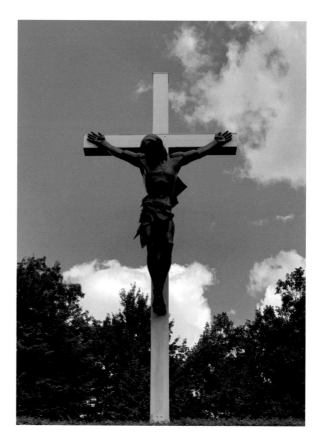

Figure 6
Marshall Fredericks, *Man on the Cross*, 1959.
Bronze and wood, height: corpus 28 ft.
(8.4 m), cross 55 ft. (16.5 m). This Danish
American sculptor was best known for his
portraits and for mythological and literary
subjects, but this monumental shrine is
among his most iconic public works.

artist received Vatican permission to represent the crucified Christ without the crown of thorns or side wound.

Though this may be surprising to some readers, monumental sculptures of Jesus have also been placed in front of a few American evangelical megachurches. In 2004 Brad Coriell, James Lynch, and Mark Mitten constructed a forty-two-foot Styrofoam sculpture, supported by an interior steel frame and coated in fiberglass, for the Solid Rock Church near Lebanon, Ohio (fig. 7). Prominently located on the east side of I-75 and readily seen by passing cars, the sculpture represents Christ at half length rising out of the church's colossal baptismal pool. With upraised arms and a partially submerged cross displayed as a trophy at his side, Jesus looks up, apparently contemplating his heavenly kingdom. Lampooned as the Big Butter Jesus, the island sculpture was struck by lightning in 2010 and subsequently melted. Two years after its destruction, the church installed a new fireproof sculpture of *Christ as the Light of the World* on the site.

Unlike painted or printed images, which are two-dimensional and hang parallel to the walls, works of sculpture are literally among us.[14] Not only do we face them, as we do paintings and prints; we also walk around sculptures in the round, as we do human beings.[15] Although our connection with sculptures is primarily in terms of sight, it often includes imagined touch. This implied tangibility tends to be less pronounced in paintings, even those rendered in high naturalism to suggest a virtual reality.

In *paragone* debates comparing the art of sculpture with that of painting, Leonardo da Vinci and Michelangelo famously opposed each other. Leonardo, giving preference to painting, noted that it is a more gentlemanly activity, without the

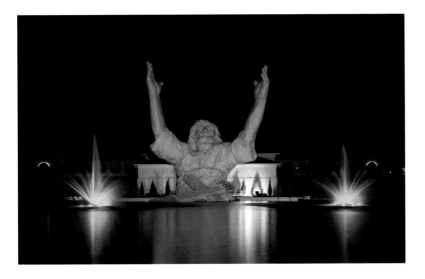

Figure 7
Brad Coriell, James Lynch, and Mark Mitten, *King of Kings*, 2004. Styrofoam coated with fiberglass, height 62 ft. (19 m). Solid Rock Church, Lebanon, Ohio.

physical force or material mess of sculpture. By contrast, Michelangelo claimed sculpture was the superior art because it demanded that the artist overcome great difficulties, such as making stone come to life, and thinking in terms of three rather than two dimensions.[16]

In northern Europe, Renaissance painters and sculptors belonged to different guilds. Sculptors were typically better paid than their counterparts, but they were not allowed to apply paint to their works. The fifteenth-century painter Jan van Eyck played off this tension by depicting monochromatic sculptures in the exterior panels of many of his triptychs as well those of the Ghent Altarpiece.[17] Although these Renaissance debates were never settled, painting has become the dominant art. From Gian Lorenzo Bernini to Auguste Rodin, there have been many powerful forces in the realm of sculpture since the Renaissance, yet the scepter has never passed, per se, to sculpture. What can be said, and experienced, however, is that the history of sculpture developed forward, seemingly uninterrupted, for centuries, carrying with it images of Jesus Christ.

Moving much closer to our own time and place, religious art in general experienced a rapid decline, and some would argue near extinction, in the twentieth century. With a few notable exceptions, such as the work of the French painter Georges Rouault (1871–1958) and of several of his contemporary German Expressionists, Christian imagery dropped precipitously from the avant-garde that is broadly thought of as modern art. From the earlier decades of the century, famous artists like Pablo Picasso and Henri Matisse may have occasionally referenced traditional religious imagery in their works, but they and their followers favored themes of everyday life and contemporary events.[18] In general, the broad currents of Expressionism and Surrealism flowed away from depictions of Christ. In early twentieth-century sculpture, perhaps only the Croatian-born Ivan Meštrović formulated a figurative style with a particularly compelling attachment to biblical imagery that was embraced by art world critics and the faithful alike (fig. 8). Even the so-called father of modern sculpture, Auguste Rodin, recognized the originality and power of Meštrović's work that sprang from historical models boldly into the new century, describing him as a "phenomenon" in sculpture.[19]

However, it was the formalist tendency toward abstraction that most powerfully disrupted centuries of tradition for religious imagery. Abstract or nonrepre-

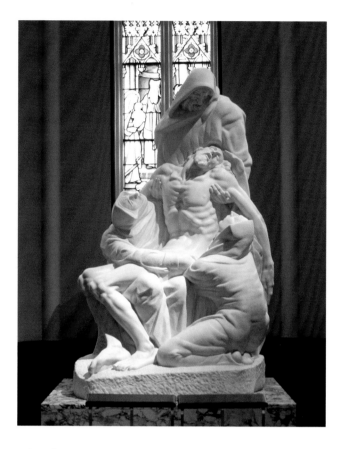

Figure 8
Ivan Meštrović, *Pietà*, 1942–1946. Marble, height 11.2 ft. (3.4 m). Basilica of the Sacred Heart, University of Notre Dame, Notre Dame, Indiana. A devout individual, the artist was widely admired across Europe and America by the 1920s and was the first living artist to be given a retrospective exhibition at New York's Metropolitan Museum of Art, an honor rarely conferred.

sentational art flourished across America and, belatedly, Europe by midcentury. There is little doubt that Abstract Expressionism, through both gestural painting and its companionable Color Field painting, was the dominant vision and voice of postwar art. With rare exceptions, figuration was banished from the avant-garde. Color Field painters would frequently assert the spiritual underpinnings of their work, but their aggressive painted and welded surfaces operated well beyond anything that would accommodate traditional modes of Christian imagery. The power of abstraction has proven to be transformational, and it affected all the visual arts. Specific to works of sculpture, a new, still-flourishing tradition was formed by the 1970s that adopted the spiritual sentiments once reserved for religious art but expressed them in nonreligious and nonfigurative terms. Sculptors in this tradition include Mark di Suvero, Richard Serra, Richard Hunt, and Beverly Pepper, among others. Pepper's profoundly moving colossi, *San Martino Altars* (fig. 9), are seemingly far removed from any traditional notion of "altar" and contain no references to the human body, but their solemnity evokes feelings similar to those experienced before traditional sacred sculpture and in hallowed spaces. Their monumentality actually evolves beyond merely sculptural toward the architectonic.

For this narrative to be honest, it must be admitted that religious, specifically Christian, art has been produced across Europe and America from the mid-twentieth century onward, but rarely by the most compelling artists heralded within the art world. Centuries of artistic tradition in which Jesus Christ was arguably the most important subject matter seemingly dissolved as the distinctions between the sacred and the secular grew increasingly more distinct over time. Among the notable exceptions

Figure 9
Beverly Pepper, *San Martino Altars
(Solemn Celebrant, Eternal Celebrant)*,
1993. Cast iron, height 10.2 ft. (3.1 m) each.
Beverly Pepper Sculpture Park, Todi, Italy.
Among the most well-known abstract
sculptors of her generation, Pepper calls
upon a variety of religious traditions
in her work. Although never religious
objects, her sculptures are intended to be
in conversation with the larger history
of religious art and architecture.

to this trend is artist Giacomo Manzù, who, drawing on the history of sculpture in his native Italy, included images of the life of Christ in his repertoire (see cat. no. 46). Perhaps more significantly, Manzù was among a small but powerful group of sculptors that maintained a commitment to the figure that was accepted and embraced by the avant-garde. Although working in Italy and frequently for the Vatican itself, Manzù was not a religious person. He was, however, deeply concerned about the inequities and violence perpetuated by humans, which only the historical Christ, through his suffering such wrongs, seemed to embody. For Manzù, images of Christ were more than *the* Christ; they were the suffering, the poor, the noble disenfranchised.

As the pendulum of art history swung, the human figure reemerged in the 1980s as both a source of inspiration and a symbol. Among the most critically acclaimed artists of this generation, none could be thought of as a religious artist, yet many have exhibited a deep social consciousness or have suggested a heightened mysticism through their work. One major international sculptor, Jonathan Borofsky, has crafted a body of work that is decidedly spiritual; his *God* paintings and installations are among the most profound works that overtly reference the Divine, but in humanistic rather than religious terms (fig. 10). If one accepts the claim that artists like Manzù helped saved figurative art at midcentury, artists like Borofsky repositioned the fig-

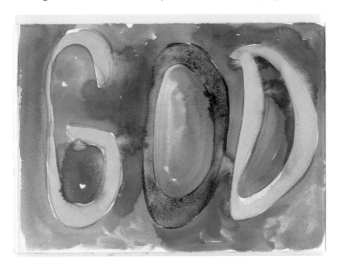

Figure 10
Jonathan Borofsky, *God*, 1997. Watercolor
and pencil on watercolor paper, 11½ ×
8¼ in. (29 cm × 21 cm). Deeply humanistic
and concerned with the health of the spirit,
Borofsky emerged as one of the most im-
portant figurative artists of his generation
in the 1980s. Many of his works convey a
heightened sense of the spiritual but do not
overtly reference any specific faith tradition.

ure as once again a viable object of inspiration and creative expression. The former sculptor, however, still addressed religious images as a part of his oeuvre and therefore participated in and extended the continuum of images of Christ within art history, whereas the latter and his peers did not. The question left unexplored is, what role do images of Christ play within this new figurative tradition?

Even the most seasoned museum professional or avid gallerygoer would be hard-pressed to find a large number of critically acclaimed artists working today whose repertoire is populated by religious works, let alone imagery of Jesus Christ. Often those who identify as religious sculptors and who produce work for churches and religious shrines are working in a tired tradition, repeating iconic images from bygone eras. Their sentiments may be sincere, but the work is often uninspired. The aforementioned sculptor Jay Hall Carpenter is unique (fig. 11). His commitment to the figure first and the content after has won the praise of arts audiences, and his search for sincerity and originality in even the most traditional

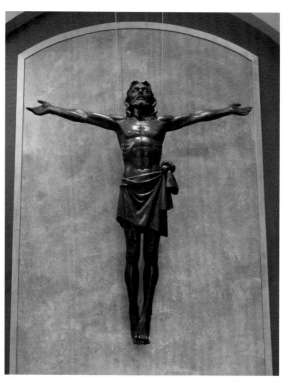

Figure 11
Jay Hall Carpenter, *Christ Crucified, Christ Risen*, 2001. Bronze, height 79 in. (201 cm). One of America's most gifted ecclesiastical sculptors, Carpenter worked for more than twenty years on carvings for the National Cathedral in Washington, DC, producing more than five hundred works for the building. His depiction of the corpus of Christ is his most famous and has been made available in a variety of scales.

subjects has captured the attention of even tradition-oriented Christian audiences. Although he worked on the carved statuary of the National Cathedral in Washington, DC, for more than twenty years, it is his *Corpus* that has been the most popular. Well aware of iconography surrounding the crucifixion, death, and resurrection of Christ, Carpenter focuses instead on an original vision of conjoined moments. Further, rather than copying earlier corporeal forms of the Divine, it is immediately apparent that he is working with a model, studying from life, to create a realistic form that elevates humanity toward eternity.

More typical for sculptors working today is to reference traditional poses, compositions, and symbols associated with Christ but to employ them toward a nonreligious theme. In other words, history and art historical tradition are employed

to capture the secular, the everyday. Working in a hyper-realistic style, Ron Mueck has emerged as one of today's most important figurative sculptors. His *Youth* is a compelling representation of a Black male adolescent (fig. 12). Small but elevated on a pedestal, this urban figure is shown in a T-shirt and jeans, and he lifts his shirt to show a gaping, bloody wound. The position of the wound and its exposure to the viewer immediately call to mind Christ's presentation of his side wound to the doubting Thomas following the Resurrection; the art historical and iconographic references are clear. Although an echo of more traditional representations, like Andrea del Verrocchio's *Christ and Saint Thomas* (cat. no. 19), *Youth* extends the trajectory of images of Christ in a way authentic to Mueck's own time and place, just as Verrocchio and others have done before him. After all, art is contextual. However, whereas masters of the past attempted to offer visions of the Divine to humanity, Mueck offers us a difficult vision of violence against people of color, particularly male youth, in terms that suggest the preciousness and suffering of Christ himself.

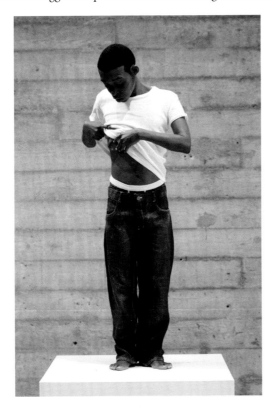

Figure 12

Ron Mueck, *Youth*, 2009. Mixed media, 25⅝ × 11 × 6¼ in. (65 × 28 × 16 cm). One of the sculptor's most compelling images, this sculpture honors urban youth while also lamenting the tragic reality of violence that surrounds them. Made more than a decade before the murder of George Floyd and the Black Lives Matter movement, it captures a history of violence and discrimination against people of color.

As a catalog for an exhibition that could never be, this book attempts to show a wide variety of representations, but it is not encyclopedic. However, the opportunity to consider artists as diverse yet companionable in time and place, media, and meaning as Mueck and Verrocchio, Meštrović and Michelangelo, Pepper and Plensa, is unique. The judicious selections in the ensuing pages provide a chronology of forms and ideas across history. Whether in marble, bronze, wood, or, most recently, stainless steel or ash, images of Jesus Christ have played a crucial role within the history of Christianity. Although perhaps less well known and familiar than their two-dimensional counterparts, sculptures often offer opportunities to experience the Divine in a shared space, intensifying the religious sentiment that Christ is among us.

Notes

1. Rebecca Zorach and Elizabeth Rodini, eds., *Paper Museums: The Reproductive Print in Europe, 1500–1800* (Chicago: University of Chicago Press, 2005). Exhibition catalog.

2. André Malraux, *Les voix du silence* (1951), trans. Stuart Gilbert as *The Voices of Silence* (Princeton, NJ: Princeton University Press, 1978).

3. See Alfred Gell, *Art and Agency: An Anthropological Theory* (Oxford: Oxford University Press, 1998); and David Freedberg, *The Power of Images: Studies in the History and Theory of Response* (Chicago: University of Chicago Press, 1989).

4. David Morgan, *Visual Piety: The History and Theory of Popular Religious Images* (Berkeley: University of California Press, 1999), 29–34.

5. Anthony Cuttler, *The Hand of the Master: Craftsmanship, Ivories, and Society in Byzantium* (Princeton, NJ: Princeton University Press, 1994).

6. Among the best and earliest resources for understanding the significance of visual literacy and instruction is Bruce Cole's landmark book, *The Renaissance Artist at Work* (New York: HarperCollins, 1983).

7. Henk van Os, *Sienese Altarpieces, 1215–1460*, 2 vols. (Groningen, Netherlands: Egbert Forsten, 1988); Barbara G. Lane, *The Altar and the Altarpiece: Sacramental Themes in Early Netherlandish Painting* (New York: Harper and Row, 1984); and Lynn Jacobs, *Early Netherlandish Carved Altarpieces, 1380–1550: Medieval Tastes and Mass Marketing* (Cambridge: Cambridge University Press, 1998).

8. Bonnie Noble, *Lucas Cranach the Elder: Art and Devotion of the German Reformation* (Lanham, MD: University Press of America, 2009).

9. Eamon Duffy, *The Stripping of the Altars: Traditional Religion in England, 1400–1580* (New Haven, CT: Yale University Press, 1992); and Mia Mochizuki, *The Netherlandish Image after Iconoclasm, 1566–1672: Material Religion in the Dutch Golden Age* (Aldershot, UK: Ashgate, 2008).

10. For more on iconoclasm, see Lee Palmer Wandel, *Voracious Idols and Violent Hands: Iconoclasm in Reformation Zurich, Strasbourg, and Basel* (Cambridge: Cambridge University Press, 1995); and Carlos M. N. Eire, *War Against the Idols: The Reformation of Worship from Erasmus to Calvin* (Cambridge: Cambridge University Press, 1989).

11. Perhaps the most important recent discussion of the phenomenon occurred with the Metropolitan Museum of Art's landmark exhibition *Heavenly Bodies: Fashion and the Catholic Imagination*, May 10–October 8, 2018, which shattered all attendance expectations and was one of the most popular exhibitions hosted by the museum in its nearly 150-year history.

12. One of the most comprehensive discussions of the widespread development of civic statuary is found in Penelope Curtis, *Sculpture: 1900–1945* (Oxford History of Art) (Oxford: Oxford University Press, 1999).

13. Caroline Goldstein, "Rio de Janiero Used Cutting-Edge Technology to Transform Its Giant Jesus Statue into a Doctor to Honor Health Care Workers," *Artnet News*, April 13, 2020.

14. David Summers, *Real Spaces: World Art History and the Rise of Western Modernism* (London: Phaidon 2003), 36–60.

15. Mikel Dufrenne, *Phénoménologie de l'expérience esthétique* (1953), trans. Edward Casey as *The Phenomenology of Aesthetic Experience* (Evanston: Northwestern University Press, 1973), 73–78, 138–46.

16. David Summers, *Michelangelo and the Language of Art* (Princeton, NJ: Princeton University Press, 1981), 177–85.

17. Lynn J. Jacobs, *Opening Doors: The Early Netherlandish Triptych Reinterpreted* (University Park: Pennsylvania State University Press, 2012), 67–75.

18. The notable exception is Matisse's famed Chapelle du Rosaire de Vence (1947–1951), where the artist produced everything from the chapel's stained glass and wall mosaics to priestly vestments.

19. Gagro Bozidar, *Ivan Meštrović* (Zagreb: Globus, 1987).

Photo credits

Christ among Us

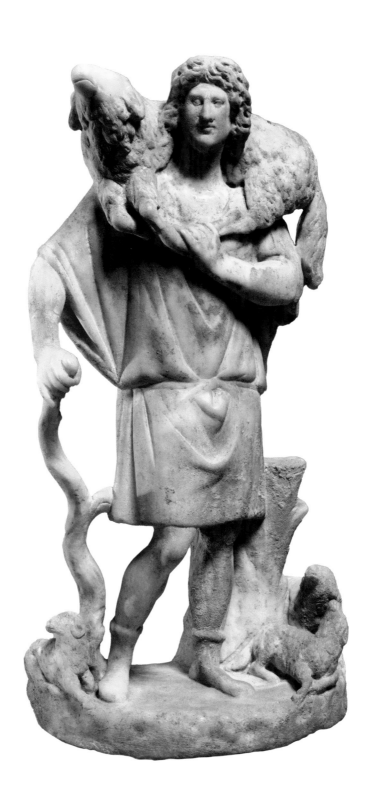

The Good Shepherd (ca. 280–290 CE)

UNRECORDED ARTIST (EASTERN MEDITERRANEAN, LIKELY PHRYGIA)

MARBLE | 19½ × 10¼ × 6⅜ IN. (49.5 × 26 × 16.2 CM) | CLEVELAND MUSEUM OF ART, CLEVELAND, OHIO |
JOHN L. SEVERENCE FUND

Prior to the 1960s, the majority of scholars believed that although wealthy Christians commissioned paintings and relief sculptures before the reign of Constantine, there were no sculptures in the round until the fourth century. The discovery of a cache of eleven objects, allegedly found in a single *pithos*, or storage jar, provides evidence to the contrary. Freestanding sculptures with Christian themes predate the legalization of the religion in the Edict of Milan in 313. The items unearthed include six portrait busts representing three married couples, four sculptures associated with the biblical tale of Jonah, and a depiction of the Good Shepherd. All these sculptures, now housed at the Cleveland Museum of Art, are rendered in high-quality marble and were likely produced in ancient Phrygia (present-day western Turkey).

In the Good Shepherd sculpture, a youthful, beardless figure stands among his flock beside a tree stump. Leaning on a staff, he carries one of his sheep on his shoulders. In John 10, Christ is identified with the Good Shepherd described in Psalm 23. The sheep he bears may also allude to the lost creature that now is found (Luke 15:4–7). Nonetheless, the shepherd's appearance is closely aligned with pre-Christian and pagan imagery produced in Greco-Roman antiquity. He wears a loose tunic, held at the waist by a belt, and his right knee is bent, indicating that he is standing at rest. His holding a sheep on his shoulders is reminiscent of Greco-Roman personifications of philanthropy and images of Alexander the Great and other idealized

rulers to be followed. Carved in fine marble, a material favored by the Greco-Roman elite, the sculpture conveys a sense of luxury and devotion.

The sculptor of the Cleveland *Good Shepherd* rendered the figure's hair with a drill, a technique that accentuates the juxtaposition of highlight and shadow, making the image appear more dramatic. The reverse side of the sculpture is unpolished, suggesting that it may not have been intended to be seen from all sides. Yet a satchel looped around the shepherd's neck, invisible from a frontal view, is represented on the sculpture's backside.

Unfortunately, the function of this work remains unknown. Eusebius, the biographer of Constantine, mentions courtyard fountains decorated with images of the Good Shepherd, suggesting that the statue may have stood with others in the garden of a Roman villa. A depiction of Christ as the Good Shepherd, now at the Yale University Art Gallery, is also painted in the lunette above the font in the third-century baptistery of the house-church at Dura-Europos. Like the fresco, this sculpture may have evoked the leadership of Christ, who guides his sheep to still waters, offering them the refreshment of new life. Images of the Good Shepherd also regularly appear in catacomb paintings and on sarcophagi, indicating that the Cleveland sculpture may have been placed in a funerary niche within a family mausoleum. Although its original location eludes us, the sculpture likely offered spiritual comfort to viewers seeking eternal life.

HML

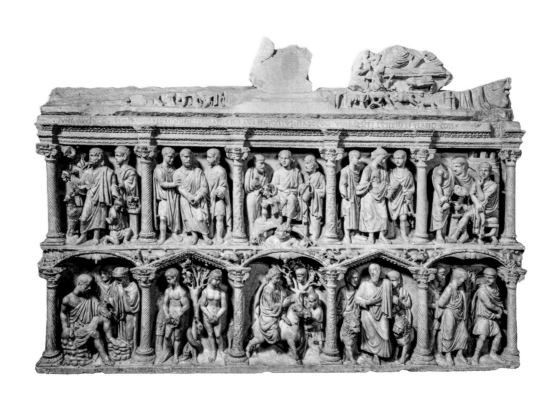

Sarcophagus of Junius Bassus (359 CE)

UNRECORDED ARTIST (ROME)

MARBLE | 55½ × 95⅝ IN. (141 × 243 CM) | TREASURY OF ST. PETER'S BASILICA, VATICAN CITY

On August 25, 359, Junius Bassus, a Roman prefect, died at the age of forty-two. His remains were interred in a wooden coffin placed inside a marble sarcophagus carved in high relief. The manner of his burial was befitting of his cultural status. Roman sarcophagi, pagan and Christian, were often decorated with scenes associated with the victory over death and the promise of life anew, and this example is no exception. Discovered under the Old St. Peter's Basilica in 1597, the sarcophagus appears Greco-Roman in style, but its elaborate iconography is explicitly Christian, reflecting the decedent's desire to unite with Christ in a loftier and eternal place, the kingdom to come. An inscription above the imagery describes the prefect as newly baptized. Like the emperor Constantine, Junius Bassus may have confirmed his conversion upon his deathbed.

Unfortunately, the marble coffin's lid has been severely damaged. However, it appears to show a funerary banquet (*agape*), a means of communal remembrance practiced by Roman pagans and Christians alike. Putti (chubby male children with wings) harvesting grapes and wheat, an allusion to the Eucharist as well as to the celebration of life and the renewal of the seasons, decorate the sides of the stone container. Consumption of the bread of life and fruit from the true vine provides an antidote to death. Unlike other ancient Roman sarcophagi, the front of this marble coffin has two horizontal registers depicting a total of ten biblical scenes (four Old Testament, six New Testament), each in its own niche and separated from neighboring scenes by columns. The figures are dressed in Roman attire. Although images of Noah and Jonah are commonplace in early Christian sarcophagi, they do not appear here. The Old Testament stories include, at the upper left, Abraham attempting to sacrifice Isaac, a prefiguration of the sacrifice of Christ. Depictions of the patience of Job, the fall of Adam and Eve, and Daniel in the lions' den appear in the lower register, revealing the need for a New Adam and for the salvation of those who are willing to suffer trials and tribulations in the name of God.

The representations of these narratives also suggest that divine providence will ultimately prevail—the gift of atonement is always, already present. The remaining imagery derives from the New Testament. Three of these scenes address the miscarriage of justice: the arrest of Saint Peter, the imprisonment of Saint Paul, and the trial of Jesus, with Pilate washing his hands after the conviction. These narratives denote the power and responsibility of public officials.

In the upper center, Christ sits on a throne flanked by Peter and Paul. He is youthful and beardless, reminiscent of depictions of the pagan god Apollo (Helios), who reinforces order and offers enlightenment for the benefit of others. Christ holds a scroll in his left hand, implying the *traditio legis*, the transference of the law, a gesture traditionally performed by Roman emperors to indicate their extension of authority to others within their administration. The bearded figure below Christ holds up a canopy. He personifies the sky (*caelus*) and thus suggests the celestial presence of Christ, who rules in heaven. Imperial allusion is also present in the Palm Sunday scene below. Although Christ rides humbly on the back of a donkey, his arrival foreshadows his victory over death. The procession of a visiting prominent Roman political leader, such as Junius Bassus, was often called an *adventus*, a coming forth. In this regard, the magisterial Christ enters the city of Jerusalem triumphantly like a Roman ruler on parade. The juxtaposition of these two scenes—the *traditio legis* and Christ's entry into Jerusalem—in the center of the sarcophagus likely held special meaning for a Roman prefect anticipating his own arrival into the heavenly city, the New Jerusalem.

In the exquisitely carved spandrels (the triangular spaces between the tops of the arches), miniature lambs reenact a variety of biblical stories, including the three men in the fiery furnace, Moses striking the rock, the miracle of the loaves and fishes, the baptism of Christ, Moses receiving the law, and the raising of Lazarus—scenes that reveal God's grace and the power of resurrection.

HML

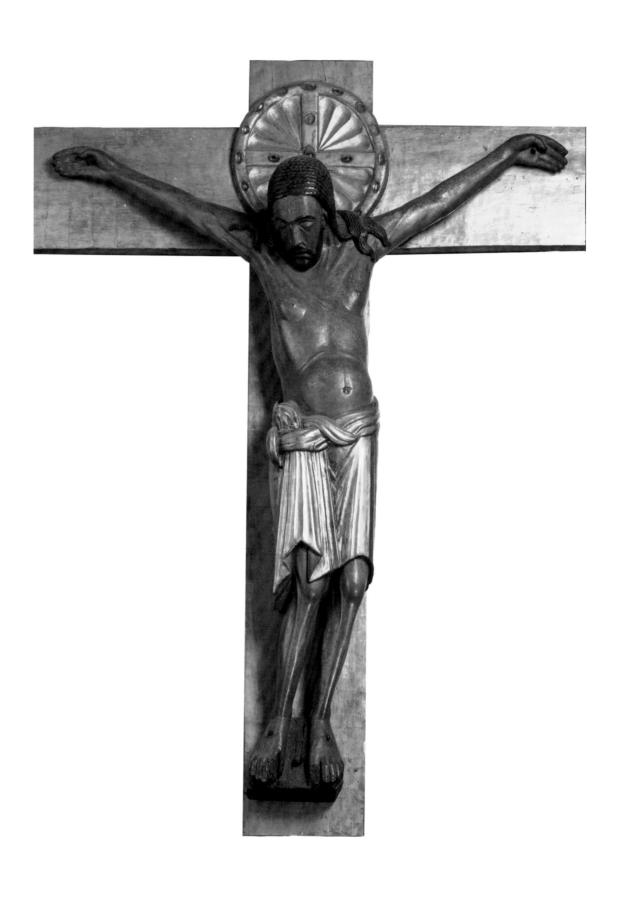

Gero Crucifix (ca. 970)

UNRECORDED ARTIST (COLOGNE)

POLYCHROMED AND GILDED OAK | 74 × 65 IN. (188 × 165 CM) | KÖLNER DOM, COLOGNE

Although the crucifix is arguably the most popular symbol of Christianity today, that was not always the case. In fact, representations of Christ on the cross do not appear until the fifth century, and in these images Jesus is typically depicted as alive, with his eyes open and with no indications of pain. The Gero Crucifix, by contrast, is one of the earliest renderings of the mortality of Christ.

The archbishop of Cologne, named Gero, commissioned this life-size crucifix in the late tenth century for the city's cathedral. It was initially placed in the center of the nave, where it crossed with the church's transept. Members of the laity were regularly served Communion there, which was also planned to serve as the site of the archbishop's tomb. In the late Middle Ages the crucifix was moved to a chapel on the northern side of the cathedral. A large sunburst was placed behind it during the seventeenth century.

Although Jesus never loses his divinity, this innovative sculpture focuses primarily on his humanity. Not only is he depicted on a human scale; he is also shown as a dead man who has suffered. The belly of his sagging corpse is swollen. His downcast chin rests upon a lifeless chest, reinforcing his humiliation and the somber aspect of his death. Originally, Gero's Christ wore a crown of thorns (now lost). Traces of blood can be seen on his forehead, promoting empathic identification. The naturalistic appearance of the sculpture comple-ments contemporary meditations on Christ's passion, which also elicit an emotional response.

According to the Ottonian chronicler Thietmar of Merseburg (975–1018), Archbishop Gero one day discovered a crack in a wooden crucifix that he had commissioned. Instead of hiring a sculptor to repair the damage, Gero called upon the help of the "greatest of artisans," Christ, to restore it. The cleric placed a fragment of the consecrated host into the crevice, and miraculously, the sculpture was healed. Whether the crucifix described by Thietmar is the same as the work illustrated here remains unknown.

Nonetheless, the Gero Crucifix has strong eucharistic associations. Not only was its placement closely tied to the Eucharist, but its emphasis on the physicality of Christ's sacrifice also reinforced the reality of his presence within the church. During the ninth century, Paschasius and other theologians debated the nature of the sacrament, noting that the visual appearance of the elements—namely, bread and wine—do not change during or after their consecration as Christ's body and blood. For Paschasius, the historical Jesus, despite his seeming invisibility, was literally present in the Eucharist, and his flesh became one with those participating in the sacrament. Although the Truth is concealed within the consecrated wafer, sculptures like the Gero Crucifix reveal the means of salvation by representing the sacrificial Christ as the bread of the cross.

HML

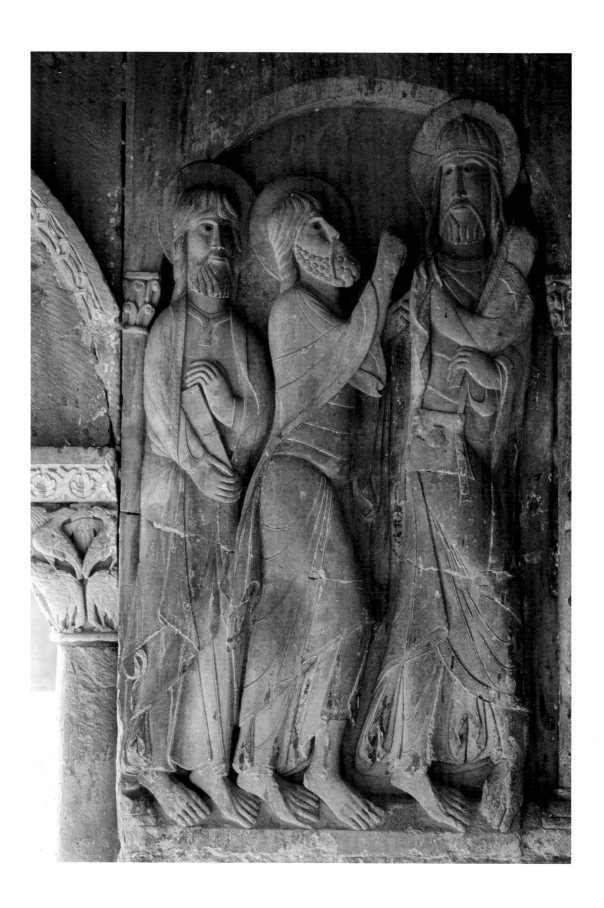

Christ on the Road to Emmaus (ca. 1100)

UNRECORDED ARTIST (CASTILE, SPAIN)
LIMESTONE, PIER RELIEF IN CLOISTER | SANTO DOMINGO DE SILOS, SPAIN

During the late eleventh century, the Benedictine abbey of Santo Domingo de Silos became an important pilgrimage site on the road to the miraculous burial place of Saint James, Santiago de Compostela. Sojourners traveling to Santiago, most of them hoping to acquire corporeal or spiritual healing, often stopped at Silos to venerate the monastery's collection of sacred relics. The visit, they believed, offered an effective means of encountering the Divine. Not surprisingly, pilgrims also celebrated the Mass at Silos. Their presence, however, came with a drawback. Monasteries are places of seclusion, but pilgrims, happy to arrive at their destination, can be quite disruptive. A new cloister—an enclosed courtyard reserved for quiet contemplation—was constructed to relieve tensions.

Within the cloister, believers were granted opportunities to meditate on the life of Christ as they considered their own spiritual journey. Like the enclosed garden described in the Song of Songs, the cloister offered a space for love, where Christians could become more intimate with God. Although the cloister was frequently closed to the laity, it was occasionally opened to them. Six of the piers supporting a colonnade around the cloister were decorated with sculptural reliefs. In the northwest corner, a scene of Christ on the road to Emmaus is depicted (Luke 24:13–35), showing three barefoot travelers moving from left to right. The nearly life-size figures gaze in different directions, suggesting their unfamiliarity with one another. The resurrected Christ, who is slightly larger in scale, appears to lead the other two, his right leg crossed over his left. Most importantly, his posture evokes a moment of hesitation. Christ seems to address his fellow sojourners, asking them about the nature of their conversation. Unaware of Christ's identity, they describe their disappointment that the Messiah has failed to arrive. At this moment, Christ continues to conceal his true self. They will have to wait until an evening meal. Within the context of the cloister, viewers learn to walk with Jesus prior to knowing who he really is. The process of meditation, it is expected, will provide such insight.

Christ wears a satchel decorated with a scallop shell, the attribute of Saint James that frequently appears on pilgrimage badges. Its presence in the pier relief reinforces the pictorial analogy between sojourners on the way to Emmaus and pilgrims on the road to Santiago de Compostela.

HML

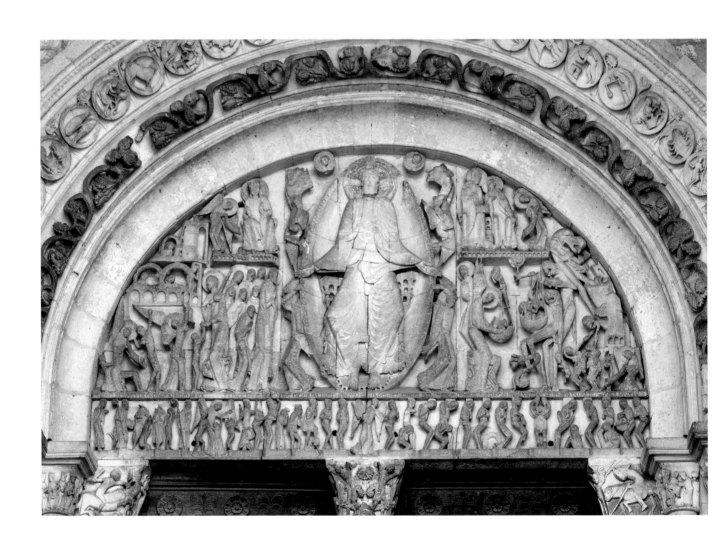

Last Judgment (ca. 1130–1140)

UNRECORDED ARTIST (BURGUNDY)

LIMESTONE TYMPANUM, CENTRAL PORTAL OF THE WESTWORK | SAINT-LAZARE, AUTUN, FRANCE

The Romanesque church of Saint-Lazare in Autun houses the relics of the brother of Mary and Martha, a man Christ raised from the dead. Above the central door of the church's main facade, the Last Judgment is depicted in a semicircular area called a tympanum. In the center of the composition, a large figure of Christ with his hands extended in equilibrium confronts viewers as they consider their eternal fate. Christ's palms are open, offering the gift of redemption. He sits inside a mandorla, an almond-shaped glory-cloud, framed by a Latin inscription that reads, "I alone dispose all things and crown the deserving; those bound to crime I will judge and punish." Four elongated angels support the mandorla as they proclaim Christ's triumphal return. This tympanum is designed to instill fear of eternal punishment in those entering the church. Rather than face the terrors of hell, viewers are encouraged to live virtuously in preparation for the final judgment.

On the lintel below the tympanum, the dead rise from sarcophagi. The figures on Christ's right (our left) prayerfully offer thanks for their heavenly reward. Two of the saved hold satchels, one decorated with a scallop shell and the other with a cross. These men are pilgrims—one has traveled to Santiago de Compostela, and the other to Jerusalem. An adjacent figure wears chain mail, indicating the man's Crusader status. Above the saved, a Latin text states, "Thus shall rise again everyone who does not lead an impious life, and endless light of day shall shine for him." On the sinister side of the lintel (our right), terrified figures, responding to a sword-wielding angel, process toward hell. Their bodies are contorted and compressed in space as they approach the inevitability of eternal death. Their postures reveal their utter anguish. One of the figures is caught in the inescapable clutch of monstrous claws. The inscription above the damned proclaims, "Let fear strike those whom earthly error binds, for their fate is shown by the horrors of these figures."

To Christ's right, the saved are welcomed into heaven. Saint Peter, holding a large key across his shoulder, is ready to open the gates. He is surrounded by angels and apostles awaiting the arrival of those blessed with eternal life. Above him the Virgin Mary, accompanied by a celebrating angel, is enthroned as the queen of heaven. Her prominent position at the right hand of Christ reinforces her status as an intercessor. On Christ's left, the reprobate are held accountable for their sins, being grabbed by demons bearing hooks. One of the damned is mauled as he enters the toothy jaws of hell. Adjacent to the scene, the archangel Michael performs the *psychostasis*, the weighing of souls, the scales suspended from a small cloud. There is a man in the left basket of the measuring device, whose fate will be decided by the weight of his virtue. Although a cheating demon grabs the scales, trying to alter the results, his efforts have no effect, as the man's soul can be seen floating above the scales toward the kingdom of heaven. Meanwhile, behind Michael, another angel holds closed the book of life. Those unnamed in this sacred inventory will be cast into a lake of fire (Rev. 20:15).

The Latin phrase *Gislebertus hoc fecit* ("Gislebertus made this") appears directly below Christ's feet. Its meaning is ambiguous. It may refer to the head of an artist's workshop, or, as has been more recently suggested, to a generous duke who brought the sacred relics of Saint Lazarus to Autun, a good deed that will undoubtedly be recognized at the Last Judgment.

HML

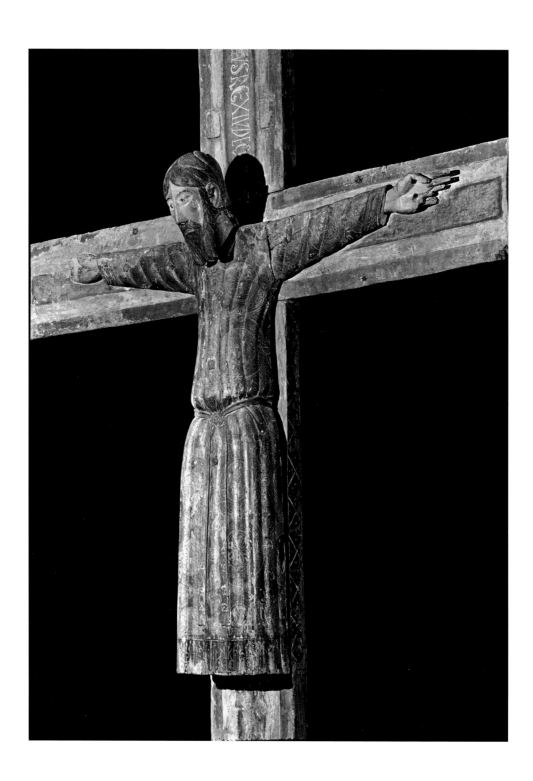

Batlló Crucifix (ca. 1150)

UNRECORDED ARTIST (GIRONA, CATALONIA)

POLYCHROMED WALNUT, WILLOW, ELM, AND HOLM OAK | 61 × 47 × 8 IN. (155 × 119 × 20.5 CM) |
MUSEU NACIONAL D'ART CATALUNYA, BARCELONA | GIFT OF ENRIC BATLLÓ, 1914

In 1914 Enric Batlló, a Catalan industrialist, donated a large crucifix to Barcelona's Municipal Museum of Fine Arts, later to become the National Museum of Catalan Art. Although the wooden sculpture's provenance is unknown, it was probably made for a church in La Garrotxa county in the region of Girona. It likely hung above the church's altar, though it is possible that it may have been suspended over the entrance to the church's chancel instead. The cross is a fine example of a *majestat*, a large crucifix showing Christ triumphant over death. This is one of many that were produced near the Pyrenees.

Although Christ's solemn head is slightly bowed, he shows no indication of suffering or pain. His physique is presented in rigid frontality, and he seems to stare at the viewer in a manner that conveys his authority. A Latin inscription on the cross reads, "Jesus of Nazareth, King of the Jews." He does not wear a white loincloth but rather is dressed in a long-sleeved red and blue silk tunic decorated with floral and geometric patterns associated with Islamic culture, its hem bearing pseudo-Arabic script. The costly garment, known as a colobium, was often worn by Muslim lords in medieval Spain. This did not stop twelfth-century Christians living during the Reconquista of Spain from making cultural appropriations. Although the expensive tunic was Muslim in origin, it did not pose a threat to Christian orthodoxy, and it provided an effective way to communicate Christ's majesty.

The Batlló Crucifix is also based on the Volto Santo (Holy Face). According to legend, Nicodemus, the converted Pharisee who helped remove Christ's body from the cross and place it in the tomb, sculpted a commemorative crucifix. Nicodemus's work, called the Volto Santo, quickly became credited with miraculous power and was brought to Lucca, Italy, during the eighth century for safekeeping. For five hundred years, pilgrims traveled to the Tuscan city to venerate the sculpted relic. But in the twelfth century the Volto Santo was allegedly destroyed by pious sojourners who chopped it apart in an effort to bring the sacred home with them. Nonetheless, the Batlló Crucifix served as a substitute for the Volto Santo. Not only did the *majestat* emulate the visual appearance of the Holy Face; it was also venerated as an extension of the sacred sculpture.

HML

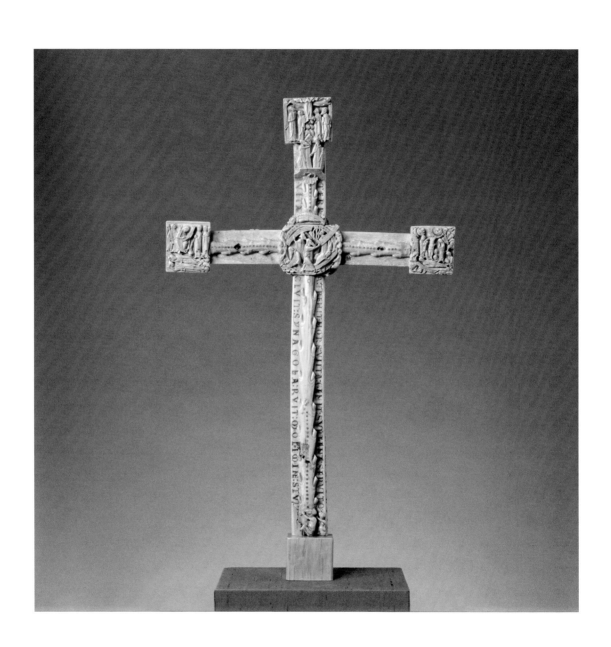

The Cloisters Cross (ca. 1150–1160)

UNRECORDED ARTIST (ENGLAND)

WALRUS IVORY | 22⅝ × 14¼ × 1¼ IN. (57.5 × 36.2 × 3.2 CM) | THE METROPOLITAN MUSEUM OF ART, NEW YORK | THE CLOISTERS COLLECTION

One of the most iconographically complex objects from the twelfth century is this cross made out of walrus ivory. It includes ninety-two figures and ninety-eight inscriptions. Due to its stylistic similarities with Master Hugo's illuminations in the monumental Bible of Bury St. Edmunds, the cross has been linked with that English Benedictine abbey, now in ruins, that once housed the relics of the ninth-century saintly king of East Anglia. Some scholars, however, have not been persuaded by this attribution, suggesting that the work may be German or Franco-Flemish, or may have been produced elsewhere in England.

The ivory cross was likely placed on an altar, affirming the nexus between Christ's sacrifice and the Eucharist, but it also probably functioned as a processional cross. The presence of exquisitely carved reliefs on the front and back suggests that it was meant to be viewed from both sides. Looking at the cross, like viewing the elevation of the eucharistic host, may have been associated with miraculous healing and communion with the Divine.

Pruned branches of the tree of life (*lignum vitae*) are represented on the front. Holes in the ivory indicate that the body of Christ, now missing, likely once hung here. The Crucifixion, Resurrection, and Ascension are rendered on three of the square terminals, and the lost scene from the bottom terminal likely showed the harrowing of hell. At the base of the tree are Adam and Eve. Their presence affirms the status of Christ as the New Adam, who redeems humanity from original sin, as well as reinforces the legend of the True Cross, which is said to derive from the tree of life described in Genesis. In addition, the site of the Crucifixion, Golgotha, the "Place of the Skull," has been tied to the location of Adam's grave.

Directly below the Ascension scene at the top, the high priest Caiaphas and Pontius Pilate debate the wording of the titulus, the placard to be placed above Jesus's head on the cross. Rather than identifying Jesus of Nazareth as the king of the Jews, the inscription on this object surprisingly refers to him as the "king of the confessors." This alteration may have been motivated by the desire to minimize the status of Jews as God's chosen people and draw greater attention to their shameful role in Christ's execution.

In the center of the cross a medallion, which would have been partially concealed by Christ's head and would thus have appeared like a halo, depicts the Old Testament story of Moses and the brazen serpent. According to Numbers 21:5–9, those bitten by poisonous snakes were cured by gazing upon a bronze sculpture elevated on a pole. This narrative serves as a poignant prefiguration of the power of the crucified Christ, lifted up on a tree.

On the reverse of the cross, busts of Old Testament prophets, with the addition of Saint Matthew, hold banderoles foretelling Christ's death and resurrection. At the terminals, symbols of the four evangelists (minus Matthew, who would have appeared on the bottom) are rendered. In the center, a medallion represents the Lamb of God (Agnus Dei), who takes away the sins of the world. The animal is being attacked with a lance held by Synagoga, a personification of the Jewish people. Though not blindfolded, as she traditionally is, Synagoga turns away from Christ, refusing to acknowledge him as the awaited Messiah. Her legs seem to buckle, suggesting the tumbling of Judaism in the face of the Christian faith. Anti-Semitic inscriptions from the *Glossa ordinaria*, a collection of biblical commentaries drawn mostly from the church fathers, also run along the sides of the cross. Ham, the son of Noah, is reported to have laughed at seeing his drunken father's genitalia, an act that resulted in a curse, the subjugation of the Israelites. On the other side, Jews are accused of laughing at the dying God. The implied folly of the Jews reveals their lack of understanding. By contrast, Christians recognize the redemptive power of the crucified Christ, whose blood purifies all that it touches.

HML

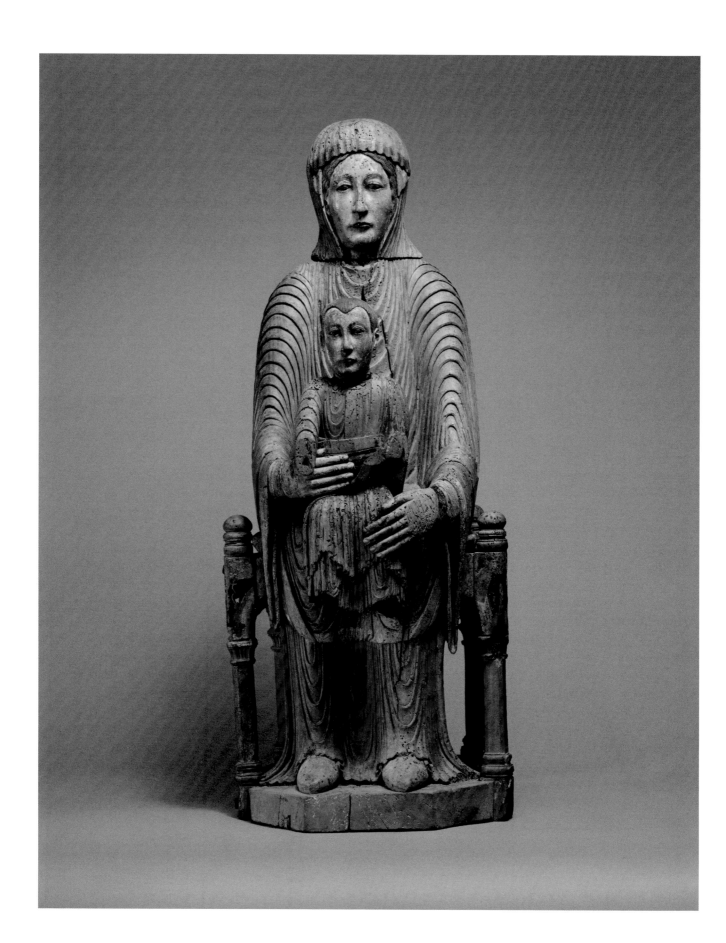

The Virgin and Child in Majesty (ca. 1175–1200)

UNRECORDED ARTIST (AUVERGNE, FRANCE)

POLYCHROMED WALNUT | 31¼ × 12½ × 11½ IN. (79.5 × 31.7 × 29.2 CM) | THE METROPOLITAN MUSEUM OF ART, NEW YORK | THE CLOISTERS COLLECTION | GIFT OF J. PIERPONT MORGAN

In this majestic freestanding sculpture of the Virgin and Child, Mary appears as the Throne of Wisdom (*sedes sapientiae*), on which Christ—divine wisdom incarnate—is seated. Frontally positioned, they face viewers with a regal bearing. Although his hands and arms are now lost, the infant Christ probably held a Gospel book in his left hand and offered a blessing with his right. Mary's large hands reveal her maternal care. The work was originally polychromed, and traces of red and blue paint appear on her symmetrically folded robe. It was originally placed on a church altar, reinforcing the link between the Virgin and that site. In her womb, Mary miraculously contained that which cannot be contained—the infinite, omnipresent God. In a similar way, in each celebration of the Eucharist, Christ reappears on the altar within the confines of the elements. In other words, the altar, like the Virgin, holds that which cannot be held.

Named after the famous American banker who donated the wooden sculpture to the Metropolitan Museum of Art, the Morgan Madonna is no passive illustration of the Virgin and Child. On the contrary, it once had powerful agency, including the capacity to re-present the heavenly monarchs in the here and now. The sculpture has two cavities on its back, suggesting that it may have once served as a reliquary. In addition, the heads of both figures are removeable, suggesting that on special occasions, the Virgin and Child may have been dressed in actual clothing. On the sixth of January, the feast of Epiphany, this sculpture and others were taken off the altar and carried in a grand parade to commemorate the Adoration of the Magi. The sculpture performed the role of the Virgin and Child in liturgical plays of the Epiphany. During these annual performances, three clerics, dressed in exotic costumes, portrayed the magi, who were also commonly believed to be monarchs. The trio of actors approached the sculpture, paying tribute to the King of kings. Members of the laity were encouraged to follow this priestly procession like a royal entourage and bring forth gifts to the Christ child. Not only did the Morgan Madonna likely house sacred relics; it also served as an effective means to convey the real presence of the Christ in majesty.

HML

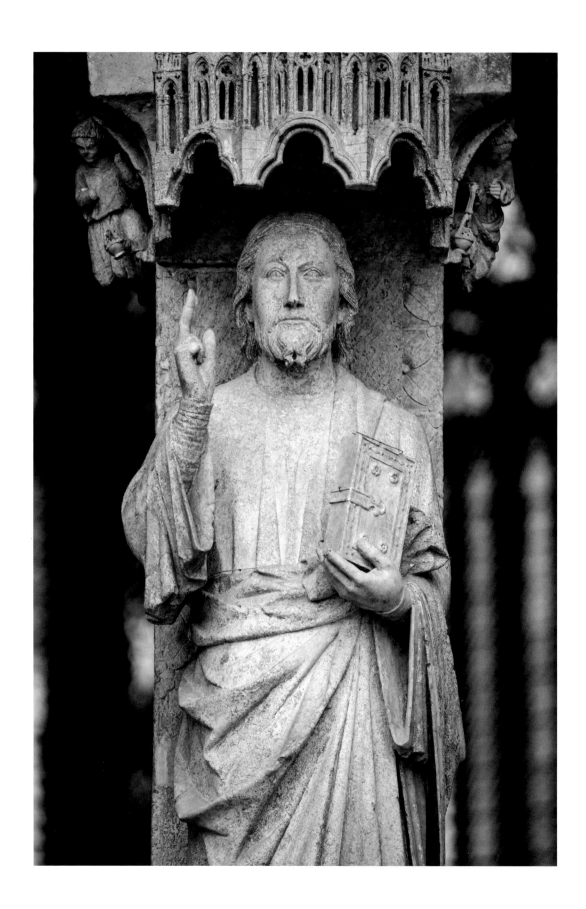

Beau Dieu (ca. 1230–1235)

UNRECORDED ARTIST (FRENCH)

LIMESTONE | TRUMEAU OF THE CENTRAL PORTAL, WEST FACADE, AMIENS CATHEDRAL, AMIENS, FRANCE

In his book *The Bible of Amiens* (1884), the first volume of an unfinished series on the history of Christianity, the English critic John Ruskin praises this work as "one of the noblest pieces of Christian sculpture in the world." For Ruskin, the *Beau Dieu* (literally "Beautiful God") is a mere fragment of a magnificent visual sermon made of stone. The decoration of Amiens Cathedral's facade tells a glorious story, in a manner that is true to nature and that promotes social virtue.

The *Beau Dieu*, which was originally painted, is sculpted on the top section of the trumeau, or central post, separating the middle doors of the largest Gothic church in France. (The cathedral is nearly 140 feet in height.) The tall and slender figure of the resurrected Christ appears stern but benevolent. In his left hand he holds a Gospel book, and he offers a blessing with his right. As foretold in Psalm 91:13, Christ tramples a lion and a dragon with his feet (not pictured), signifying his victory over sin and death. Although he is a triumphant figure, he remains serene—a conqueror with a calm demeanor. Dressed in a long tunic, he seems more interested in teaching than in warfare. Directly below the *Beau Dieu*, a king is represented in high relief. Most likely it is a depiction of Jesus's ancestor Solomon, the author of the Song of Songs, noted for his love and wisdom.

On the surrounding doorjambs are representations of the wise and foolish virgins, the twelve apostles, and personifications of the virtues and vices (not pictured). These depictions advocate moral order as they indicate the dangers of sinful behavior. Yet the *Beau Dieu* does not incite fear. On the contrary, he seems to provide wise counsel.

Above the trumeau, Christ appears twice in a tympanum (not pictured)—first, presiding over the Last Judgment. Although he is usually shown raising his right hand to save the elect and lowering his left hand to condemn the damned, in this image Christ's hands are symmetrically raised at the elbow. With palms out, he exposes his wounds, revealing the gift of salvation. At the top of the tympanum, Christ is rendered a second time, with double-edged swords coming out of his mouth. This representation does not elicit apocalyptic trepidation, though. Instead, Christ appears ready to assist those who recognize his authority as the beginning and the end (Rev. 1:16–17). These two representations are placed on the same vertical axis as the *Beau Dieu*, reinforcing the central message of grace for all those who choose to enter the church.

HML

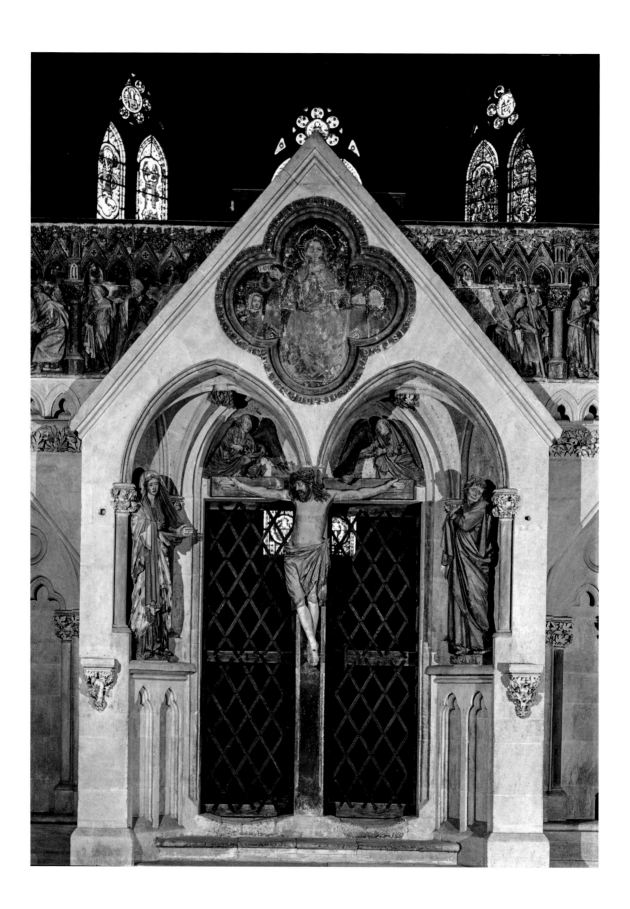

Crucifixion (ca. 1255)

UNRECORDED ARTIST (SAXONY-ANHALT, GERMANY)

POLYCHROMED LIMESTONE | CHOIR SCREEN, NAUMBURG CATHEDRAL, NAUMBURG, GERMANY

In 1249 Dietrich II, the bishop of Naumburg, commissioned a new *Westlettner* (rood screen) to demarcate the nave from the newly constructed west choir of the city's cathedral. Like the cathedrals of Hildesheim and Bamberg, Naumburg's main church, dedicated to Saints Peter and Paul, is a "double-ender," a basilica with apses on two sides. Worshippers would enter the church on the south side. A cloister is located on the cathedral's north. The altar at the west end is devoted to the veneration of the Virgin Mary. Sculptures of prominent local donors from the city's past—the most famous being of the margrave Ekkehard and his wife, Uta—decorate the choir and apse.

The rood screen, or choir screen, a large sculpted partition, functioned as a boundary, marking an important spatial division within the church. The laity were excluded from entering the choir, which was consecrated space, reserved for the liturgical activities of clerics. But the screen not only served as a physical separator, enclosing and ensuring the sanctity of the choir space; it also, paradoxically, provided a point of access. A large portal was placed in the middle of the screen, enabling the laity to view the religious rituals being performed in a location they could not call their own. This liminal space permitted laypersons to see, for example, the elevation of the host, without transgressing borders.

The *Westlettner* at Naumburg consists, first of all, of a blind arcade (a series of arches that are filled in instead of left open) topped by a horizontal band of painted, high-relief carvings of scenes from Christ's passion. Unlike most rood screens, which place an image of the Crucifixion *above* the partition, the one at Naumburg depicts this sacred narrative within the central doorway, the meeting point between the choir and the nave. To enter the western part of the church, priests would walk under the outstretched arms of the crucified Christ, passing by the mourning figures of Saint John and the Virgin Mary. The life-size depiction of Christ is striking in its naturalism. Above his head, angels wave incense in adjacent lunettes, reinforcing the sanctity of the choir. Above them, a painted quatrefoil shows the enthroned Christ as the divine judge, surrounded by angels holding instruments associated with his passion (the *arma Christi*). An inscription referencing the separation of the sheep from the goats (Matt. 25:31–46) frames the image.

In this context, the Crucifixion and the Last Judgment are closely aligned, both figuratively and literally. Like a set of scales, the cross functions as a balance differentiating the saved from the damned. Those who are willing to believe in the grace offered by Jesus's death will pass through the final judgment into heaven. By contrast, those who refuse to look for divine mercy will receive eternal punishment.

The central location of the crucified Christ on the trumeau both conceals and reveals the celebration of the Mass. For those standing in the middle of the nave, it blocks immediate visual access to the Eucharist. Nonetheless, it unites Christ's sacrifice with the sacrament, reinforcing his real presence in the church.

HML

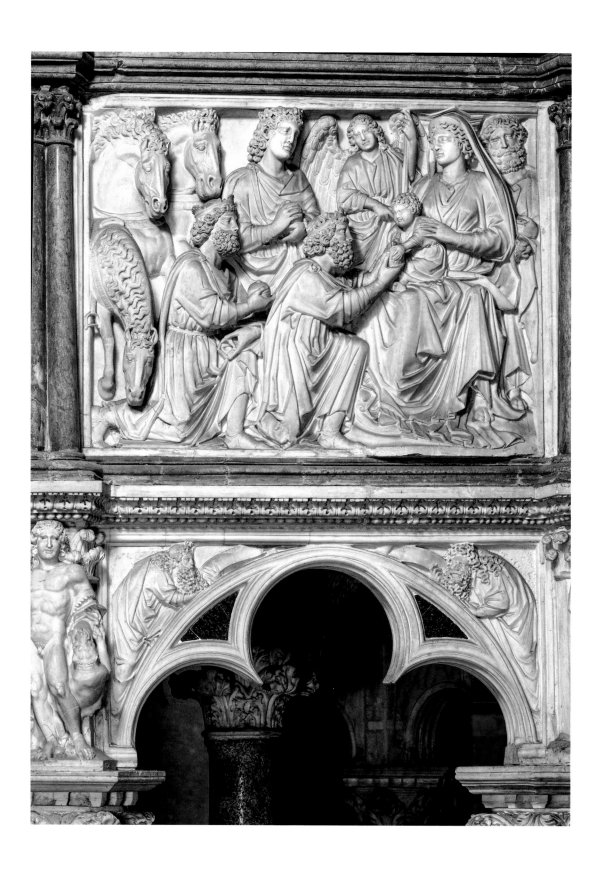

Adoration of the Magi (1260)

NICOLA PISANO (ITALIAN, ACTIVE 1258–1278)

MARBLE | 33½ × 44½ IN. (85.1 × 113 CM) (PANEL) | PULPIT RELIEF, CATHEDRAL BAPTISTERY, PISA, ITALY

The famed Pisa Pulpit, which was completed in 1260 and includes the majestic *Adoration of the Magi*, is often seen as the earliest and most complete stirrings of what would eventually develop into the Italian Renaissance. This complex series of carved marble reliefs is dated and signed by Nicola Pisano, the most influential sculptor of the thirteenth century. The pulpit was created specifically for the monumental domed baptistery building that is immediately in front of the ornate Pisa Cathedral, and it was used to elevate the priest above the crowds when he was reading the Gospels. As a result, the five individual reliefs narrating scenes from the life of Christ would be easy to see from below. In particular, the *Adoration of the Magi* is highly articulate in terms of both form and composition.

Because he was working in the thirteenth century, it would be easy to characterize Pisano as a medieval artist, but he was actually foundational to the Renaissance of the ensuing centuries. The term "Renaissance" means "rebirth," broadly indicating a return to the visual ideals of the classical world. Many of Pisano's figures are not merely realistic but decidedly Roman or Greek in inspiration. The figures of Mary, the magi, and even the horses were influenced by sculptural fragments of Roman sarcophagi, or outer coffins, that the sculptor would have seen in and around Pisa. Whereas other medieval artists tended to ignore physical elements of the "pagan" world, Pisano was among the first to seriously reevaluate and begin to incorporate the sense of realism and concern for form and composition that was critical to classical art. Such was a tradition in sculpture that would evolve in the work of Renaissance masters from Donatello and Verrocchio to Michelangelo.

As a relief sculpture, the *Adoration of the Magi* unfolds across the frontal plane with little to no indication of a middle or background space. All the figures and, by extension, the story feel very immediate to the viewer. The narrative moves from left to right, from the three animated horses who have carried the magi on their journey, to the triad of crowned, gift-bearing men, to the infant Christ seated firmly in the lap of the regally seated Madonna. Slightly behind are the attending figures of a youthful angel and an aged Joseph. Although most images of Mary and the Christ child of this era place them at the center of the composition, Pisano has chosen to place them to the right of center, facing left. In doing so, the sculptor does not undermine their primacy but, rather, subtly suggests a sense of movement or procession of the three magi who have journeyed far to pay homage to the child. In addition to such ceremonial overtures, the formality of poses and gestures further calls to mind a sense of nobility, albeit in religious terms, for the child who would be held out as the King of kings and the mother who would be memorialized as the Queen of Heaven.

For the widespread popularity of the subject of the Adoration of the Magi that continues to the present day, it is surprising to note that it is discussed only in the Gospel of Matthew (2:1–12). By age, the three are traditionally identified as Caspar or Jasper, who offers gold, symbolic of kingship; Balthazar, bearing frankincense, an aromatic resin associated with divinity; and Melchior, who brings myrrh, used for the embalming of the dead. Terms like "wise men" or "kings" have been used synonymously with "magi" over time. Historically, the magi were seen as turbaned Persian astrologers; however, in most images they are shown as crowned royalty, as Pisano has put forward.

JAB

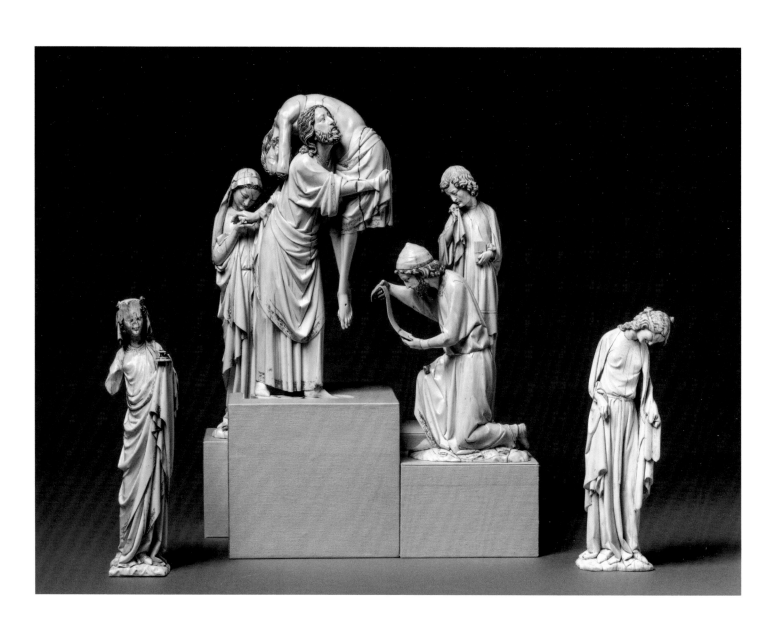

Deposition from the Cross (ca. 1260–1280)

UNRECORDED ARTIST (PARIS, FRANCE)

ELEPHANT IVORY ENSEMBLE, WITH TRACES OF POLYCHROME AND GOLD LEAF | CHRIST AND JOSEPH OF ARIMATHEA:
11⅞ × 5¼ × 3⅛ IN. (30 × 13.2 × 8 CM) | MUSÉE DU LOUVRE, PARIS

In 2013 the Société des Amis du Louvre initiated a suc-
cessful crowdfunding campaign to purchase two ivory
figurines that belong to an unusual ensemble in the
museum's collection. The statuettes of Synagoga and
Saint John were acquired for 2.6 million euros. This
was not the first addition to the initial grouping given
to the Louvre in 1896. The original donation from
Charles Mannheim consisted of four figures: Joseph
of Arimathea, Christ, the Virgin Mary, and Ecclesia. In
1947 another ivory was acquired from the Rothschild
collection, a kneeling man initially believed to repre-
sent an Old Testament prophet. However, conservators
discovered that the scroll held by the figure was a later
addition. The ends of a set of pliers can be seen on his
right knee, indicating that he is likely Nicodemus, the
converted Pharisee who is traditionally credited with
having removed the nails from Christ's corpse.

Although the set of statuettes lacks a protective
shell, it was probably originally housed within a micro-
architectural setting. After all, the figures stand on mul-
tiple levels. At the top tier, Joseph of Arimathea bears
the dead Christ across his shoulders. He does not touch
the corpse with his bare hands. Instead, his hands are
covered in cloth, suggesting the preciousness of that
which he carries. Initially, the figure of the Virgin was
attached to the couple. Her body is positioned on a
lower plane. In her grief, she is reaching to kiss the
hand of her dead son. Meanwhile, Saint John wipes
tears from his face with a cloth. The ensemble includes
Ecclesia and Synagoga, personifications of the church
and the synagogue, respectively. The upright Ecclesia
originally held a chalice, a reference to the Eucharist,
specifically the availing of Christ's blood to believers,
but today, only the foot of the cup remains. Synagoga
is blindfolded, implying her inability to see the truth.
She likely originally held the law in her left hand and
a broken lance in her right, but these items have been
lost over time.

Made from imported African elephant tusks, the
sculpture group was exotic and costly. It was probably
a courtly commission. Although the imagery depicts
a tragic event, it is quite elegant, and the use of poly-
chromy (now mostly lost) and gold leaf accentuates
the set's rich appearance. Unfortunately, the set's prov-
enance prior to the twentieth century is unknown. It
was likely placed in an aristocratic or royal home, or
perhaps in a private domestic chapel. However, it is
uncertain whether it was displayed seasonally (like a
nativity set) or year-round. Despite the fact that much
about the group's original context remains unknown, it
undoubtedly served two functions. It offered a means
of evoking piety associated with Christ's descent from
the cross, while simultaneously operating as a marker
of luxury.

HML

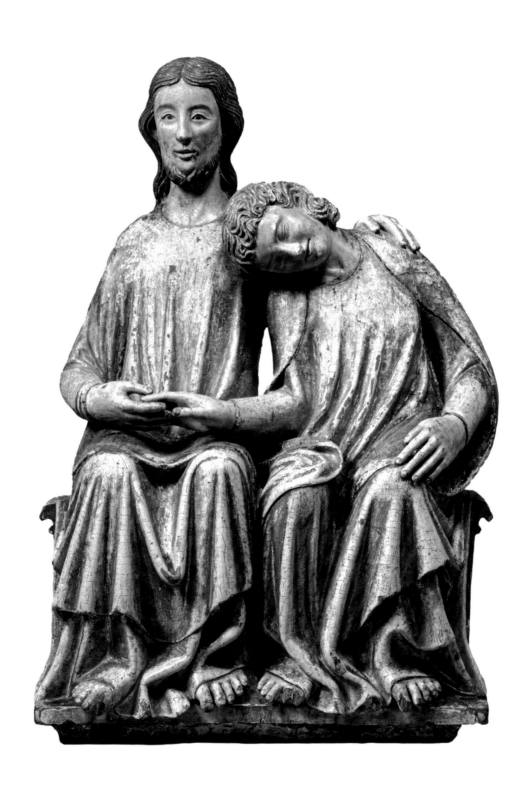

Christ with the Sleeping John (ca. 1300–1320)

UNRECORDED ARTIST (SWABIA, GERMANY)

POLYCHROMED AND GILDED OAK | 36½ × 25¼ × 11¼ IN. (92.7 × 64.4 × 28.8 CM) | CLEVELAND MUSEUM OF ART, CLEVELAND, OHIO | J. H. WADE FUND

This sculpture offers an emotionally charged abbreviation of the Last Supper. Only Christ and his beloved disciple Saint John the Evangelist are shown, thus encouraging viewers to focus on their mutual relationship. The sculpture was likely made for a chapel inside a Cistercian or Dominican convent in southwestern Germany. It probably hung against the wall, as its reverse side is relatively flat.

The effeminate figure of Saint John is sleeping. He is not ignoring Christ. On the contrary, he is fully immersed in the Divine. Shutting his eyes to the things of this world, the youthful disciple has obtained mystical insight, the ability to see Christ alone. He and Jesus are intimately intertwined, sharing a loving embrace. Christ tilts his head toward John, who rests his head upon Christ's breast. John longs to get closer to the heart of Jesus. His affection toward Christ echoes the Song of Songs 5:2: "I sleep and my heart watches."

The right hands of Jesus and John delicately touch one another. This gesture, known as the *dextrarum iunctio*, is a conventional marker of nuptial love, suggesting the marital bliss of Christ and the beloved soul. This mystical union between Jesus and John was intended to evoke greater desire for God among the nuns who regularly encountered the sculpture and meditated on its significance.

HML

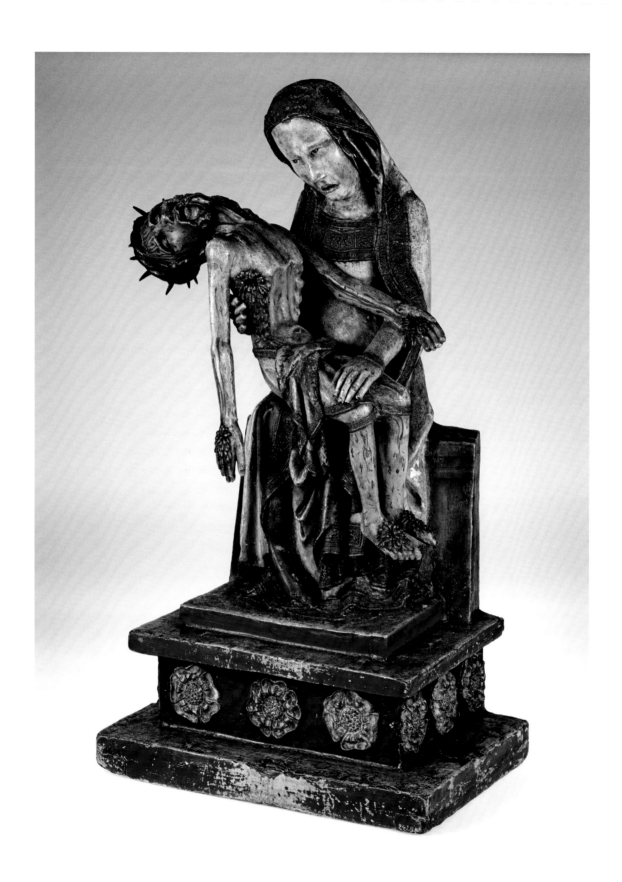

Röttgen Madonna (ca. 1330–1360)

UNRECORDED ARTIST (MIDDLE RHINELAND, GERMANY)

POLYCHROMED LIMEWOOD | HEIGHT 34½ IN. (87.6 CM) | RHEINISCHES LANDESMUSEUM BONN, BONN, GERMANY

The Röttgen Madonna, or Röttgen Pietà (Vesperbild), named after a former collector, was originally placed on the altar in a nunnery chapel. When nuns celebrated the Eucharist, they would have been confronted with this wooden sculpture that evokes pity and piety. It would have held special significance during Good Friday Vespers, during which the liturgy focuses primarily on the lamentation over the dead Christ. By reducing the narrative to the interaction between mother and child, the image fosters deeper compassion.

Although the work represents the Virgin Mary and her son, the child cradled on her lap is now an adult. She is still the Throne of Wisdom (*sedes sapientiae*), but Christ has already served his role as sacrificial victim. He is dead. His body is severely broken.

The Röttgen Madonna, unlike the young Michelangelo's Pietà (1499), renders the Virgin Mary and her deceased child not in idealized beauty but in gruesomeness, intending to elicit a visceral emotional response from viewers. Christ's suffering cannot be overlooked. The thirteenth-century Saxon mystic Mechthild of Hackeborn called believers to contemplate Christ's gaping wounds as he lies upon his mother's lap. This sculpture is an aid to such contemplations, as blood oozes from the deep holes in Christ's flesh. The bright crimson paint may have faded, but the thick, bursting drops still succeed in conveying the horrific violence Christ endured. In addition, Christ's head is snapped back, and the crown of thorns appears to impale his forehead like spikes.

Although painful to see, Christ's blood is the gift of redemption. The fourteenth-century Rhineland mystic Heinrich of Suso encouraged the faithful to meditate on Christ's suffering and learn to make his wounds into their spiritual homes. Through empathetic identification, viewers are invited to move from the visual to the visionary, where they may experience mystical union with God.

The base of the Röttgen Madonna is decorated with rosettes, signifying love. Because of her profound love for Christ, the Virgin Mary, whom nuns are called to imitate, is overcome by grief. Translucent tears are painted on her cheeks. The size of her head is exaggerated to help viewers understand her pain and be moved by it. Pulling on emotional heartstrings, the sculpture encourages viewers to cry, to share in the Virgin's tears of longing, for they will ultimately be replaced with tears of joy.

HML

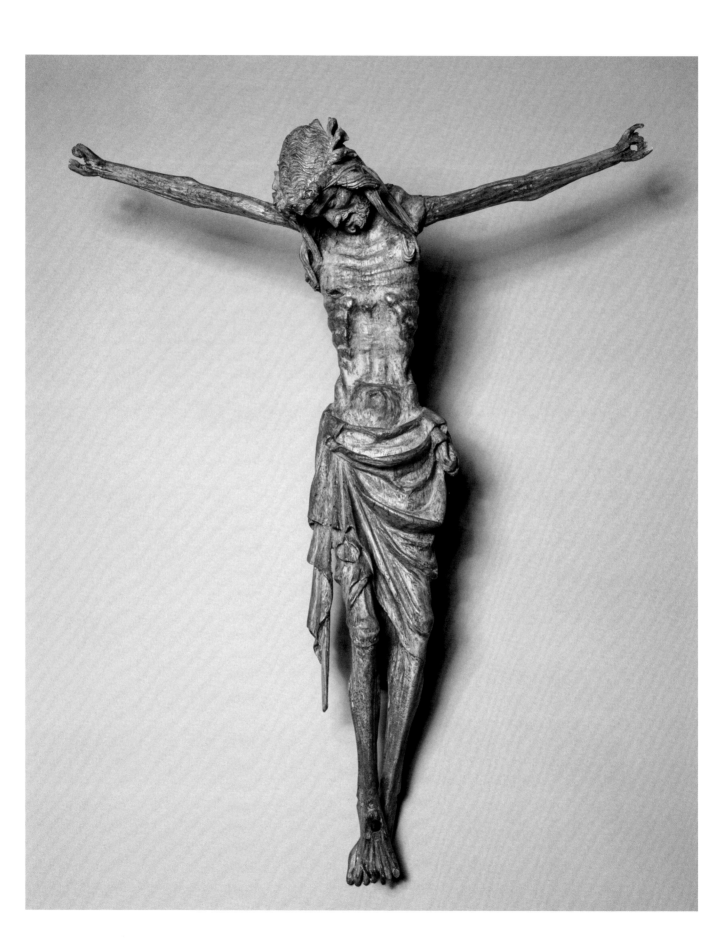

Crucified Christ (ca. 1340–1350)

UNRECORDED ARTIST (MIDDLE RHINELAND, GERMANY)

WALNUT (FORMERLY POLYCHROMED) | 16⅜ × 14½ IN. (41.6 × 36.8 CM) | CLEVELAND MUSEUM OF ART, CLEVELAND, OHIO | ANDREW R. AND MARTHA HOLDEN JENNINGS FUND

Although this sculpture is less than two feet tall, it evokes an intense psychological response. The pathetic figure of Christ is emaciated. His rib cage is immediately apparent, and his lower torso appears to have been clawed away. His head is gaunt and slumps into his chest. A grimace of pain is suggested by his partially open mouth and disjointed jaw. But not only does Christ's wretched body show the physical pain of the Crucifixion; it also conveys the depth of his emotional suffering—his feelings of being forsaken, abandoned by God. For pious viewers, such a horrific sight of their Savior would be difficult to see.

Christ's limbs are reduced to skin and bones, his outstretched arms pulled to the extreme. The figure of Christ was originally attached to a forked cross, which is now lost, as are Christ's hands. Unlike the traditional Latin or Greek cross, which has beams of wood intersecting at a right angle, the forked cross is Y-shaped and more closely resembles the branches of a tree. The use of the forked cross may have elicited associations with the biblical tree of life. Sin and death entered the world in Eden, when Adam and Eve took forbidden fruit from the tree of knowledge. By contrast, the cross, upon which the New Adam was crucified, plays a crucial role in the redemption from sin and the promise of eternal life.

This type of sculpture, which was popular in the late Middle Ages, especially in the area around Cologne, is sometimes described as a *Pestkreuz*, a plague cross, because Christ looks as if he were a victim of the Black Death. However, it is important to note that sculptures like this were produced prior to the introduction of the bubonic plague to Europe. Consequently, most scholars today would label the Cleveland work an example of a *crucifixus dolorosus*, or painful crucifix, a visual complement to contemporary mystical literature.

Unfortunately, the original location of the Cleveland crucifix is unknown. It may have hung in the side chapel of a church, in a monastic cell, or in a domestic setting. Regardless of its placement, the small sculpture promoted personal meditation on Christ's passion. It called for empathy from viewers, who were expected to model their lives after Christ. The artist portrayed Christ's anguish to provoke a visceral response to his torment and a deeper understanding of the atonement. Contemplation of Christ's pain and suffering evinces a preoccupation not only with the grotesque but also, even primarily, with the wondrous gift of salvation offered through Christ's sacrifice.

HML

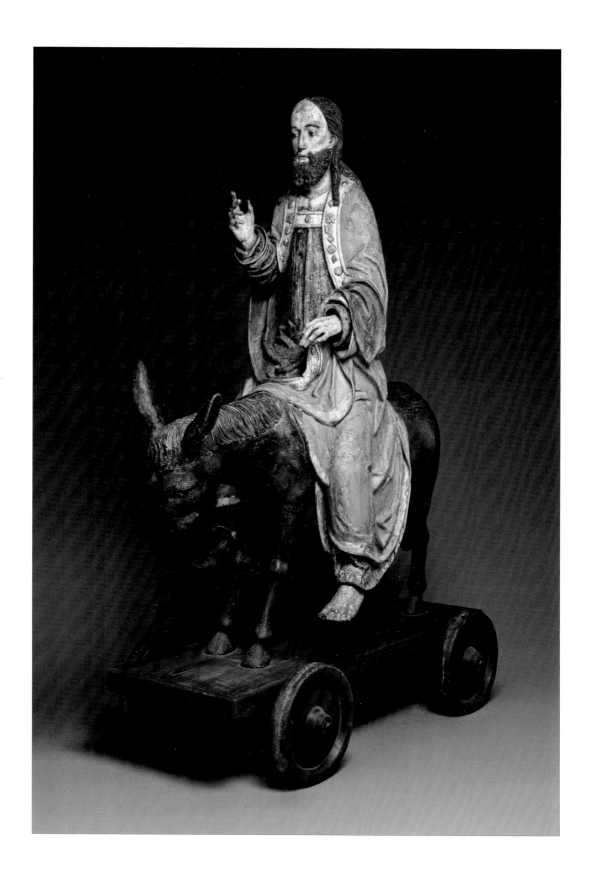

Christ on a Donkey (15th cent.)

UNRECORDED ARTIST (FRANCONIA, GERMANY)

POLYCHROMED LIMEWOOD WITH THE LATER ADDITION OF A BASE | 61½ × 23¾ × 54½ IN. (156.2 × 60.3 × 138.4 CM) |
THE METROPOLITAN MUSEUM OF ART, NEW YORK | THE CLOISTERS COLLECTION

On the morning of Palm Sunday, a sculpture of Christ on a donkey, called a *Palmesel*, was paraded through the streets of late medieval German cities and towns. Almost every community had one of these objects, though few survive today. Many *Palmesels* were seized by Protestant authorities and destroyed. A similar event occurred during the Catholic Enlightenment, when these sculptures were deemed superstitious and consequently burned or demolished in the late eighteenth century.

Marking the beginning of Holy Week, Palm Sunday celebrates Christ's triumphal entry into Jerusalem, an event mentioned in all four Gospels. *Palmesels*, which were typically placed on wheeled platforms, functioned as props in liturgical processions. Some members of the community walked behind the pulled object as it was taken outside the church and returned. Meanwhile, others cast palms in front of it as it moved along. If palms were not available, they threw flowers and willow branches instead. Small children were sometimes permitted to ride on its base or, in some places, on the donkey itself, behind Christ.

This particular sculpture may have been made for a church in Mellrichstadt, a town in Upper Franconia. Christ, who may have once possessed a halo, is well dressed as a monarch, yet he sits astride a humble donkey, gazing peacefully forward. He appears solemn, understanding the demands of the forthcoming week— his impending passion and death. With his right hand he offers a blessing, and his left hand likely once held the animal's reins. The sculpture not only commemorates Christ's arrival in the ancient city of Jerusalem but also anticipates his future triumphal return.

HML

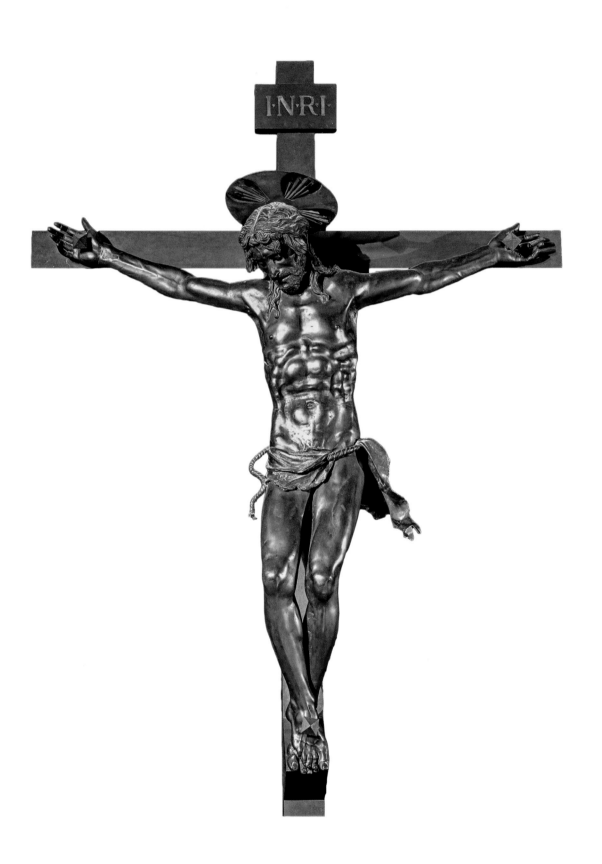

Crucifix (1444–1449)

DONATELLO (ITALIAN, 1386–1466)

BRONZE | HEIGHT 71 IN. (180.3 CM) | IL SANTO (BASILICA DI SANT'ANTONIO), PADUA, ITALY

Although inextricably linked to the Italian Renaissance, Donatello has proved to be one of the most influential and admired sculptors of all time. Inventive and versatile, his sensitivity to materials led to startling achievements in wood, clay, stone, and bronze, and his commitment to realism in sculpting the human figure was not limited to the physical but penetrated the psychological as well. His life-size *Crucifix* is one of the most compelling crucifixes ever created and the first to be cast in bronze at such a scale during the fifteenth century. Although most of his career was spent in Florence and frequently in association with Medici family projects, he created his *Crucifix* during a ten-year sojourn to the northern Italian university town and pilgrimage center of Padua.

For centuries, painted and sculpted images of the crucified Christ were hung above or slightly behind the altar of a church. Here they could be seen by the faithful both from below and at a distance down the central aisle. Donatello's version was created for the monumental Basilica di Sant'Antonio, commonly known as Il Santo, whose association with miraculous events and popularity with pilgrims continues to the present day. Although the *Crucifix* originally hung as a singular work, it was later moved forward to the high altar to be seen as part of a large sculptural altarpiece Donatello created slightly later around the Madonna and Child, Saint Francis of Assisi, and one of Francis's most beloved and revered followers, the namesake of the basilica, Anthony of Padua. Regardless, the *Crucifix* remains a powerful vision and, at life-size, is clearly legible from yards away.

Among the most striking features of this work is the artist's concern for anatomical accuracy. In its attention to the bone structure and musculature of the figure beneath nuanced passages of flesh, it is quite unlike any crucifixes or crucifixion scenes then known.

Most earlier versions tended to focus on graphic physical anguish or generalized corporal rigidity meant to elicit strong and immediate emotions in the faithful. However, Donatello's Christ is a physically fit, even athletic, male in the prime of life. The seeming vibrancy of the figure, which is also owing to the artist's choice of highly polished bronze, stands in contrast to the reality that Christ is on the verge of death or has just expired. Donatello not only rendered all bodily details with care but also insisted on a meticulous patination and polishing of the metal so that light and shadow fall across the surface of the sculpture in a manner that lends a heightened sense of realism.

Of particular note is the portrait-like rendering of the downcast face. The eyes, nose, and mouth are articulated in smooth passages carefully framed by cascades of hair and currents of beard. Such concern for individuality makes this Christ seem familiar, known. Donatello's command of realism was initially inspired by his interest in classical statuary, which he studied in great detail in his early career and, by extension, was foundational to the flowering of the Italian Renaissance in his native Florence. However, his mastery of physical reality came from his observations of life and his acknowledgment of the power of illusion through art. His *Crucifix* clearly exhibits his penchant for a realism that elevates his interpretation of the world around him to the heights of classical dignity. His goal was the impact of a physical presence married with the evocation of human pathos, reflecting a psychological and spiritual drama. In Donatello's *Crucifix*, illusion and reality begin to merge, and the viewer is invited to contemplate Christ's sacrifice. Herein is a new classicism that would ignite artists and audiences for generations.

JAB

The Christ Child (ca. 1460)

DESIDERIO DA SETTIGNANO (ITALIAN, CA. 1429–1464)

MARBLE | 12 × 10⅜ × 6⅜ IN. (30.5 × 26.5 × 16.3 CM) | NATIONAL GALLERY OF ART, WASHINGTON, DC | SAMUEL H. KRESS COLLECTION

Carved, cast, and painted imagery of the Christ child abounds in art history, yet singular images of the child absent his mother, Mary, or a retinue of saints and angels are rare. This delicate marble carving is by the Florentine master Desiderio da Settignano, who was among the most celebrated sculptors of his generation. His skills as a carver and his sensitivity with materials were matched by his insightful and serene depictions of his subjects. Although his mature career lasted little more than a decade, his sculptures, and in particular his portraits, were praised for the sense of intimacy and timelessness they suggested.

During the Italian Renaissance, the art of portraiture achieved an elevated level of cultural importance and popular appeal not enjoyed since the Roman period. Images of leading personalities and celebrated beauties were commissioned with regularity and enthusiasm in the fifteenth century, inspired in part by a revival of all things Roman—especially statuary. While Renaissance portraits of children are less frequent, they merit consideration, especially in the hands of masters like Desiderio, whose legacy includes several depictions of male children and youth in both relief carvings and freestanding busts. *The Christ Child* is a surprisingly important representative of the latter. In strictest terms, the sculpture is not a portrait, since the artist had no access to physical descriptions of Jesus; however, the individualized sweetness and beauty of visage were undoubtedly inspired by a young boy the artist knew.

In *The Christ Child*, Desiderio gives form to a Jesus slightly older than the cherubic infant depicted in scenes of the Nativity, or the toddler positioned with his mother in myriad examples of the Madonna and Child. One encounters a small boy in physical trans-formation; while fleshy cheeks and jowl call to mind infancy, the leaner passages around the mouth and chin and the full waves of hair speak of boyhood. The detail in the eyes, nose, and even ears references an individuality rather than a universal type. Such specificity of characteristics points to the importance of a model to the sculptor in the creative process and has led some scholars to consider this a secular work. Desiderio's mastery of materials and carving techniques allowed him to capture fine details but with a degree of softness that others feel suggests the purity and innocence of a sacred subject.

Like other portrait busts by the sculptor, there is a sense of animation in the positioning of the head, which is not square with the shoulders but looks slightly downward and turns to the viewer's left. As a result, Desiderio has avoided the stiffness of official or commemorative portraiture in favor of the relaxed familiarity of everyday life. However, unlike other portraits of children who grimace or grin in a manner suggesting the mischief indulged in at this age, Desiderio's Christ child appears pensive, lost in thought. This is particularly noticeable in the treatment of the eyes and mouth.

It is not known who originally commissioned *The Christ Child*, nor the original context of display. Traditionally, small-scale sculptures and paintings would have been reserved for a domestic environment and an image of the Christ child related to faith formation. However, records from the eighteenth century describe this work by Desiderio and a companion piece, *The Young Saint John the Baptist* by his contemporary Antonio Rosselino (1427–1479), in niches above doorways on either side of the high altar of an oratory, or private chapel, in Florence.

JAB

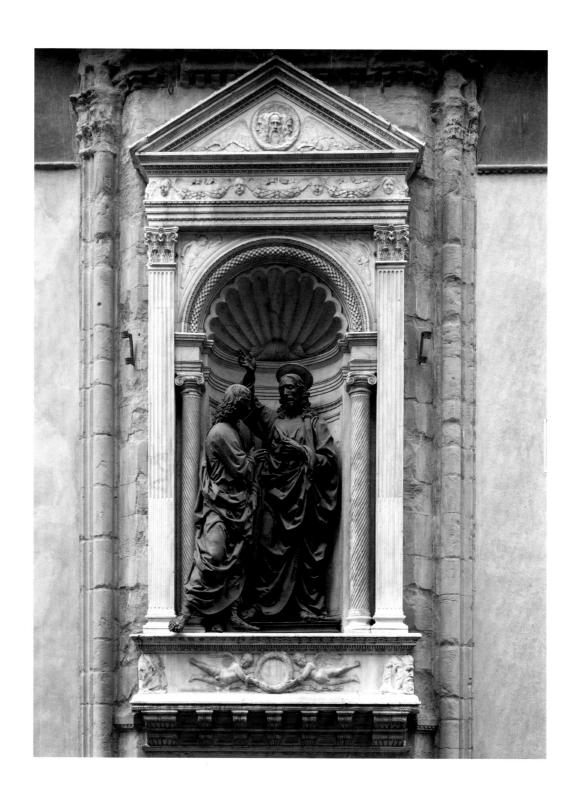

Christ and Saint Thomas (1467–1483)

ANDREA DEL VERROCCHIO (ITALIAN, 1435–1488)

BRONZE | HEIGHT 90½ IN. (229.9 CM) | ORSANMICHELE, FLORENCE, ITALY

The story of Christ's postresurrection appearance to Saint Thomas is relatively well known today among both the religious and the nonreligious. The phrase "Doubting Thomas" appears frequently in the English vernacular to describe a person who doubts in the absence of physical evidence. In biblical tradition, Thomas, whose name means "twin" in Aramaic (the Greek equivalent is Didymus), was one of the twelve apostles. According to John 20:19–29, he was absent when Christ first presented himself to the other apostles following the Resurrection and proclaimed incredulously, "Unless I see the mark of the nails in his hands and put my finger into the nail marks, and put my hand into his side, I will not believe."

It is the moment of revelation, contact, and belief that follows that is captured in this life-size bronze by the Italian Renaissance master Andrea del Verrocchio—one of the most important artists and teachers of the era. The two honey-colored bronze figures stand facing each other in a shallow niche of classical design. Christ is slightly right of center, is elevated on a step or parapet, and, in three-quarters view, faces both Thomas and the viewer. His right arm raised blessing, Christ parts his tunic with his pierced left hand to reveal another, more compelling view of a seemingly mortal wound to both his apostle and the world. Verrocchio has positioned Thomas to the left. Whereas the upper torso, face, and left leg turn in profile toward Christ, much of the lower torso and right leg swivels outward toward the viewer. In fact, much of the figure, especially the right leg and foot, extends beyond the confines of the niche, breaking into the viewer's space to engage them with the composition.

Verrocchio's sculpture is among the most celebrated and influential works of the fifteenth century. The master spent most of his career in Florence, the epicenter of the Italian Renaissance. *Christ and Saint Thomas* demonstrates the dedication to realism, suggestion of Greco-Roman antiquity, and extraordinary craftsmanship that marked this golden era of "rebirth" of classicism in the visual arts. The sculpture and its niche exist just above eye level on the front facade of one of the city's main buildings, then a multifunctional chapel, granary, and mercantile exchange known as Orsanmichele. Then as now, the extended right leg and foot of Thomas capture the attention of passersby and direct the view diagonally through the leg and torso to the saint's right hand, then directly to the revealed wound in Christ's side. As a result, the viewer is drawn into the scene as if a witness to or participant in the event.

Christ and Saint Thomas was one of the largest and most complex bronze castings of the period. In fact, from the original clay model through to the installation of the completed bronze, the project consumed a significant portion of Verrocchio's mature career. Few life-size figurative groups were created in bronze at this time, owing to the costs and difficulties of casting. The concern for physical details and the extraordinary treatment of the cloth worn by each figure are noteworthy and account, in part, for the length of the project. Verrocchio's idealized depiction of his subject and use of graceful, balletic gestures would be highly influential for future generations of artists, including the young Pietro Perugino and Leonardo da Vinci, who were his apprentices during the creation of *Christ and Saint Thomas*.

JAB

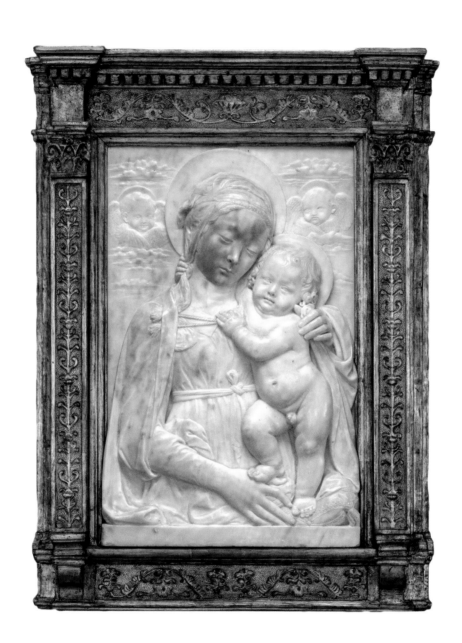

Madonna and Child (ca. 1475)

BENEDETTO DA MAIANO (ITALIAN, 1442–1497)

MARBLE | 23 × 15⅜ × 3⅞ IN. (58.3 × 39 × 9.8 CM) | NATIONAL GALLERY OF ART, WASHINGTON, DC |
SAMUEL H. KRESS COLLECTION

Images of the infant Christ held close by his mother yet presented to the viewer fall under the broad art historical title of "Madonna and Child." Considering the great abundance of such imagery that has survived from the early Christian period through the Baroque, it is among the most popular subjects in the history of art and is found in nearly every medium. Although precursors of maternal imagery related to the presentation of a noble child can be found in ancient Egyptian, Greek, and Roman art, the Christian depiction of Mary and the divine child Jesus depicted as having authority was greatly influenced by the art produced in the Byzantine world. The millennium-long artistic outpouring of Madonna and Child images began in earnest in the fifth century, when Mary was first recognized as Theotokos, or "God-Bearer."

However, in Europe the tradition of the Madonna and Child greatly expanded during the Middle Ages and Renaissance. In the former, Mary was seen in courtly terms and often referred to as a queen, and her child was likewise depicted in a stately or formal manner. In the latter, both the young mother and her child were imagined in more humanistic terms, with painted and sculptural works inspired by local beauties of the time and their fleshy offspring. This was especially true in fifteenth-century Florence, where sculptors like Benedetto da Maiano would have found great demand for their work for both public and private devotion. The intimate scale of this particular *Madonna and Child* suggests it was a more personal work and likely intended for a domestic environment. During this period, most homes of the merchant and noble classes would have had such imagery on display, especially in the bedroom or private chambers of the head of household or that of his wife.

Benedetto was born in a small town outside Florence and began his career as a wood-carver in his father's workshop. Early on he mastered stone carving and is regarded as one of the more gifted practitioners of his day, with a reputation for finely realized reliefs as well as observant and articulate portraits. His virtuosity with marble enabled him to portray his subjects—which were primarily biblical figures or contemporary personalities—in a very lifelike fashion; this naturalism gave his sculptures an aura of antiquity, which was essential to Renaissance aesthetics. His *Madonna and Child* is exquisitely rendered and full of charm. As was common, Mary is presented at half length, gently embracing her lively son who is climbing atop a small pillow further into her arms. At the base of the composition a horizontal ledge or parapet establishes the space between the adorer and the adored. This element, in combination with the open sky behind the figures, creates an illusion of the mother and son being at an open window or on a balcony.

Mary is depicted in contemporary attire of the period, and her facial features, while idealized, are likely based on the likenesses of young Florentine maidens Benedetto would have known. Her focus is her son, who stares directly out at the viewer. Common in artistic depictions of the period, the infant Jesus is shown unclothed. Such nudity generally points to a kind of purity and innocence shared among all infants, but specifically, it serves as a visual reminder of the human nature of Christ. As a counterpoint, both he and his mother are crowned with haloes as overt reminders of their holiness. Ultimately, the triumph of this relief sculpture is made possible by the artist's carving sensibilities. While the clouds and angelic hosts in the background are barely sketched into the surface of the stone, the main figures gradually yet measurably increase in their three-dimensionality. As a result, their presence nears the viewer, bridging the distance between the mortal and the Divine.

JAB

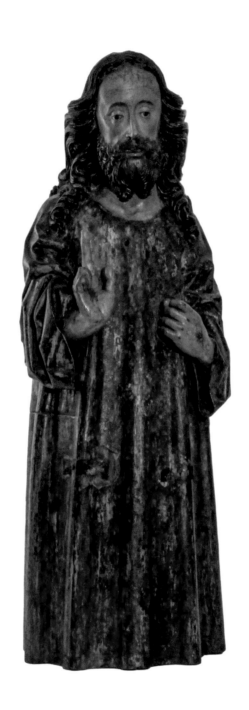

Ascending Christ (1476)

MASTER ARNT OF KALKAR AND ZWOLLE (ACTIVE CA. 1460–1491)

POLYCHROMED OAK | 39 × 14 × 11 IN. (99 × 35.5 × 28 CM) | MUSEUM KURHAUS KLEVE, CLEVES, GERMANY

According to archival records dated 1476, Master Arnt and his workshop produced a sculpture of Christ ascending into heaven for the church of Saint Victor in Xanten, a town in the Lower Rhine region. Although the artist later moved to Zwolle (1484), he lived in Kalkar, a city near Xanten, at the time this work was commissioned. Master Arnt may have carved the sculpture. However, guild regulations stipulated that an image-carver could not also paint. The polychromy was likely applied by Theodor von Ginderich, a member of the city's painters' guild.

The legless figure of Christ is nearly life-size. A long-sleeve robe conceals much of his body; however, his hands are exposed, revealing evidence of the Crucifixion. Christ raises his right index finger, a gesture that blesses viewers and indicates his imminent ascent to heaven. His hair is curled and parted in the middle, and these contours are echoed in his beard. His receding hairline makes his forehead a prominent feature, but no traces from the crown of thorns are visible. His heavy eyelids appear naturalistic.

The polychromed sculpture was seasonally exhibited in the church at Xanten. On Easter morning the upright figure was shown risen from the tomb. For the next forty days it stood in the church as a sign of salvation. The sculpture is hollow and has two metal rings attached to its back so that on Ascension Day it could be easily hoisted to the ceiling, which was temporarily decorated with clouds. The reverse side contains a hinged door. Flowers and eucharistic hosts may have been placed inside the compartment with the expectation that they would fall out of the elevated sculpture onto worshippers below. Although the ascending figure of Christ disappeared into the heavens, it would return the following year at Easter to represent the gift of eternal life.

HML

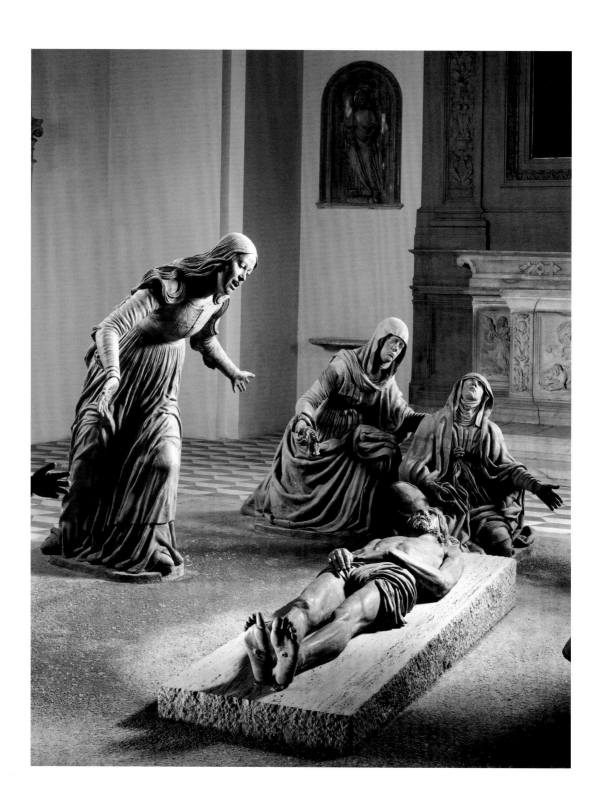

Lamentation over the Dead Christ (1492)

GUIDO MAZZONI (ITALIAN, 1445–1518)

TERRACOTTA | HEIGHT 64 IN. (162.6 CM) (TALLEST FIGURE) | SANT'ANNA DEI LOMBARDI, NAPLES

The Lamentation is a scene of mourning that focuses on the corpse of Christ, surrounded by multiple grieving figures. In general, it is a more expansive and dramatic variation of the Pietà, which traditionally involves one figure, usually the Virgin Mary, or a small group of mourners. Although neither scene is specifically mentioned in biblical text, they are imagined moments that could have likely occurred and that register as familiar with viewers from their own experiences of grief. The Lamentation theme is found frequently in paintings of the Renaissance and Baroque periods. In sculpture, it is encountered with rarity, especially in comparison to numerous carved or cast devotional images of the Pietà. Of these, a series of remarkable Lamentation scenes were created by the northern Italian master Guido Mazzoni at the end of the fifteenth century, of which the grouping in Naples is perhaps his most celebrated.

Mazzoni enjoyed success in Italy and, later, France, but his position as a leading sculptor of his generation is unusual for several reasons. First, he worked largely outside the main cultural centers of the period, such as Florence, Milan, and Rome, and is associated with his native Modena and the highly cultivated court at Ferrara. Second, he is known largely for work in terracotta rather than more venerable and timeless materials, like marble and bronze. Finally, he preferred a high degree of realism in his figures and seems to have eschewed the more classicizing tendency of the age that emulated the Greco-Roman tradition. We know little about his early life, but in addition to sculpting, he is documented as a painter and a maker of theatrical sets and masks. With the latter, he worked in papier-mâché and likely grew comfortable taking casts from life, which would greatly impact the verisimilitude of his life-size terracotta sculptures.

In keeping with tradition, the corpse of Christ is central in Mazzoni's *Lamentation over the Dead Christ*. He has been humbly placed on a slab that rests firmly on the ground. In the positioning of the arms and face, there is a touch of informality. The body has been cleansed of blood and dirt, but the wounds of crucifixion are clearly evident—especially in the feet. Gathered around in a semicircle are the traditional seven mourners: the Virgin Mary, Mary Magdalene, Mary Cleophas, Mary Salome, John the Evangelist, Nicodemus, and Joseph of Arimathea. Although we cannot be sure that the current arrangement of the figures is exactly what Mazzoni intended, we do know that the overall composition is correct in that it leaves the front open to the viewer. More than just an unobstructed view of the event, the opening creates the illusion that the viewer is a part of the scene, their contemporary self transposed into the biblical past. The illusion is greatly enhanced by the life-size scale of the figures and the extraordinary details of their clothing and demeanors. The original painted surfaces, now missing, would have enhanced the illusion even further. There is a likelihood that such scenes were inspired by passion plays and religious *tableaux vivants* of the period, which were first popular in northern Europe.

This sculptural ensemble was commissioned by the duke of Calabria, who later became Alfonso II, king of Naples. One of the great art patrons of the Renaissance, it is his likeness that Mazzoni used for the figure of Joseph of Arimathea (not pictured). The realism of all the figures is undeniable, and each may be based on known persons of the period. Undoubtedly, Mazzoni was working from life, and his earlier experience with mask making would have guided his efforts. Because Mazzoni was working in clay that would be fired, known thereafter as terracotta, there was a high degree of malleability in his material, allowing him to achieve great detail that would have been difficult, even unimaginable, for most sculptors working in marble or bronze. The placement of contemporary figures, especially donors, in such historical religious ensembles was common in Renaissance art as a testimony to both piety and patronage.

JAB

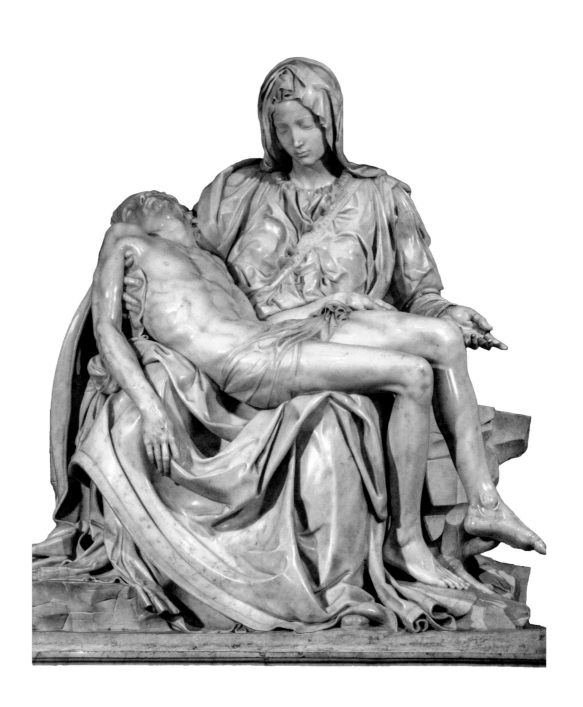

Pietà (1498–1499)

MICHELANGELO BUONARROTI (ITALIAN, 1475–1564)

MARBLE | HEIGHT 68½ IN. (174 CM) | ST. PETER'S BASILICA, VATICAN CITY

There are very few works from across the history of art whose seeming familiarity, even celebrity, is so pronounced that it can be challenging to consider the original form and artist's intent anew. Michelangelo's renowned *Pietà*, his first in a series on the subject to be executed over the course of his long, illustrious career, is perhaps foremost among them. Commissioned in papal Rome in 1498 and unveiled the following year, the sculpture established the young Florentine artist as the foremost sculptor of his generation and, by extension, one of the most influential sculptors of all time. Until this point, the precocious Michelangelo had carved but a handful of works on both mythological and Christian themes, evidencing his exposure to the collections of Greek and Roman art, as well as discussions of classical and religious literature and philosophy, in the revered Medici household of his native Florence, the center and compass of the Italian Renaissance.

For the widespread popularity of the Pietà theme, there is no biblical foundation for this moment when the corpse of Christ is held and considered by his mother, Mary. Other figures may be included, but the devotional focus is a three-way relationship between mother, son, and viewer. Literally meaning "to pity," the theme is frequently encountered in German and French art of the Middle Ages and the Renaissance, where emphasis is placed on the physical agony of the recently expired Christ, usually bloodied and broken, and the visible anguish of his tearful mother. Michelangelo's interpretation of the subject was entirely new and established a significant art historical and philosophical precedent for devotional imagery in Italy and beyond. The quiet, contemplative mood of his *Pietà* is the antithesis of its highly emotional and physically tormented northern European forerunners, and it kick-started the trend of more meditative Christian imagery that has continued until today.

To focus the viewer's attention, Michelangelo has arranged the figures within the visually steady confines of a triangular composition that reaches from the tip of Mary's head down through her arms and the body of Christ to the sculpture's base. Owing to its three-dimensionality, the sculpture becomes a flowing pyramid based on the intersection of two forms: the seated verticality of the mother, and the son horizontally draped across her lap. Central is the physical relationship between Mary's bowed head and the slumped body of Christ. Supported by visual geometry, Michelangelo's *Pietà* invites both intellectual and spiritual contemplation. Mary's face is tranquil as she carefully ponders the corpse of her son, and her gestures are serene; her lower torso and legs steady the weight of her adult child. The body of Christ is relaxed and largely free from any evidence of violence; the repose of his athletic form calls to mind the classical statuary Michelangelo so deeply admired rather than the visual turbulence so common among northern European Pietàs.

Michelangelo positions the body of Christ in a slightly upward fashion—he is propped up and turned out. The result is that Mary's human instinct to clutch and grieve her child is replaced by a divinely inspired willingness to present him to and share him with the world. Symbolically, her ample lap serves as an altar table, and the depiction of the physical body of Christ clearly calls to mind the concept of the Eucharist. Ideas of the Mass, practices of eucharistic adoration, and notions of Mary as the church itself are embedded in this work.

When Michelangelo completed the *Pietà*, public acclaim was resounding. Critiques of Mary's youthful appearance were quieted by Michelangelo's claim that her purity enabled her perpetual youth, and the enlarged scale of her torso and legs were immediately acknowledged as a visually logical means to support Christ. Just twenty-four when the sculpture was unveiled, Michelangelo was largely unknown in Rome, and many viewers initially ascribed his work to other, mature sculptors. To clarify his authorship, he then carved "Michelangelo of Florence Made This" down the band that passes between Mary's breasts. It is the only work Michelangelo would ever sign.

JAB

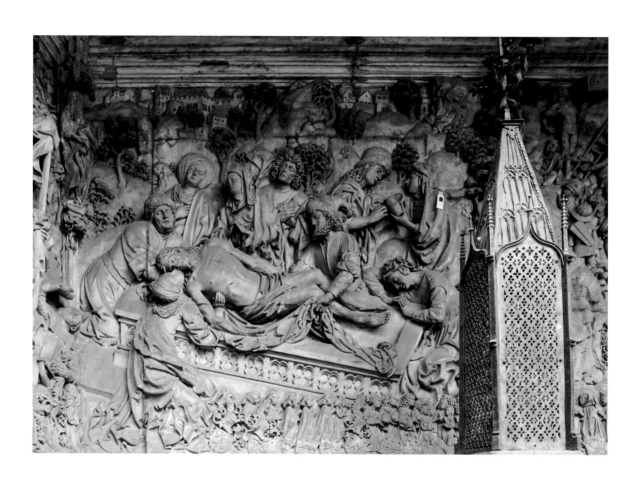

Schreyer-Landauer Funerary Monument (1499–1505)

ADAM KRAFT (GERMAN, CA. 1460–1509)

SANDSTONE | SEBALDUSKIRCHE, NUREMBERG, GERMANY

In the late fifteenth century, Sebald Schreyer (1446–1520) and his nephew Matthäus Landauer (ca. 1451–1515) commissioned a stone epitaph to replace a heavily damaged mural commemorating their family's dead. The monument, carved by Adam Kraft, was placed on the exterior of the church of St. Sebald in Nuremberg, at the site of their kin's burial plot. Kraft's funerary sculpture consists of three sandstone relief panels positioned between two buttresses on the north side of the church's choir, facing the city hall. The use of stone, a material more durable than paint, offered a more permanent means of marking the gravesite. It also was substantially more expensive, indicating the wealth of its patrons in a very public setting.

Schreyer served in the upper chamber of the city council and was the church's superintendent. He also financially supported the publication of the famous *Nuremberg Chronicle*, an illustrated history of the world. Landauer founded the Zwölfbrüderhaus, or House of the Twelve Brothers, a home for elderly artisans down on their luck, and was one of Albrecht Dürer's most important patrons. For instance, Landauer commissioned Dürer's *Adoration of the Trinity* (1508–1511) for the Zwölfbrüderhaus.

The epitaph resembles a triptych in its format. The sequence of panels is counterintuitive, moving from right to left. On the right (not pictured), Christ carries his cross on the way to Golgotha. In the center, the Crucifixion and Entombment are depicted; at the lower right of this panel (not pictured), Kraft depicted himself, wearing a fur hat and holding pincers and a hammer, in the guise of Nicodemus. Landauer may be portrayed next to him in the role of Joseph of Arimathea, who grips the crown of thorns. In the Crucifixion scene, the middle one of the three crosses is surprisingly empty (see top right of photo). Christ's absence in the scene may relate to his presence, as the consecrated host, within the large sacramental tabernacle located on the opposite side of the wall. On the left panel is the Resurrection. Its depiction on the east end of the epitaph, on the side where the sun rises, may be to reinforce the theme of new life. Miniature figures from the patrons' family can be seen at the bottom of each of the panels. They are arranged in a pious procession, witnessing Christ's passion and anticipating their own resurrection from the dead.

HML

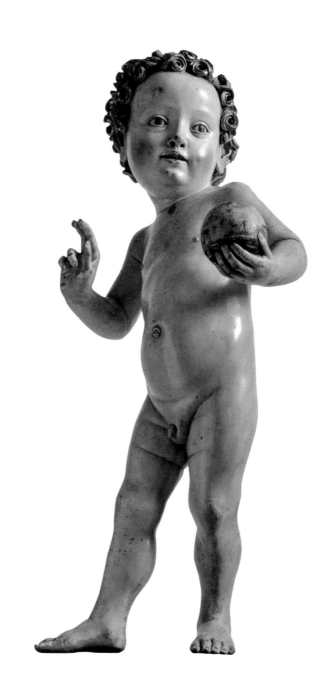

Christ Child with the Terrestrial Globe (ca. 1500)

GREGOR ERHART (GERMAN, CA. 1470–1540)

POLYCHROMED LIMEWOOD | HEIGHT 22¼ IN. (56.5 CM) | MUSEUM FÜR KUNST UND GEWERBE HAMBURG, HAMBURG, GERMANY

Gregor Erhart was born in Ulm around 1470. His father, Michel, was a prominent sculptor in the Swabian city, known for the florid style of his wood carving. Gregor likely served as his father's apprentice, but in 1494 he moved to Augsburg, a wealthier community, exporting his father's style. Gregor became a master sculptor two years later and spent the rest of his career working in Augsburg.

The Erharts produced works made of limewood, also known as lindenwood. Limewood is a softer material than oak. In addition, it is less likely to split as it dries. The tree grows throughout Germany; however, the broad-leaved variety is more prevalent in the South. Although the tree is quite abundant, the wood was more expensive than oak or walnut. Nonetheless, limewood was preferred over other woods. This may be related to the symbolic significance of the material. Prior to the introduction of Christianity, Germanic people danced around linden trees for healing. After their conversion to Christianity, they continued to venerate the tree. Votive tablets used for seeking protection from the plague were displayed in linden trees, and pregnant women ate lime seeds to save their unborn children from harm.

This life-size sculpture of the infant Christ was produced for a Cistercian convent at Heggbach. Standing upright, he offers a blessing with his right hand and holds a terrestrial globe with his left. A landscape is painted on the orb, marking his authority over all the earth. Christ's nudity reveals that he is fully human and sexually innocent. Yet nuns probably regularly dressed the sculpture in actual clothes.

On Christmas Day, images like this were placed in straw-filled cribs close to church altars. An ox and a donkey were also brought into the church to reenact the Nativity and reinforce its relationship to the Mass. These images were also presented to dying nuns during their receiving of the last rites, offering them a glimpse of the sweet child ruling heaven.

HML

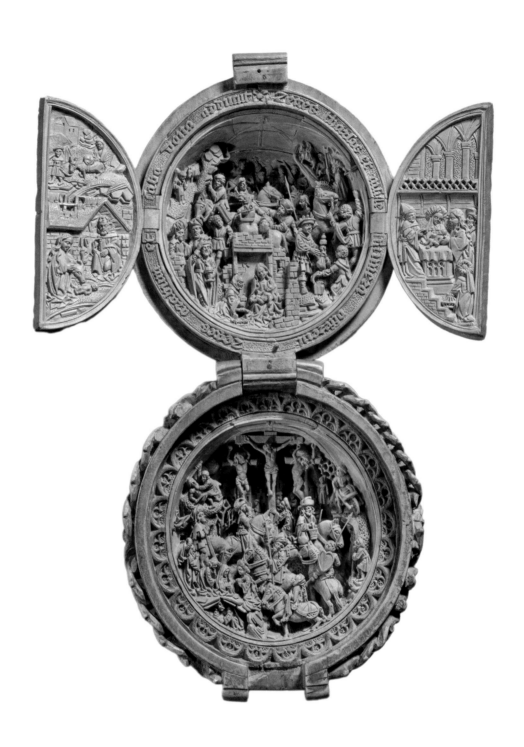

Adoration of the Magi and the Crucifixion (c. 16th cent.)

ADAM DIRCKSZ (DUTCH, ACTIVE CA. 1500–1530) AND WORKSHOP
BOXWOOD | DIAMETER 2 IN. (5.2 CM) | THE METROPOLITAN MUSEUM OF ART, NEW YORK | THE CLOISTERS COLLECTION | GIFT OF J. PIERPONT MORGAN

Although small in scale, prayer nuts are some of the most magnificent sculptures of the late Middle Ages. Made out of finely grained boxwood, these objects were intricately carved in minuscule detail. Wealthy collectors wore prayer nuts as pendants attached to rosary beads. Sometimes fragrant materials, such as sandalwood, were threaded into the openwork of the nuts. The scent of incense was intended to promote prayerful meditation.

Prayer nuts can be opened and closed. They consist of two halves hinged together. Their name, popularized in the nineteenth century, derives from their resemblance to walnuts, a traditional symbol of the dual nature of Christ. However, in the sixteenth and seventeenth centuries, these objects were frequently called "prayer apples," a devotional antithesis to the forbidden fruit.

This prayer nut is attributed to the Delft woodcarver Adam Dircksz and his workshop, which specialized in the production of small devotional objects. Its exterior is decorated with elaborate Gothic tracery and includes Latin inscriptions from Genesis 3:6 and Lamentations 1:12. The Genesis passage describes Eve seeing and taking the fruit from the tree of knowledge, whereas the verse from Lamentations describes the depths of sorrow resulting from sin, an anguish unseen by others. Opening the sculpted nut is a kinetic activity performed in conjunction with the initiation of prayer.

When the viewer peeks inside, the upper half of the object's interior remains concealed by a closed triptych, with outer doors carved with a scene of the primordial couple flanking the tree bearing forbidden fruit. When the triptych is opened, depictions from Christ's infancy can be seen on the inner wings. The journey to Bethlehem and the Nativity appear on the left, and the presentation in the temple is represented on the right. In the center, however, another narrative, the Adoration of the Magi, is rendered in higher relief. The magi arrive on horseback with an entourage of servants. Within this crowded composition, the crowned men offer gifts to the Holy Family. A Latin inscription from Psalm 72:10 surrounds the scene. The verse, which describes the sojourn of three kings bearing tribute, was often interpreted as a prefiguration of the magi's visit, when Christ is revealed to the Gentiles for the first time. The scene also has strong eucharistic connotations. After all, it is the occasion on which those who believe in the miraculous incarnation of the Divine receive the greatest gift of all—namely, God's love.

The bottom half of the prayer nut represents the Crucifixion, the event most associated with redemption from original sin. The narrative is carved in painstaking detail. Mary Magdalene grieves at the foot of the cross as the Virgin Mary and Saint John the Evangelist mourn nearby. The Roman centurion Longinus appears on horseback, accompanied by fellow soldiers. To the right, the dead Judas swings from a tree. Meanwhile, an anonymous traveler on the margins stops to gaze at Christ crucified, while another unidentified figure pushing a wheelbarrow continues his work as he glances at the scene. The addition of these extra-biblical characters is intended to foster greater piety by encouraging the viewer to ponder the meaning of the scene that they themselves are seeing represented in miniature.

HML

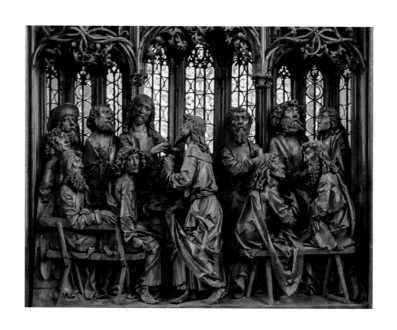

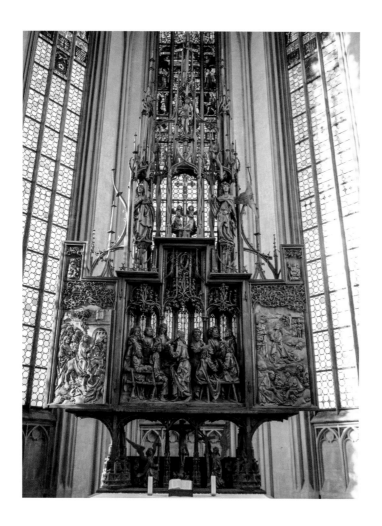

Altarpiece of the Holy Blood (1501–1504)

TILMAN RIEMENSCHNEIDER (GERMAN, CA. 1460–1531)

LIMEWOOD | HEIGHT 29.5 FT. (9 M) | JAKOBSKIRCHE, ROTHENBURG OB DER TAUBER, GERMANY

At the close of the fifteenth century, the magistrates of Rothenburg ob der Tauber commissioned Tilman Riemenschneider to sculpt a monumental altarpiece for the city's pilgrimage church of St. James. The selection of Riemenschneider is not surprising, as the Würzburg artist was one of the most prolific and highly regarded wood-carvers in the region.

His sculptures are typically covered with a brown glaze, and this altarpiece is no exception. Pigment appears on the black pupils and red lips of the figures, and the wounds of Christ also receive minimal color. The near absence of painting was not only cost-saving; more importantly, it gave the artist the opportunity to showcase his artistic skill and enabled him to convey a sense of the sacred transcending the present.

Standing nearly thirty feet tall, Riemenschneider's limewood sculpture was placed in the west chapel of the church above an altar dedicated to Saint Francis. At the base of the altarpiece (called a *Sarg* in German), Christ appears on the cross. He is flanked on both sides by angels holding instruments associated with his suffering. This scene of Christ's sacrifice complements the sacrament performed directly in front of it, serving as a visual reminder to those partaking in the Eucharist of the painful death Christ endured on their behalf.

In the central panel, or *Corpus*, above the base, the Last Supper, the biblical narrative in which Christ institutes the sacrament of the Mass, is depicted. Instead of focusing on Christ saying, "This is my body," Riemenschneider draws attention to the moment when Christ reveals that one of his disciples will betray him. The disciples seem shocked by Christ's announcement and respond to it in different ways. Some appear to discuss the content of his message, while others look to him, wondering what his words might mean.

Unexpectedly, Christ is positioned off-center. Judas is placed in the middle of the panel, holding a bag of silver coins. Christ and Judas stare into one another's eyes in anticipation of the forthcoming betrayal. Although called to be a disciple, Judas will ensure his leader's cap-

ture and arrest. The disciple seated next to Judas opens his palm toward Judas while pointing his finger at the image of Christ crucified shown below. His gesture reminds viewers of the connection between the actions of Judas and the death of Christ. Nonetheless, penitent pilgrims seeking unmerited forgiveness may have empathized with the fallen disciple. As Michael Baxandall has suggested, Judas's isolation becomes more and more prominent as sunlight moves across the sky through the chapel's windows and the translucent circular glass panes behind Riemenschneider's sculpture, casting him in shadow.

On the far left of the scene, Saint James, the patron saint of the church, can be identified by his pilgrim's hat. His marginalization may suggest that he has just arrived from afar. Meanwhile, Saint John the Evangelist rests intimately in Christ's lap, his face just visible behind Judas's moneybag. His apparent slumber reveals that he is dead to this world and already in mystical union with Christ.

On the altarpiece's two wings (*Flügeln*), Christ's entry into Jerusalem and the agony in the garden are represented. These relief panels, undecorated on their reverse sides, not only provide narrative scenes before and after the Last Supper; they also encourage further meditation on God's grace and the price paid for redemption.

The Virgin Mary and the archangel Gabriel stand on pedestals within the altarpiece's crown (*Aufzug*), announcing the presence of Christ. Two small angels are placed between Mary and Gabriel. The pair hold a crystalline reliquary cross containing a drop of Christ's precious blood. Above them stands the resurrected Christ, appearing as the Man of Sorrows. Although wounded for our transgressions, Christ offers his blood for our salvation. The intricate twisting and turning of decorative foliage throughout much of Riemenschneider's altarpiece suggests vitality and spiritual rebirth, characteristics associated with the power of the sacred relic housed in the altarpiece.

HML

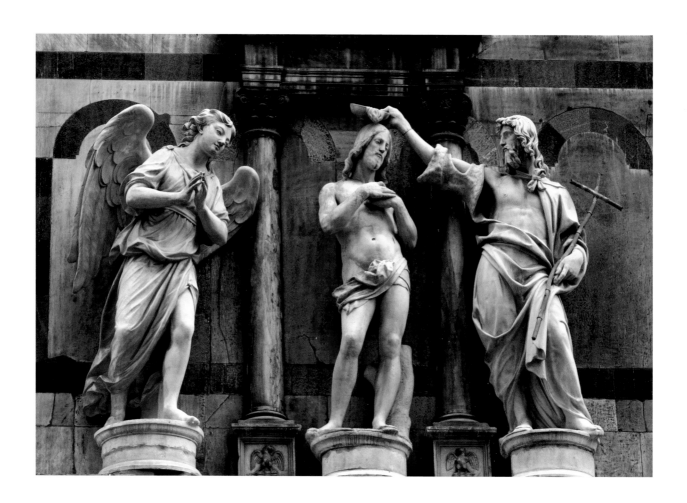

Baptism of Christ (1505)

ANDREA SANSOVINO (ITALIAN, 1467–1529)

MARBLE | HEIGHT 9.3 FT. (2.8 M) | MUSEO DELL'OPERA DEL DUOMO, FLORENCE

The baptism of Christ is among the most familiar New Testament subjects. In the visual arts it has a history dating back to the catacomb paintings of the early Christian era, telling us that both the biblical subject and the Christian ritual of baptism were significant to the faithful early on. Over time, it appears frequently in painting and relief sculpture but less so in freestanding form. Likely the need to represent two completely independent figures—John the Baptist and his cousin Jesus—in their narrative roles is a factor in its rarity. Compositionally, representing a single figure or more than one figure in physical contact with one another offers a more straightforward path to a desired visual unity. However, in this work, Renaissance master Andrea Sansovino offers three strong, independent but necessarily related forms: Jesus, John, and an angel.

In keeping with tradition, Sansovino represents John beginning to pour water from the river Jordan onto the head of a supplicant Christ. It is an event recorded almost identically in each of the Gospels—a resounding moment when the heavens opened and the voice of God proclaimed Christ as his son with whom he was well pleased. For both artist and audience, it is a scene where humanity and divinity, physicality and spirituality, converge. Sansovino follows an art historical tradition that places John at the right reaching toward an introspective Christ. Accordingly, the head of the latter is bowed and his eyes remain closed, while his hands are gently drawn across his chest. In the details of pose, one wonders if these are reactions to the waters of John or a meditation on the words spoken by God.

Sansovino is a strong representative of the Italian Renaissance and its pinnacle of visual and humanistic expression, the High Renaissance. Less celebrated than that of his contemporaries Leonardo da Vinci and Michelangelo Buonarroti, his work nonetheless embodies the idealized beauty and philosophical ideology of the age. In anatomy and pose, both John and Jesus speak to an admiration of the human form based equally on an appreciation of classical art and life studies. The disrobed figure of Christ is sensitively rendered. Although the face calls to mind those painted by Leonardo, the perfect body clearly recalls statuary of Greek and Roman deities and heroes, which Sansovino would have known. Christianity and antiquity elegantly merge. Both figures effortlessly express the timeless *contrapposto*, or weight-shift position, that sets the whole figure into subtle but interesting motion.

The baptized Christ is the undisputed focal point of this composition, but special note must be made of the Baptist himself. It is among the most handsome and gracefully presented depictions known. The face, usually described as rugged, is that of a princely philosopher. His outstretched arm and curved hip respond to and counter those of Christ. Moreover, the exquisitely carved material of his robe that flows across his figure is a tour de force of carving, evidencing careful life studies of both the body and corresponding drapery. The seemingly effortless manner in which this three-dimensional form moves through space is noticeable even from a distance—appropriate considering Sansovino's sculpture was originally positioned above the doors of the famed baptistery in the heart of Florence, a city whose patron saint is John the Baptist.

JAB

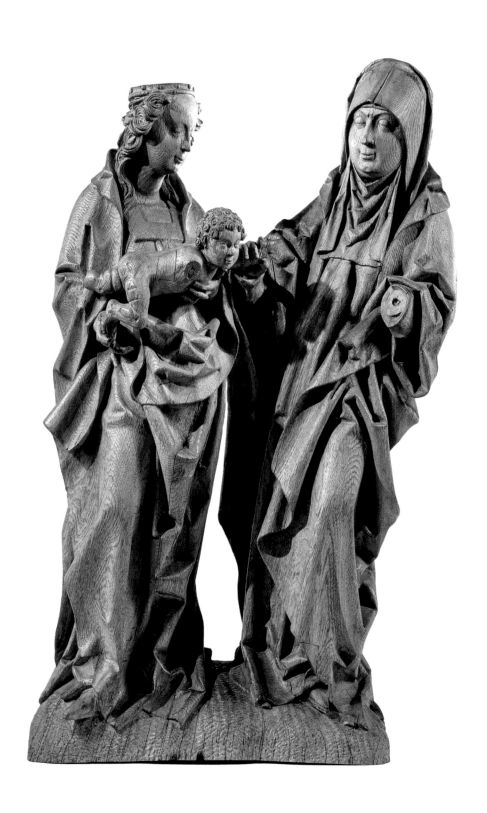

Anna-te-Drieën (ca. 1520)

MASTER OF ELSLOO (DUTCH, ACTIVE 1510–1530)
OAK (ONCE POLYCHROMED) | 32½ × 17¾ × 9½ IN. (82.5 × 45 × 24 CM) | RIJKSMUSEUM, AMSTERDAM

During the late Middle Ages, Saint Anna became a very prominent saint. Images of her were especially popular in Germany and the Netherlands. Saint Anna is not described in the Bible. However, her name appears as the mother of the Virgin Mary in the apocryphal Protevangelium of James. Tales of her life became well known thanks to Vincent of Beauvais's *Speculum historiae* (Mirror of History) and Jacobus de Voragine's *Legenda Aurea* (Golden Legend), a fourteenth-century compendium of saints' lives. The elevation of her status is thought to be the result of an increased interest in the Immaculate Conception—the belief, promoted primarily by Franciscans, that Mary was conceived by a miraculous kiss and consequently born without sin. Others, such as the Dominicans, argued that Mary's womb was purified *after* her conception. However, there is no need to get caught up in doctrinal differences. Both sides of this debate advocated the cult of Saint Anna. Most likely, this is a side effect of greater devotion to the Virgin. After all, Saint Anna opens the door of heaven by giving birth to Mary, the *porta clausa*, through whom the redemption of the world passes. The young Martin Luther prayed to Saint Anna during a horrific thunderstorm. Surviving the tempest, he became a monk. Later, the Reformer viciously attacked the veneration of Saint Anna as a misguided and ineffective invention of the church in Rome.

This sculpture is by the Master of Elsloo, a name coined by the Dutch art historian J. J. M. Timmer in 1940 after a sculpture in the Augustinuskerk in Elsloo, the Netherlands, to help with attribution problems. It represents Anna-te-Drieën, literally "Anna to be three." The Virgin Mary and Saint Anna stand side to side, similar in height. The Virgin originally wore a crown, most likely, made from a different material, but it is now missing. The Christ child lunges from her arms toward those of his grandmother, who smiles warmly.

The figure of Saint Anna is not authoritarian. There is no hierarchy of scale. Rather than indicate her familial power, the sculpture calls attention to her sweet and humble qualities as a down-to-earth grandmother enamored with her grandson. She seems preoccupied with the infant's happiness. Unfortunately, her arms are now lost. Saint Anna may have been extending her arms to embrace Christ. More likely, she may have playfully held a bunch of grapes, a traditional sign of the Eucharist, just out of Christ's reach. The sculpture portrays Anna and Mary as models of maternal care. In addition, it places Jesus within the context of an extended kinship. Although the original location of this devotional sculpture is unknown, it brings Christ closer to home. The warm and cozy relationship shared across three generations suggests a domestic ideal. Christ has strong family ties and a grandmother who adores him.

HML

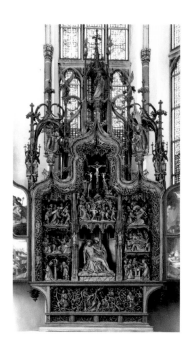

Altarpiece of the Seven Sorrows of the Virgin (1518–1524)

HENRIK DOUWERMAN (GERMAN, CA. 1480–1543)

OAK | NICOLAIKIRCHE, KALKAR, GERMANY

Henrik Douwerman produced this elaborate altarpiece for the north choir of the church of St. Nicholas in Kalkar. With incredible technical skill, he transformed oak, a hardwood, into many complex and intricate forms that together tell a story. The virtuosity and detail are exquisite. Douwerman applied very little polychromy to the sculpture. The only figures with pigment are found in the Crucifixion scene.

In the sculpture's center, the seven sorrows of the Virgin Mary are represented. During the late fifteenth century, Jan van Coudenberghe, the secretary of Philip the Fair, established the Confraternity of the Seven Sorrows in three Netherlandish churches. Devotion to the seven sorrows became widespread throughout the region. Starting in the lower right, the first of the sorrows, Simeon's prophecy at Christ's presentation in the temple, unfolds. Moving clockwise, this scene is followed by depictions of the flight into Egypt, Christ among the doctors (a sorrow because Mary temporarily loses him), Christ meeting his mother on the Via Dolorosa, the Crucifixion, the Deposition, and the Entombment. These vignettes surround an image of the Pietà, which was added in 1900 by Ferdinand Langenberg.

A cult image of the Virgin (now lost) was likely originally placed there by Douwerman. From the time of its installation, the main corpus of the altarpiece was likely protected by painted doors. However, the existing panels, attributed to Hendrik von Kalkar, were attached to the work in 1636.

The base of the altarpiece depicts the Tree of Jesse, symbolizing Christ's genealogy. Branches of the family tree, filled with Christ's regal ancestors, extend across the borders of the corpus. In the altarpiece's elaborate crown, Caesar Augustus consults the Tiburtine Sibyl on the left, and on the right, an angel directs Saint John on Patmos. Each of these pairings alludes to a heavenly vision. The former offers a revelation of the past, the emperor's dream of the *ara coeli* (heavenly altar), interpreted by the sibyl as the birth of the King of kings. Its counterpart points forward to Christ's triumphant return to earth at the end of time. At the apex of the crown, the Virgin Mary appears clothed with the sun (Rev. 12:1). Flanked by a choir of angels, the sorrowful Madonna is transformed into the victorious Queen of Heaven, who has given humanity the means of redemption, perpetually re-presented in each celebration of the Eucharist.

HML

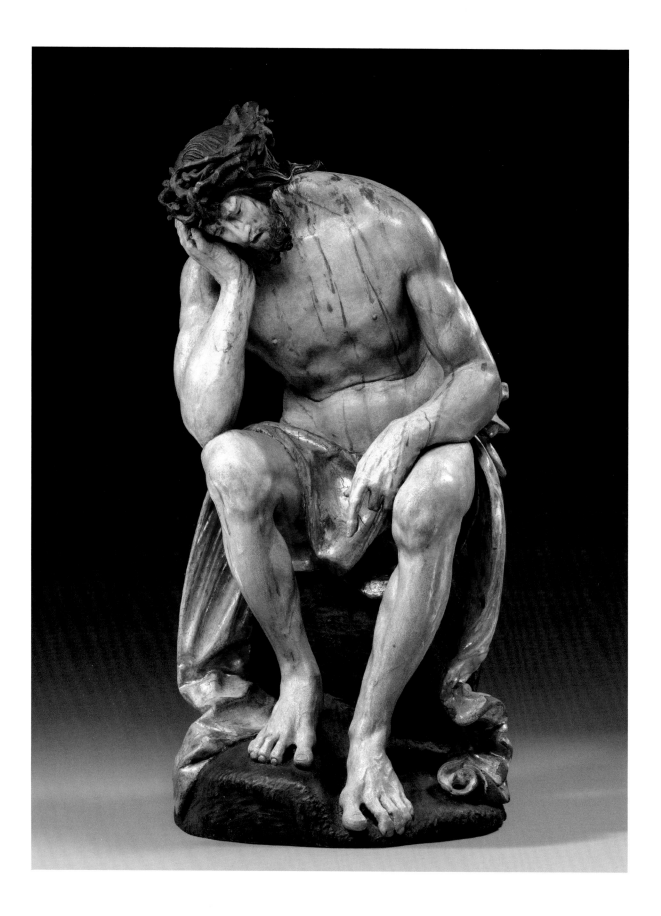

Christ on the Cold Stone (ca. 1525)

HANS LEINBERGER (GERMAN, CA. 1475–1531)

POLYCHROMED LIMEWOOD | 29½ × 14¼ × 11½ IN. (75 × 36 × 29 CM) | STAATLICHE MUSEEN ZU BERLIN, BERLIN

Hans Leinberger lived and worked primarily in the Bavarian town of Landshut. He likely produced this sculpture for the local Franciscan church, which was later destroyed in 1803. The sculpture, flat on the reverse, was probably exhibited against a wall inside the church. Although Leinberger carved the image in limewood, a material traditionally used by sculptors in his region, his style of representation is quite different from that of Tilman Riemenschneider and Gregor Erhart. By comparison, Leinberger's work seems less florid and more Italianate in appearance. Christ seems herculean in his proportions and musculature, and yet despite his heroic strength, he appears emotionally broken.

Rather than represent a particular episode from the passion cycle, such as the crowning with thorns or the flagellation, this work collapses multiple events into an imagined moment in which Christ reflects on everything he must endure to ensure humanity's salvation. The seminude Christ supports his downcast head on his open right palm as his flexed elbow rests on his knee. Wearing a crown of thorns, the mocked man sits alone in silence, contemplating his further suffering and impending death. He looks melancholic, resigned to his irreversible fate. Sculptures of Christ on the cold stone are modeled after depictions of the Old Testament figure of Job. Like the distraught Job, Christ patiently places his trust in God as he encounters torment and temptation. As viewers peruse the sculpture, they are encouraged to turn inward and to empathize with the alienated figure of Christ. By looking with the eyes of their hearts, viewers, it is hoped, will intensify their compassion and love for the Man of Sorrows.

HML

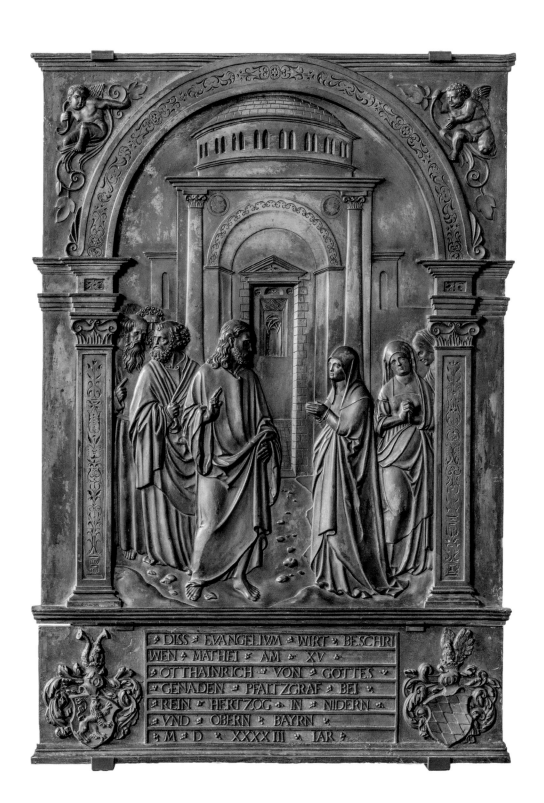

DISS · EVANGELIVM · WIRT · BESCHRI
WEN · MATHEI · AM · XV
OTTHAINRICH · VON · GOTTES
GENADEN · PFALTZGRAF · BEI
REIN · HERTZOG · IN · NIDERN ·
VND · OBERN · BAYRN ·
· M · D · XXXXIII · IAR ·

Christ and the Canaanite Woman (1543)

HANS VISCHER (GERMAN, CA. 1489–1550)

BRASS | 48 × 40 × 4 IN. (122 × 86.3 × 10.2 CM) | BAYERISCHES NATIONALMUSEUM, MUNICH

In the city of Nuremberg, four generations of the Vischer family maintained a metalworking shop. They produced numerous costly items in bronze and brass. Although Peter the Younger is the most famous artist in the dynasty, his brother Hans received some important commissions.

This brass cast, made of an alloy of copper and zinc, was made for Ottheinrich, count of the Palatine. The large plaque, which portrays Christ and the Canaanite woman, was placed over the entrance to the count's palace chapel in Neuburg an der Donau. Hans Vischer may have been selected for the project because of his connection with Andreas Osiander, an Augustinian monk from Nuremberg who became a prominent preacher promoting Lutheran theology.

Ottheinrich welcomed Osiander to his palace in 1542. Within a few months of the visit, Ottheinrich converted his territories to Protestant worship. Vischer, sympathetic to Lutheran ideals, may have been advised by Osiander during the production and installation of the plaque. The epitaph inscribed below the image calls attention to Ottheinrich as the sculpture's donor. Luther and his followers accepted the use of liturgical and devotional paintings. They also employed polemical prints to criticize the papacy and advocate Protestant reform. However, Lutherans did not place sculptures in the round, with the exception of monumental tombs, inside their houses of worship. Likely fearful of encouraging idolatry, they did not commission ecclesiastical sculptures. This may help explain why Vischer's work is rendered in relief and was located immediately outside the chapel.

The panel shows a Canaanite woman asking Jesus for a miraculous cure for her daughter, who suffered from demon possession (Matt. 15:21–28). Christ grants her request on the basis of her faith alone (*sola fide*). Because she believed in him, Christ healed her daughter. The count may have identified with the Canaanite woman in seeking the salvation of his subjects. Vischer's plaque, rendered in perspective depth and containing figures modeled in light, resembles Italian Renaissance imagery, especially in the calm restraint of Christ and the classicizing architectural backdrop. Nonetheless, the work seems to promote Protestant ideals. The figure of Saint Peter, the legendary first pope of the church, turns away from the miracle, suggesting Catholicism's failure to face the truth. Salvation is not offered in response to good works but is given to those who believe in the power of divine grace.

HML

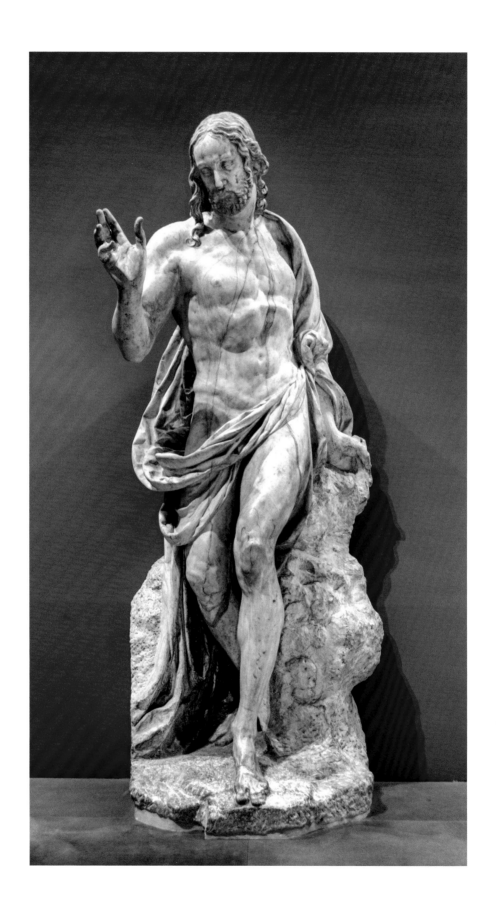

Resurrection (1572)

GERMAIN PILON (FRENCH, 1525–1590)

MARBLE | HEIGHT 85 IN. (215.9 CM) (CENTRAL FIGURE) | MUSÉE DU LOUVRE, PARIS

Central to Christian belief, the Resurrection appears with great frequency in the history of art. Also known as the Triumph over Death, the imagery almost always features a figure of Christ as the focal point of the composition. His body is often elevated, even slightly, above the ground or an open tomb to underscore the uplifting message of his divine victory over the finality of human mortality. The figure can be shown alone or near the guards assigned to secure the entrance to his tomb. The inclusion of guards visualizes the action detailed in the Gospel of Matthew, wherein the Pharisees and chief priests convince Pilate that the followers of Jesus might try to steal his body and proclaim its resurrection. So guarding the entrance was a necessity (Matt. 27:62–66). Tradition holds that the guards fell asleep while on watch and were profoundly surprised and in great fear when Christ appeared among them.

For the vast number of such images, the life-size sculpture by the French artist Germain Pilon is most unique. A highly animated composition, it features a standing figure of Christ flanked by a pair of reclining guards (not pictured) who recoil in fear and disbelief. It is a muscular Christ who steps boldly forward with his left leg. The body twists at the hips, and the entire torso turns in space. The right hand is extended in benediction, but it also suggests a forward-moving momentum. Christ's form suggests vibrancy and notions of reawakening or, specific to the faithful, new life. The guards add to the dynamic quality and overall visual impact of the sculpture, as their muscular forms, although recumbent, twist and turn. The guard at the left is the more dramatic, as he turns his head and covers his face, while the one at the right seems to be inching his way in the opposite direction of Christ. In short, Pilon imagines the story of the Resurrection unfolding immediately before our eyes.

Although Pilon was a celebrated figurative sculptor and received numerous portrait commissions, he also prospered in the genre of funeral imagery. He received many royal commissions, but among the most important were funeral effigies of Henry II of France and his wife, Catherine de' Medici. A member of a powerful Florentine family, Catherine was fully engaged in the history and efforts of artistic patronage that are synonymous with both her ancestors and contemporaries in Italy. In fact, it was Catherine who sponsored Pilon and the *Resurrection*. The work was originally intended to be placed in close proximity to funeral images of the king and queen at the royal burial church of Saint-Denis outside Paris. The use of the Resurrection theme in connection with burial sites and funeral chapels large and small is widespread, especially in painting. Conceptually, it addresses the belief of the faithful in a shared resurrection and afterlife made possible through divine sacrifice and miraculous new life. Such a grand sculptural endeavor on the theme as Pilon put forward is rare compared to painted images, but it befits its royal patronage—especially from a dynastic Italian matriarch like Catherine.

Pilon's connection to Italy and to the glories of the Italian Renaissance was not limited to his connection to Catherine. He was a great admirer of Italian artists, especially Michelangelo, who was active until his death in 1564. Pilon did travel to Italy, but it is not known whether the two sculptors met. However, the French acolyte pays homage to the legendary master's repertoire on many levels. While the athletic form of Pilon's Christ calls to mind Michelangelo's body of sculpture, the vibrancy of the pose clearly recalls the powerful figure of Christ in Michelangelo's painted *Last Judgment* in the Sistine Chapel. So too, the overall composition, including the recumbent guards, clearly references Michelangelo's famed Medici tombs in Florence—a visual reference that would have resonated deeply with Catherine. Yet it should be noted that Pilon was far from a slavish copyist. His figures are marked by a sense of graceful elongation that has led to his description as a Mannerist artist. As a final flowering of the Renaissance at large, Mannerism was a movement of stylized, independent voices that acknowledged the masters of the recent past in elegant, often exaggerated new ways.

JAB

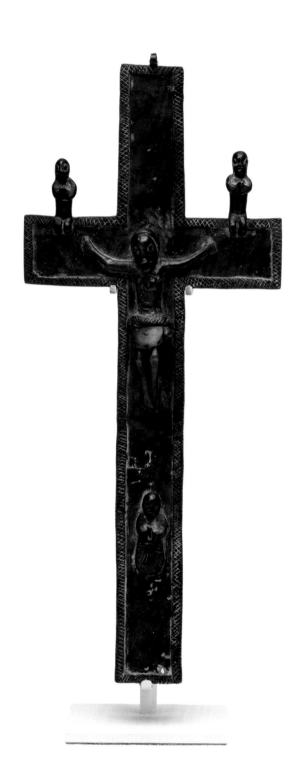

Crucifix (ca. 1600–1800)

UNRECORDED ARTIST (KONGO)

BRASS | HEIGHT 13⅝ IN. (34.6 CM) | SNITE MUSEUM OF ART, UNIVERSITY OF NOTRE DAME,
NOTRE DAME, INDIANA | GIFT OF THE RAYMOND BRITT JR. FAMILY

In 1483 Portuguese traders and missionary-priests, looking for a shorter route to India, traveled across Central Africa, where they encountered the kingdom of Kongo. Its ruler, Nzinga a Nkuwu (r. 1470–1509), striving to establish a commercial partnership, accepted the religion of these Europeans. He was baptized in 1491 and took a Christian name, João I. On the day following his conversion, an inscribed cross miraculously appeared on a black stone. This sign of grace confirmed to the Kongolese that adopting Christianity was a good decision.

Upon the king's death, a war of succession broke out between two of his sons. Mvemba a Nzinga, also known as Afonso I (r. 1509–1542), who accepted Christianity, defeated his unconverted brother. Reminiscent of the legends of Constantine's vision and Iberian tales of Santiago Matamoros (Saint James the Moor-Slayer), Afonso claimed to have witnessed an apparition of Saint James leading Christian forces under the sign of the cross appearing in the sky. After achieving victory against his brother's forces, the new king made Christianity the state religion of Kongo.

Unlike in the Americas, where Christianity was imposed by European conquerors, conversion in Kongo was promoted internally, by its own cultural elite. Acceptance of the new faith was not the result of colonization but was intertwined with trade. In some regards, Christianity readily merged with the local religion. For instance, prior to the Kongolese encountering the Portuguese faith, the cross was an important symbol to them, marking the threshold between the living and the dead. Crosses not only indicated the intersection of the visible with the invisible; they also served as amulets, active agents or conduits for the sacred to enter this world.

After the introduction of Christianity, local artisans began fashioning crucifixes out of brass, an alloy they obtained from the Portuguese. Nonetheless, they continued to follow traditional artistic conventions in rendering these crosses. For example, this crucifix is framed by crosshatching, a decorative motif articulating holy space, which also appears on Christ's loincloth. Jesus is depicted with large, bulging eyes, suggesting connection with the Divine.

Directly below Christ, the Virgin Mary kneels in prayer. Two additional figures sit on arms of the cross. Although these three figures are substantially smaller than Jesus, maintaining a hierarchical order, their placement alongside the crucified Christ conveys their proximity to the liminal space between life and death.

In the centuries that followed their conversion, the Kongolese fell victim to slavery and their monarchs lost much of their authority. At the beginning of the eighteenth century, a young woman named Kimpa Vita claimed to be the reincarnation of Saint Anthony of Padua. Declaring that she died every Friday and resurrected every Sunday, Kimpa Vita led her followers, known as Antonians, to believe that she met weekly with God in heaven. According to the Antonians, Jesus was African and Europeans purposely ignored African saints. They also rejected the use of crucifixes, which they associated with their European enemies. Although Antonians held anti-European sentiments, they sought not a return to pre-Christian religion but a new mixture of spiritual convictions. Kimpa Vita was executed in 1706 as a heretic. Although some of her followers continued to believe she was alive, many Antonians returned to the Catholic Church. This portable cross may have been produced to demonstrate rejection of Antonianism and to affirm Kongolese Catholicism.

HML

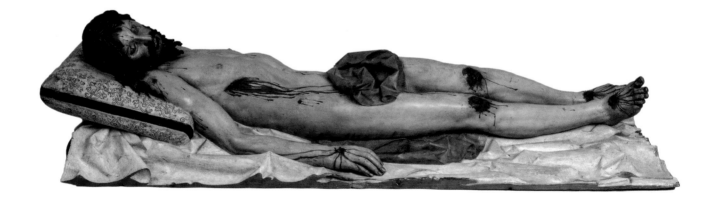

Dead Christ (ca. 1625–1630)

GREGORIO FERNÁNDEZ (SPANISH, 1576–1636)

POLYCHROMED WOOD, BULL'S HORN, GLASS, BONE, AND CORK | 18⅛ × 75¼ × 29⅛ IN. (46 × 191 × 74 CM) |
S. MARTIN, VALLADOLID, SPAIN

Perhaps nowhere in the history of Christian art is the confluence of the visual, emotional, and spiritual more acute than in seventeenth-century Spanish Baroque sculptures. Gripping realism emphasizing the physical torments of a divine or saintly subject was the norm. Such images grew out of the Catholic Church and associated traditions of devotional asceticism and deep mysticism. Instead of being relegated to museum collections where they are studied as historical objects, many of these sculptures and their heirs are actively engaged today in living religious experiences and events, especially in the calendar periods related to the passion and death of Christ. In Spain and many Spanish-influenced regions of the world, one still sees sculptural images presented to and paraded by the faithful during Holy Week in prayerful anticipation of Easter. The hyper-realistic carved and painted sculptures by Gregorio Fernández, including this compelling one depicting the brutally martyred Christ, are the most important of the age and continue to move and inspire legions of devoted Christians.

Fernández lived and worked in Valladolid, Spain, in close proximity to the royal court. His carved figures were admired for their high degree of anatomical naturalism as well as their suggestion of drama in gesture and pose. Meticulously polychromed (that is, hand-painted), they may also include other materials, like glass for the eyes or ivory for teeth, which altogether disguise the carved wooden forms. Early in his career, Fernández's skill as a sculptor came to the attention of King Phillip III and later his successor, Phillip IV, who both became patrons, as did many leading members of the court. They commissioned sculptures for a variety of locations. Additionally, Fernández was extremely popular with religious orders. Much of his repertoire involves subjects related to the passion of Christ—those moments following the Last Supper and leading to the death of Jesus. In addition, he created singular images of the saints and numerous carved altarpieces. As a result, Fernández had one of the most active and admired sculpture workshops in seventeenth-century Spain. His style was imitated in his own lifetime and by following generations.

A lifeless form lying atop a simple burial cloth, *Dead Christ* is perhaps Fernández's most compelling sculpture. The corpse is naked save for a simple blue loincloth. It is located close to the ground and is meant to be seen from above and from the sides. Through such a presentation, Fernández emphasizes Christ's emaciated body and its bloodied and soiled wounds. Absent a high degree of muscularity, the figure verges on the skeletal. This is most clearly seen in details like the rib cage and the extremities, but profile views accentuate a brittle linearity from torso to toes that is nearly columnar. For many, the exposed wounds, clotted gashes, and dried streams of blood are difficult to look at, even considering the larger narrative of forthcoming resurrection. However, it may be the partially opened yet vacant eyes and the gaping mouth that are most harrowing, that give a real sense of violation.

In the history of Christian art, there are two general currents for depicting the dead Christ. One tradition emphasizes the physical suffering and offers the painted or sculpted figure as a means for considering, perhaps even agonizing over, the pain of sacrifice and loss undertaken for the purposes of redemption. This tradition is encountered across the Middle Ages, in Germanic and Germanic-inspired imagery of the Renaissance, and, case in point with Fernández, in the Spanish Baroque. The other tradition, most closely associated with the Italian Renaissance and its followers, is more contemplative. The corpse of Christ is presented cleansed of physical abuse and seemingly in repose. These representations appeal to considerations of a divine plan and victory over death. Artists of both traditions follow currents of naturalism because presenting the body of Christ is essential; however, the degrees of turbulence versus serenity of that visual expression are strongly related to the religious and cultural context in which such works were created. For Fernández and his era, the turbulent was compelling.

JAB

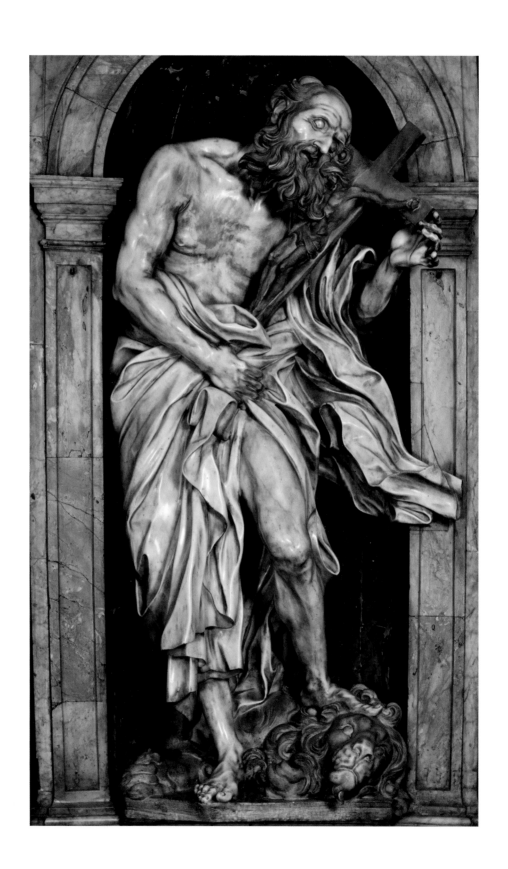

Saint Jerome with Crucifix (1661–1663)

GIAN LORENZO BERNINI (ITALIAN, 1598–1680)

MARBLE | HEIGHT 77 IN. (195.6 CM) | CHIGI CHAPEL, CATHEDRAL OF SIENA, ITALY

The preeminent artistic figure of the Italian Baroque, Gian Lorenzo Bernini was a prolific sculptor, architect, draftsman, painter, and set designer. The son of a celebrated sculptor, he spent the majority of his career in Rome working for the leading prelates and princes of the seventeenth century, and he visually defined and redefined much of the city through architecture, urban planning, and public works of sculpture. He also accepted important commissions across Italy and other parts of Catholic Europe. As a figurative artist, Bernini based his forms on classical and Renaissance ideals of anatomy and proportion, but his concern for dynamic movement and vibrant gesture verge on the theatrical. This, in combination with his bold command and manipulation of materials, especially marble, have captivated audiences for centuries. Deeply religious, Bernini's dramatic images of saints, angels, and enlightened patrons came to visualize the spirit and energy of the Catholic Counter-Reformation, which relied heavily on the visual arts to reach, engage, and maintain the faithful.

Given the breadth and depth of his career, it is surprising that single figures of Christ appear infrequently in Bernini's religious imagery. Instead, one is more likely to encounter saints fully engaged in mystical moments of their faith life or expressing their devotion and asceticism through physical or psychological means. Among these, one of Bernini's most compelling works is his *Saint Jerome with Crucifix* for the Chigi Chapel in the cathedral in Siena. It is one of a pair of over-life-size figures that the artist executed for the chapel he designed for the princely Chigi family. The other figure represents Mary Magdalene; together, with Jerome, the pair gives form to the central notion of repentance and forgiveness in Christian tradition. Although the Magdalene is associated with the historical life of Christ, Jerome (342–420) is an early Christian penitent and writer most frequently associated with translating the Old and New Testaments into Latin.

Images of Saint Jerome as penitent are common and traditionally depict the partially disrobed, aged, and emaciated figure kneeling before a crucifix in the desert. He may be accompanied by a lion, his faithful attendant, and shown beating his chest raw with a stone to dispel impure thoughts. Bernini's depiction is an extraordinary break with this tradition on multiple counts, beginning with the physical and suggested spiritual relationship between Jerome and the crucifix. Rather than kneeling before it in devotion, Jerome elevates the form of Christ on the cross to his face in a gesture of loving embrace. The positioning of the saint's head toward the downward-bent head of Christ is among the most touching gestures in Bernini's vast repertoire. This, in combination with Jerome's countenance and the nimble positioning of his left hand, suggest, more than mere physical interaction, a mystical relationship between the human and the Divine. Although the over-life-size form of Jerome is measurably larger than the divine corpus, they seem equal in visual impact and necessarily conjoined. Jerome's adoration of Christ and his gratitude for Christ's redemptive sacrifice are portrayed through a loving human gesture.

Bernini's depiction of the saint is atypical. Expected would be the gaunt frame of an aged man worn thin by time, with flesh weathered by repeated mortification. Yet the sculptor provides a vibrant, muscular form that extends forward, twisting and moving out beyond the framework of his prescribed niche. In fact, the saint seems just as vigorous as the corpse of Christ, who would have been decades younger than Jerome at the time of his crucifixion. In contrast to this solidity are the cascades of Jerome's locks and beard, and the billowing folds of his downturned tunic—both tour-de-force examples of Bernini's carving techniques that animate the figure and captivate the viewer's attention. The overall effect is visually dynamic, as the subject emerges from the confines of the niche to physically engage with the space of the chapel itself. Praise for the sculpture was immediate, emanating from none other than Pope Alexander VII, scion of the Chigi family and among the greatest art patrons of the age.

JAB

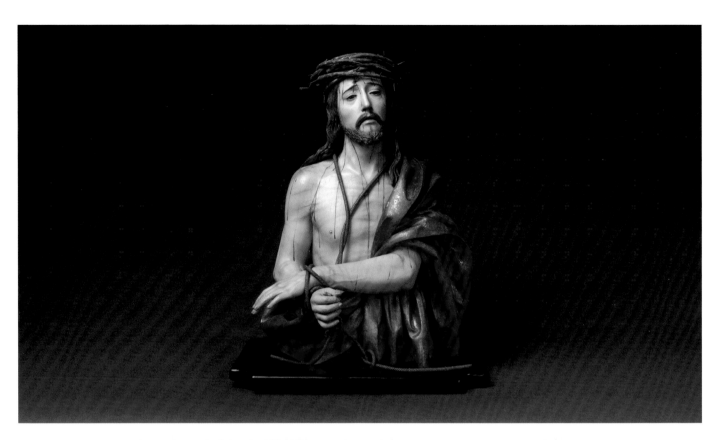

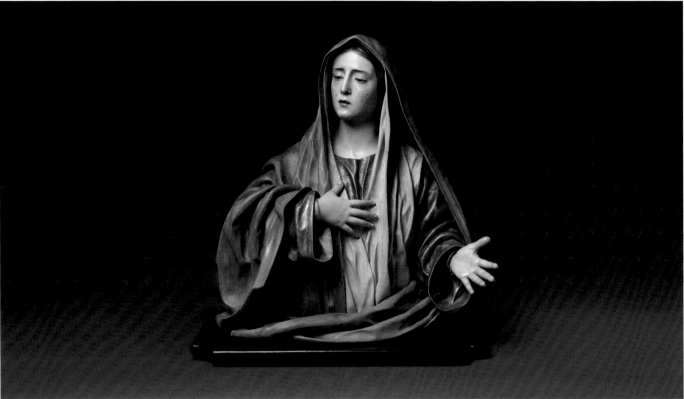

Ecce Homo and Mater Dolorosa (1674–1685)

PEDRO DA MENA (SPANISH, 1628–1688)

PARTIAL GILT POLYCHROME WOOD, GLASS, AND RESIN | 26¼ × 21 × 16⅛ IN. (66.7 × 53.3 × 41 CM); 26 × 24¾ × 16½ IN. (66 × 62.9 × 41.9 CM) | THE METROPOLITAN MUSEUM OF ART, NEW YORK

Making the Divine seem physically present was an objective of many seventeenth-century religious sculptors in Spain, and Pedro da Mena was foremost among them. Illusionism, the use of artistic techniques to create the illusion of reality, is one way to go about achieving this objective, and it is greatly enhanced when sculpture and painting converge—for example, in wooden, polychromed (hand-painted) images. Although many artists tended to specialize in either sculpture or painting, meaning a sculptor might simply collaborate or contract with a painter on a given work, we know that Pedro da Mena both carved and painted his images himself. Born into a family of artists, he studied first with his father, Alonso da Mena (1587–1646), then later with Alonso Cano (1601–1667), who was celebrated as a sculptor, painter, and architect. Pedro da Mena became one of Cano's most accomplished students, establishing a career in his native Granada, then in Málaga and Toledo.

As a part of his sculptural practice, the artist made devotional images in a variety of scales. Much of his artistic renown and popularity among patrons revolved around his highly illusionistic portrait busts of divine personalities that were intended for more immediate personal contemplation. Such images might feature only the head and shoulders, but the most riveting of them are actually half-length, which means they include the torso and arms. The additional length enhances the illusion of being present before a figure while the gestures of the arms and hands further the drama, usually one exploring pain and loss. Of these half-length figures, the artist's *Ecce Homo* and *Mater Dolorosa* were widely admired and exist in slightly different versions. Although they are technically independent works, they also work as companion pieces; as images of Christ and his mother, Mary, they share a familial and narrative bond.

Featured from the waist up, each figure is essentially life-size. Christ is presented beaten and bruised, presumably sometime prior to his march to Golgotha. His head is crowned with thorns, sending thin streams of blood running down his face and torso. A rope is draped around his neck and binds together his hands, left over right. In very forthright terms, the sculpture embodies the biblical Latin spoken by the Roman prefect Pontius Pilate: *Ecce homo* ("Behold the man"). Yet for all its references to physical abuse and pain, this is a figure of nobility. The body is upright, not slumped; a red robe cascades down from the left shoulder to the waist; and even the crown of thorns, ominous as they are, insinuate royalty. Dignity in the face of death is clearly on display. In the companion sculpture of Mary, there is a similar regal bearing. A sky-blue mantle covers her head and falls gracefully around her figure. Her gesture—the folding of one hand over her heart and the extension of the other toward the viewer—is slow-moving, majestic. Her internal pain surfaces. One glance at her tearful eyes and mournful countenance, and the title Mater Dolorosa or Our Lady of Sorrows registers deeply. Presented together before the viewer, Son and Mother, Savior and Virgin, divinity and intercessor offer themselves as visions of suffering connected to the human hope for salvation.

Although the scale and physicality of each sculpture initiates the illusion of Christ and his mother made manifest, it is the close relationship between sculpture and painting that delivers a most compelling, mystical experience. Of particular note is the subtle movement of each figure as the head, torso, and arms flow into space. Combined, there is also the tour-de-force carving with both soft contours for the flesh and deep undercuts for the folds of clothing. The painted surfaces are realized with meticulously applied layers of pigment that combine to create a truly lifelike presence. Nuances of tone in flesh and hair play out against surface details like the wounds, bruises, and blood. Verisimilitude peaks with the inclusion of glass for the eyes and resin for the droplets of tears. Pedro da Mena offers a sense of animation without exaggeration. As a result, the viewer is offered a profound experience with, or perhaps through, works of art.

JAB

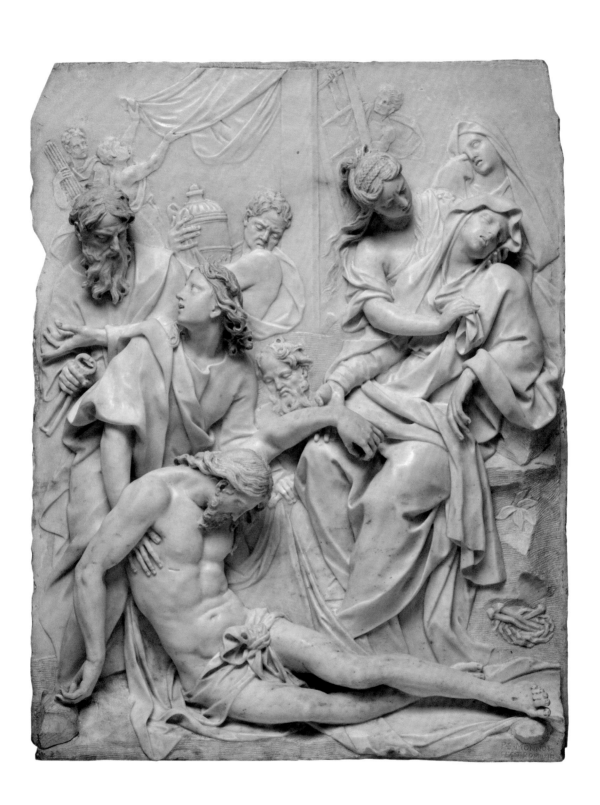

The Virgin Mary Swooning over the Dead Body of Christ at the Foot of the Cross (1710)

PIERRE-ÉTIENNE MONNOT (FRENCH, 1657–1733)

MARBLE | 28⅜ × 22¾ × 3 IN. (72 × 58 × 7.5 CM) | NATIONAL GALLERY OF ART, WASHINGTON, DC

This elegant relief sculpture captures a scene of mourning after Christ's lifeless body has been taken down from the cross to be prepared for burial. Several related scenes form a genre of holy bereavement that appears throughout the history of art, with titles such as *Descent from the Cross*, *Lamentation*, and *Pietà*. In this particular work, the dead Christ fills the lower portion of the composition as a small group of his immediate family and followers swirl above and around. Particular attention is given to the grand, swooning form of his mother, Mary. The Gospels mention a small group of those most devoted to and beloved by Christ remaining with him during his gruesome death on the cross, and this carving reflects that. The Virgin Mary is always a central figure, but other regulars include Saint John the Evangelist, Mary Magdalene, and Joseph of Arimathea—each of whom is featured here in highest relief, as if breaking out of the background plane and into our own space.

One of the most gifted European sculptors in marble of the late seventeenth and early eighteenth centuries, Pierre-Étienne Monnot was celebrated for his vigorous freestanding works as well as his meticulous reliefs. He is one of the most important figures in the history of French sculpture, but he spent much of his life working in Rome. For Monnot and for generations of sculptors preceding and following him, the preeminence of the Eternal City was based on its vibrant history that was continuing to unfold, the nearby quarries, and its abundance of marble craftsmen. Monnot was initially taught to carve by his father. He moved to Rome in 1687 and was greatly influenced by the work of Gian Lorenzo Bernini (1598–1680), the definitive sculptural genius of the Roman Baroque. Although Monnot's style is more visually and emotionally understated, it exhibits the virtuoso carving techniques and handling of forms that lead many to view him as Bernini's heir.

The Virgin Mary Swooning over the Dead Body of Christ at the Foot of the Cross is relatively modest, but the complex composition, the varied depictions of figures, and the technical brilliance of the carving itself make it a commanding work to behold. The scene has been arranged according to several compelling visual devices. Half of the figures appear at the left and half at the right, with relatively uncluttered open space between them. What joins them is the diagonal formed from the torso and outstretched limbs of Christ, which stretches from the bottom left, to the collapsing Virgin in the upper right. This tactic underscores the strain and drama of the wrenching moment, but it also leaves an unobstructed view of the hand of Mary releasing the wrist of her son. Several of the figures are carved at least partially in high relief; in fact, they forcefully pull away from the background, bursting into the viewer's space. Other figures are rendered in a very low relief and appear to have been barely sketched into the marble. As a result, the viewer is drawn into the scene and encouraged to fully explore the carved surfaces, the play of light and shadow over them enhancing the overall illusion.

For many Christian audiences, the narrative content and squared format of this relief sculpture may call to mind a significant sculptural tradition known broadly as the Stations of the Cross. Traditionally created as a sequence of relief sculptures within a square or rectangular framework, the stations present the passion and death of Christ in fourteen scenes, from his condemnation to death to his burial in the tomb. Monnot's *The Virgin Mary Swooning over the Dead Body of Christ at the Foot of the Cross* is instead an independent work, but the subject is harmonious with the thirteenth station, which depicts the body of Jesus being taken down from the cross. Stations of the Cross can be presented out of doors in grotto-like settings but are perhaps most recognizable installed along the interior walls of churches. The latter practice greatly increased in the eighteenth and especially nineteenth centuries. Sculptors of such works would have looked closely at the most compelling forerunners, and Monnot's repertoire would have certainly been inspiring to many. More than merely his ability to capture a given scene with such authority and control, his ability to stretch the limitations of relief sculpture was highly influential.

JAB

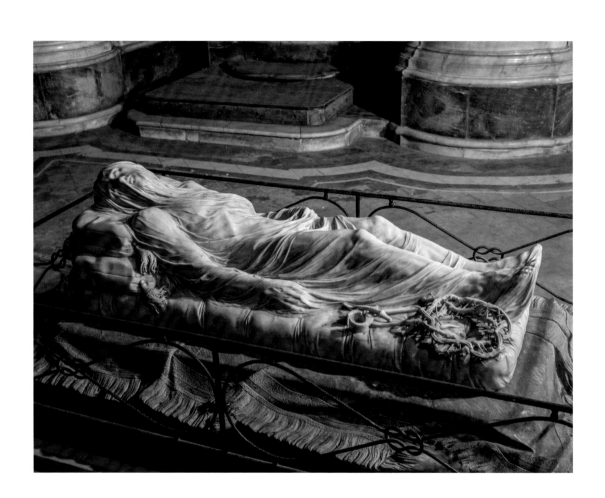

Veiled Christ (1753)

GIUSEPPE SANMARTINO (ITALIAN, 1720–1793)

MARBLE | 20 × 31 × 71 IN. (50.8 × 78.7 × 180.3 CM) | MUSEO CAPPELLA SANSEVERO, NAPLES

One of the most impressive examples of marble carving in the history of European sculpture, Giuseppe Sanmartino's *Veiled Christ* has been a focal point of religious and cultural pilgrimage for centuries. Its popularity among Christians and non-Christians alike is heightened by the ongoing respect, even incredulity, of sculptors from the eighteenth century to the present who have expressed open admiration for the work. Surprisingly, this sculpture is the artist's earliest signed and dated work. Born and trained in Naples, Sanmartino (also spelled Sammartino or San Martino) inherited the commission originally given to the Venetian sculptor Antonio Corradini, who died in 1752. Corradini left behind only two small clay models, so the *Veiled Christ* must be seen as Sanmartino's invention.

The sculpture meticulously depicts the singular figure of the recently deceased Christ laid out on a cushioned funeral bier. The corpse and portions of the bier are presented as covered with a gossamer-thin shroud that allows most of the details of the face and body to be seen even from a distance. The sculpture references the practice of presenting a draped human corpse for the purposes of mourning prior to burial. Installed directly on the floor of the Sansevero Chapel, it also references the artistic tradition of placing the body of Christ on the ground—to encourage the role of viewer as mourner, but also as a reminder of Christ's humility and humanity, his being not only divine but also of the earth.

The striking realism of the marble figure is owing in part to its life-size scale and in part to its precise anatomical rendering. The skeletal framework of this Christ is made more pronounced by his stiffened muscles and extremities. He is thin but not quite gaunt—slightly muscular, in fact, but far from athletic. The body is depicted after it has been cleansed of dirt and blood, although some of the wounds of crucifixion are discernible. Interestingly, Sanmartino's Christ is not shown completely parallel to the ground; instead, his head and shoulders are slightly elevated on a stacked set of cushions contemporary to the period. The knees, too, are slightly upraised, but in the absence of any support, this likely references the stiffening of the knees and legs during crucifixion.

Such fundamentals considered, attention turns to the extraordinary shroud that at once veils and presents the corpse of Christ. The degree of carved material thinness in relation to the anatomy is technically superb. In Sanmartino's hands there is a near liquid-like quality to this aspect of the sculpture that makes it seem as if the veil is washing over the figure rather than blanketing it. The aforementioned positioning of the body, with areas of elevation and corresponding recess, creates a kind of landscape across which the veil moves organically with a seemingly endless variety of gathers and folds that are visually engaging. There is a hushed liveliness to such physical treatment, which exists in opposition to the stillness of death—perhaps a subtle nod to the resurrection to come. Whereas the corpse is solid and suggests human mortality, the veiling takes what is supposedly mortal into the realm of divinity, into indefinable mystery.

In many ways this work is without peer, as was the artist among his contemporaries. Active from this point through to the end of the eighteenth century, Giuseppe Sanmartino occupies a position between the visual ebullience, even excesses, of the Baroque and the distilled, cerebral quiet of Neoclassicism. He is often described as a Rococo artist by scholars. Although the historical timing is accurate, the decorative and largely secular concerns of that era certainly don't apply to his work—especially to masterpieces like the *Veiled Christ*. Perhaps the sculpture's uniqueness, not to mention its conceptual and technical brilliance, is partially responsible for its continuous appreciation over the centuries.

JAB

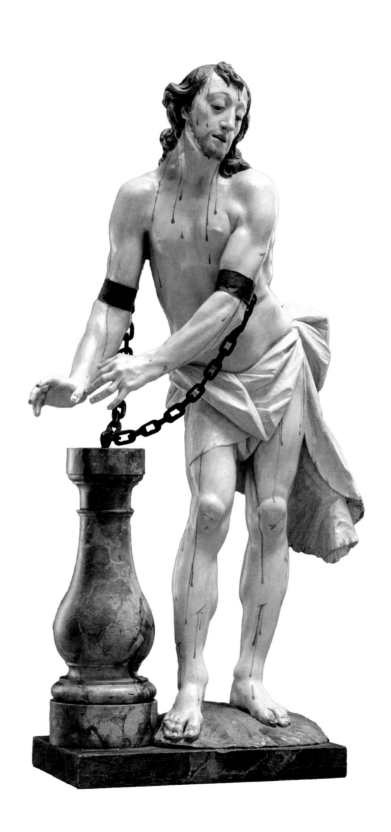

Christ at the Column (1754)

FRANZ IGNAZ GÜNTHER (GERMAN, 1725–1775)

POLYCHROMED LIMEWOOD | 29¼ × 17¼ × 7½ IN. (74.3 × 43.8 × 19.1 CM) | DETROIT INSTITUTE OF ARTS, DETROIT, MICHIGAN | FOUNDERS SOCIETY PURCHASE

In 1732, Premonstratensian monks living in the Bavarian abbey of Steingaden produced a makeshift image of Christ scourged to be carried in Good Friday processions. After a few years of use, the object lost its charm and was placed in storage. It would have likely remained there indefinitely had the statuette not caught the attention of Maria Lori, a local farmer's wife. Lori, having fond memories of seeing the object on parade, asked the monks if she could have it. They agreed to give it to her, and the Catholic figurine found a new home, a farmer's house called Auf der Wies, or "from the meadow." One day, according to Lori, she witnessed actual tears running down Christ's sculpted face. In response to this miraculous event, pilgrims began to travel to the Loris' farmhouse. To accommodate sojourners hoping to see the sacred image, the architect Dominikus Zimmermann built a highly ornate church in the Rococo style. Numerous prints and figurines modeled after the miraculous image were sold at Auf der Wies as amulets or souvenirs.

Most of these reproductions appear stiff and are poorly designed. Yet Franz Ignaz Günther offered something different. His copy is quite elegant. The arms and head of the shackled Christ turn gracefully in opposite directions, evoking dynamic equilibrium and counterbalance. Lines of blood drip down his body. However, Günther's figure is neither grotesque nor pathetic. On the contrary, Christ seems to resemble fine porcelain.

HML

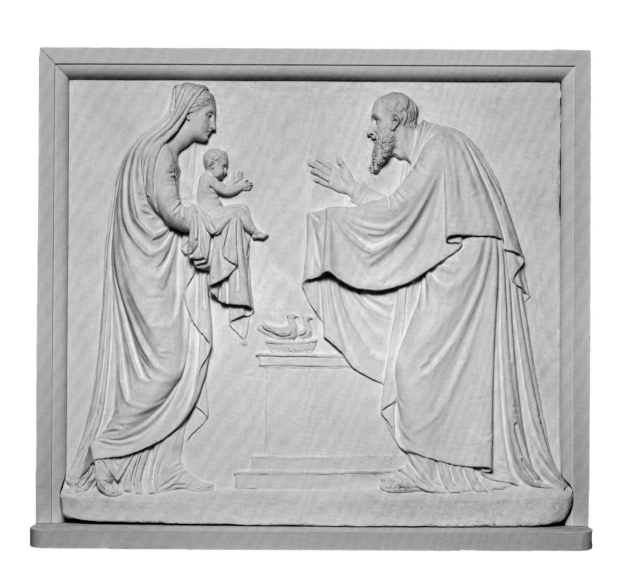

Presentation of the Christ Child in the Temple (1820–1822)

ANTONIO CANOVA (ITALIAN, 1757–1822)

PLASTER | 45¼ × 47¼ IN. (114.9 × 120 CM) | GALLERIE DELL'ACCADEMIA, VENICE

Other than the Nativity and the Adoration of the Magi, scenes from the early life of Christ are less frequently encountered than those from his mature years. Few are recorded in the New Testament, yet among them the presentation of the Christ child in the temple is well known. Here, the holy infant as a firstborn is brought to the temple in Jerusalem by his parents to be consecrated according to Mosaic law. Simultaneously, the event celebrates the purification of his mother, Mary, through the offering of two turtledoves. According to Luke 2:22–38, the Gospel narrative for the event, the Holy Spirit had revealed to a devout man named Simeon that he would not die until he beheld the Messiah. Upon encountering the Holy Family in the temple, he took the Christ child in his arms and proclaimed to God, "Now, Master, you may let your servant go in peace, according to your word, for my eyes have seen your salvation."

Two centuries ago, the Neoclassical master Antonio Canova provided a definitive rendering of this episode in pristine white plaster. An exacting relief sculpture, the image depicts the innocent mother and child at the left directly facing the aged Simeon at the right. With only three figures, a rather minimalist indication of an altar, and the requisite basket of turtledoves, Canova's scene is rather stark. All is shown in strict profile as if in silhouette, like the faces in antique relief sculpture or coinage. Draped in flowing classical attire and devoid of haloes or any overt symbols of saintliness, the figures seem as if they could have been carved in the ancient Greek or Roman world. Even the altar table itself bears no evidence of historical period. Because it's so related to the aesthetics of classical statuary, only knowledge of this precious moment from the early life of Christ reveals it as Christian.

More than imitative and yet fully intoxicated with all things classical, Antonio Canova is the definitive artist of Neoclassicism, a style that flourished in Europe, then America, from the mid-eighteenth century through most of the nineteenth. In fact, in the decades surrounding 1800, Canova was the most famous artist in the Western world. His most iconic work, primarily produced in marble, was governed by a profound understanding of the classical world and was seen as an idealized and romantic reinvention of it. Although he dealt with themes from antiquity, he was highly sought after as a portraitist, especially by Napoleon and his elite, and by the papacy. The *Presentation of the Christ Child in the Temple* is from a series of seven large-scale reliefs based on the opening passages of Genesis and the early life of Christ. Executed during the final years of Canova's long career, each survives in plaster but was originally intended to be carved in marble. They were intended to be placed in relationship to the architecture of a Neoclassical church of his design in his native town of Possagno in northeastern Italy, where he spent his final years, and the church became his mausoleum.

Canova was born in Possagno, the son of a stone-carver and grandson of a local sculptor. He attended the Accademia in Venice before venturing to Rome in 1779, where he immersed himself in the study of antiquity and Renaissance art. The city became his home for most of his mature career. Stylistically, the *Presentation of the Christ Child in the Temple* epitomizes the clarity and form of his work that attracted such high levels of attention. Further, the symmetry of his composition, with Mary and the Christ child perfectly balanced by Simeon within the rectangular picture plane, evidences his reliance on the visual calm that geometry can afford. More than a revelation just to Simeon, this was also a profound moment in the life of Mary, as Luke shares. "Behold, this child is destined to be the rise and fall of many in Israel, and to be a sign that will be contradicted (and you yourself a sword will pierce) so that the thoughts of many hearts may be revealed," the old man shares with the young mother. In the hands of Antonio Canova, this landmark event is captured with lucidity and a sense of timelessness.

JAB

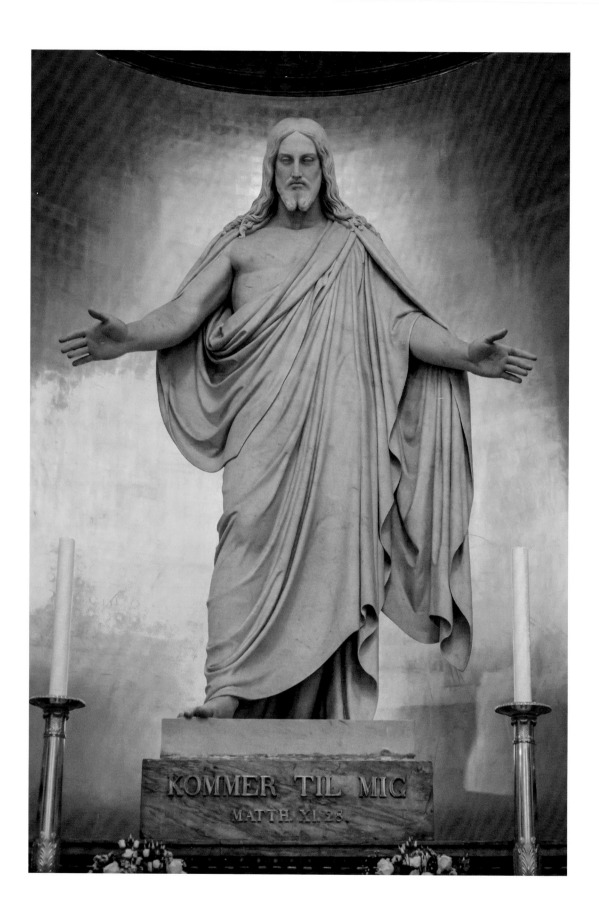

Christus (modeled 1821, completed 1827–1828)

BERTEL THORVALDSEN (DANISH, 1768/1770–1844)

MARBLE | HEIGHT 11.3 FT. (3.5 M) | CHURCH OF OUR LADY, COPENHAGEN

There is little doubt that Bertel Thorvaldsen's emblematic *Christus* is among the most influential Christian images of the nineteenth century. A commanding presence, the pristine white marble sculpture depicts the resurrected Jesus as mature and muscular, his body draped in a flowing shroud cum classical robe. With a slight step forward and arms boldly outstretched, he gazes gently down as if to both welcome and bless the faithful. Thorvaldsen's Christ is distinguished, handsome, heroic, benevolent—and spiritually appealing. The authority of this image was strongly felt across Europe and the United States well into the twentieth century in other versions by the artist and through reproductions, copies, and a multitude of reinterpretations of varying quality. It was conceived at a time of broad religious revival and studied reevaluation of Greek and Roman art, which intersected with Thorvaldsen's personal admiration for the High Renaissance masters.

It is thought that the artist was born to an Icelandic wood-carver in 1770, but another tradition says he was born illegitimately in 1768. Regardless, he became a highly successful student while still a teenager at the Academy of Fine Arts in Copenhagen, where the highest regard was placed on the study and copying of classical art from both ancient Greek and Roman cultures—a widespread European art and aesthetic movement known as Neoclassicism. In 1797 he arrived in Rome, a city that became his home and his muse for much of his adult life. He initially copied and then drew inspiration from the city's vast public and private holdings of antiquities. A decade later, he was viewed as one of the most important sculptors of the era and, with Antonio Canova, one of the luminaries of Neoclassicism at large. Thorvaldsen ran a well-organized workshop whose highly trained assistants allowed him to accept profitable commissions from across Europe.

As a strong physical specimen elegantly draped, Thorvaldsen's *Christus* could easily be seen as a Greek or Roman deity reimagined as the Christian icon. However, a more careful examination shows that the sculpture was equally inspired by the work of High Renaissance masters of the late fifteenth and early sixteenth centuries. In many ways the muscular body type of Christ calls to mind the heroic carved and painted male figures of Michelangelo. The overall symmetry of the forward-facing figure, idealized visage, and emphatic but gentle gestures echo the painted ideals of both Raphael and Leonardo. Thorvaldsen had easy access to the work of Michelangelo and Raphael in Rome, as he did antiquities, while Leonardo's *Last Supper* in Milan was as famous then as it is today. The Danish master, like his High Renaissance forebearers, saw in Greek and Roman sculpture a physical perfection that could be furthered beyond humanity to imply divinity.

For the imposing presence of *Christus*, there is also stillness. More than simply a defined form locked in marble, the artist's Christ figure, heavily reliant on geometry and symmetry, projects a visual stability to be contemplated. With minor exceptions, the left side of Jesus perfectly mirrors the right. In this, Thorvaldsen demonstrates what the ancients, especially the Greeks, understood: reality is based on the study of nature, and the perfect form follows a mathematical precision. Thorvaldsen's *Christus* was created for the classically inspired high altar apse of the rebuilt Copenhagen cathedral, the Church of Our Lady. However, it should be viewed in the larger context of nineteenth-century religious revivals. In the wake of the Napoleonic Wars in Europe and through the vast establishment of immigrant communities in the United States, church buildings with sculpted and painted imagery greatly increased.

The popularity of Thorvaldsen's image in the later nineteenth century and beyond is undeniable, as witnessed by the number of readily available reproductions. Perhaps more significant are the number of high-quality reproductions associated with Latter Day Saints' communities. Thorvaldsen's *Christus* may also have been a source of inspiration for the Sacred Heart images closely associated with Catholic statuary.

JAB

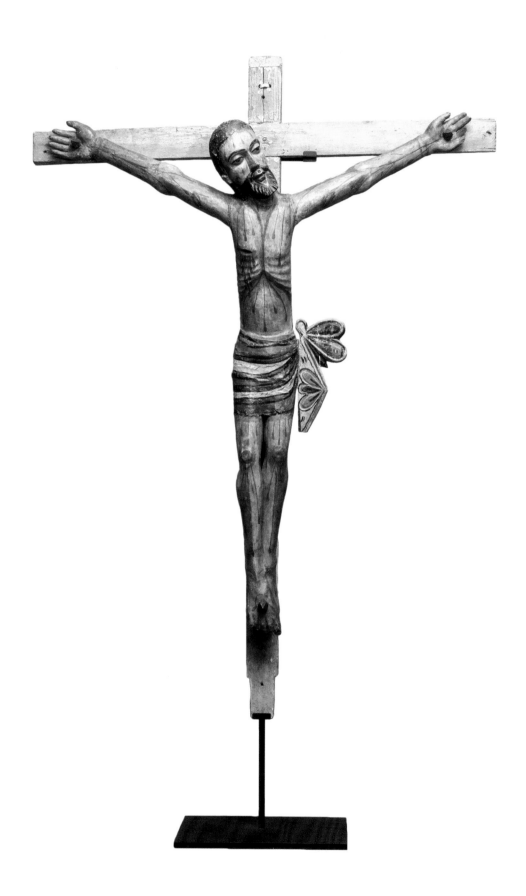

Christ Crucified (ca. 1835)

JOSÉ ARAGÓN (NEW MEXICO, 1796–1850)

WOOD, GESSO, CLOTH, AND PAINT | 53 × 38½ × 9¾ IN. (134.6 × 97.8 × 24.8 CM) | SNITE MUSEUM OF ART, UNIVERSITY OF NOTRE DAME, NOTRE DAME, INDIANA

Santos, or images of Christ and the saints from Mexico or the southwestern United States, are widely known and studied today. Small tabletop pieces were often created for domestic devotion and are more commonly encountered, but large-scale examples, usually for public display, do exist. At more than four feet in height, this finely crafted example of *Christ Crucified* (*Cristo Crucificado*) is grand in scale as well as in spiritual and emotional resonance. The size and stark frontality of the figure suggest that the sculpture may have functioned as a processional object carried during special times in the liturgical calendar, like Holy Week.

Created by José Aragón, the work dates to just prior to the Mexican-American War, to what is considered the classic period of santos sculptures in Mexico and New (Nuevo) Mexico. Although many santeros, or saint-makers, remain unidentified, Aragón is one of the best-known practitioners whose name and reputation have come down to us today. By the 1820s, he and his family were living in the artists' district of Santa Fe and began to accept commissions of both painted wooden panels (*retablos*) and sculptures (*bultos*). He moved throughout the region in the following decade and continued to accept both domestic and public commissions. His reputation was acknowledged throughout the Santa Cruz Valley region and around Taos, where he worked on individual figures and multipart altar screens.

Aragón worked with the native woods of the region, like pine. The wood was initially carved and then covered with layers of gesso, or plaster, and then carved again so that the figures took on a more refined, less rustic appearance. Cloth and leather could be incorporated beneath the gesso to achieve bolder visual effects or applied to the surface to add a heightened degree of realism. *Christ Crucified* is a moving example of the artist's mature style. The elongated body contains dramatic accents like the deeply carved ribs, and the lower torso and legs, in their elegant verticality, seem to merge with the lower portion of the cross.

The bold use of color and the use of painted black lines for dramatic accentuation are two of Aragón's signature elements. They help to visually stimulate the very presence of the Divine before the faithful. However, the most sophisticated details that truly enliven the work are the subtle tilt of the head, the flourishes of the loincloth, and the gestures of the feet and hands. Carved santos tend to be very stiff and rigid, but for experts like Aragón, inventive details like those just mentioned animate the form and provide a more engaging visual experience. Finally, the red paint that indicates blood is judiciously used, referencing Christ's suffering but not in an overly dramatic manner.

As a genre, santos are among the most well-known religious and art historical objects from the Spanish Colonial world. In addition to images of the Virgin of Guadalupe, they speak of powerful visual traditions for Spanish and Indigenous communities in Mexico and New Mexico from the eighteenth and nineteenth centuries. Tradition holds that not only were the santeros skilled sculptors; they were upstanding members of the community as well.

JAB

The Reunion (1926)

ERNST BARLACH (GERMAN, 1870–1938)

BRONZE | HEIGHT 35⅜ IN. (89.9 CM) | ERNST BARLACH HOUSE, HAMBURG, GERMANY

Traditions of wood carving and woodworking in both religious and secular contexts abound in Germany from the Middle Ages onward. However, by the late nineteenth century, rapidly developing technologies for bronze casting and marble carving swept across Europe, quelling the artistic production of, let alone experimentation in, wood. The Expressionist sculptor Ernst Barlach is the most noteworthy and contradictory exception. Trained in sculpture in Hamburg and Dresden, he was influenced early on by academic realism and the sinuousness of Art Nouveau. However, a 1906 trip to Russia transformed his career. He was inspired by the physicality and humble nobility of the peasantry, particularly farmers, which led to a drastic change in his representation of the human figure. Returning home, he began to experiment with carving in wood, taking great delight in the material's inherent roughness and texture. As a sculptor he would work in other materials, but wood would remain his preference.

Made in 1926, *The Reunion* is Barlach's personal reinterpretation of the Doubting Thomas story. Two men are brought together. The standing, bearded, more stoic figure is Christ, and the humbly bent figure gazing up into his face is his formerly skeptical disciple, Thomas. Although touching with extended arms, the two are not conjoined in a deep embrace. Barlach chose to maintain an open space between them. Considering this spatial distance and the facial features, there is a seeming formality, even awkwardness, between the figures. Further, the standard visual elements of this narrative, such as the pierced side of Christ and the stigmatic marks of the Crucifixion, are decidedly absent. This is not the traditional visualization of the New Testament story. Perhaps it is a prefiguration of the Crucifixion, and Christ, with his distant gaze, foresees the event rather than presents evidence of it after the fact. Alternatively, *The Reunion* might serve as a conflation of all the many embraces Christ gave during his lifetime. Despite such uncertainty, the sculpture is a hallmark of

Barlach's sterling reputation among art audiences and his condemnation by Nazi leaders.

Barlach is a leading figure of the art historical movement known as German Expressionism, in which artists depicted forms and utilized materials in exaggerated, often unnaturalistic ways to solicit a greater emotional response from the viewer. As a figurative artist, Barlach used elements of the human form to achieve this goal. In *The Reunion*, for example, the hands and feet are gnarled, as if by the harsh realities of physical labor. The faces, too, are amplified with pronounced features, insinuating strong emotions. In both Christ and Thomas, the area around the eyes, nose, and mouth are boldly articulated to emphasize the solemnity of Jesus in comparison with the longing for connection expressed by his follower. The expressive power of these details is furthered by their play against the relative simplicity of the cloaked bodies. However, it is Barlach's potent carving skills that enable the texture and surface of the wood to contribute to the emotional and psychological tenor of the work. Ironically, wood does not offer the permanence sculptors desire, so the artist selected a few wood originals to be cast into bronze. His initial carving skills were so profound that they translate boldly in bronze.

Although Barlach had achieved widespread art-world acclaim by the 1920s and received numerous commissions, he was held suspect by the Nazis in the 1930s. German Expressionism was deemed distasteful by the Third Reich, who preferred heroic realism in art and appreciated idealized figures engaged in worthy social causes. By the mid-1930s, many of Germany's greatest painters and sculptors were singled out as degenerate and their works confiscated and in many cases destroyed. *The Reunion* was among the artworks taken by the Nazis in 1937 and displayed as a part of the now infamous *Degenerate Art* exhibition that traveled across Germany. The sculpture managed to survive both the exhibition and the war, becoming a standout in the house museum dedicated to Barlach and his career.

JAB

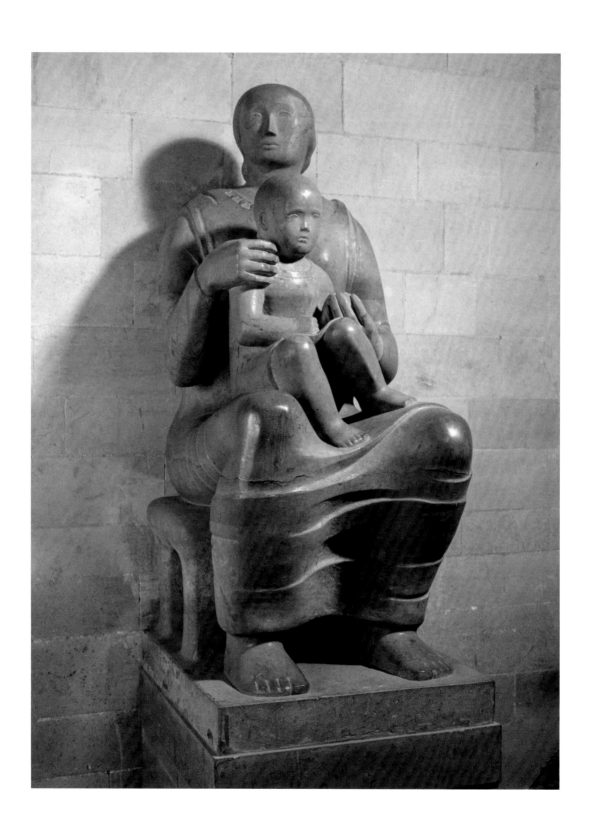

Northampton Madonna and Child (1943–1944)

HENRY MOORE (BRITISH, 1898–1986)

HORTON STONE | HEIGHT 59 IN. (150 CM) | ST. MATTHEW'S CHURCH, NORTHAMPTON, ENGLAND

In redefining the languishing figurative tradition for the modern world, British sculptor Henry Spencer Moore (1898–1986) was one of the most innovative and influential sculptors of the twentieth century. And yet for such progressiveness, he was profoundly interested in the art of the past from both Western and non-Western traditions. Moore was attentive to classical, medieval, and Renaissance sculpture as well as that from African, pre-Columbian, and Inuit cultures, among others. Although Moore was to work through abstraction and nonrepresentational imagery over the course of his long career, he became best known for his figurative sculptures, carved in stone or cast in bronze, that conveyed a sense of universal humanity. Consequently, his work was embraced across Europe, the Americas, and Asia.

The Northampton *Madonna and Child* of 1943–1944 was a site-specific commission for the north transept in the parish church of St. Matthew in Northampton, England. The project was sponsored by the vicar Walter Hussey, who sought to build a bridge between the traditions of the church and modern art. As the subject anticipates, the young Mary embraces her momentarily becalmed child. Despite the organic quality of the sculpture's rounded contours and volumes, and the warm tones of the stone, there is a formality to it. Mary serves as a kind of physical and symbolic chair that both protects and presents the infant Christ. Her posture is decidedly forward, and yet her head turns to the right to observe the faithful who travel the nave toward the church's altar. However, the child faces forward to the altar itself with a clear, unobstructed view of the ritual space. This evidences Moore's concern for the exact placement of the sculpture and the precision of gesture and composition.

Considering the epic dimensions that would define his career, it is interesting to note that Henry Spencer Moore was born the son of a coal miner in rural York-shire, England. His interest in art began early, upon hearing about Michelangelo and examining medieval sculpture. He also attributed his youthful sensitivity to the human form in part to the massages he routinely gave his arthritic mother, with whom he was extremely close. Following World War I, Moore began his sculptural studies in earnest at the Royal College of Art in London and traveled to Italy. However, he was equally drawn to the famed historical and ethnographic collections of the British Museum and the Victoria and Albert Museum. Although firmly a part of a European sculptural tradition stretching back to antiquity, he was drawn to the clarity of forms and simplicity of carving that defines much of non-Western art. As a result, he developed an approach to the figure that, while representational, abstracts the human form in an original way that found favor with the public from the 1940s onward.

Aided by a religious context, the Northampton *Madonna and Child* conveys a formality reminiscent of medieval and Renaissance carving. However, close inspection of the sculpture reveals two pioneering aspects. First, seemingly small details like the position of the child's legs, the mother's clasping of her son's hands, and the simplicity of the stool on which they sit convey a kind of *in*formality suggestive of modern life rather than a regal past. Second, the generalized volumes of the body types and stylized treatment of dress echo the strong but simplified figures frequently encountered in pre-Columbian art, while the facial features of both mother and child echo those seen in Inuit carving. Absent haloes, crowns, and other iconographic elements, this sculpture can be understood as a more universal representation of one of humanity's most precious relationships—a mother and child. However, in the specific context of a church and with a direct relationship to both worshipper and altar, the figures convey the authority and solemnity of the Divine.

JAB

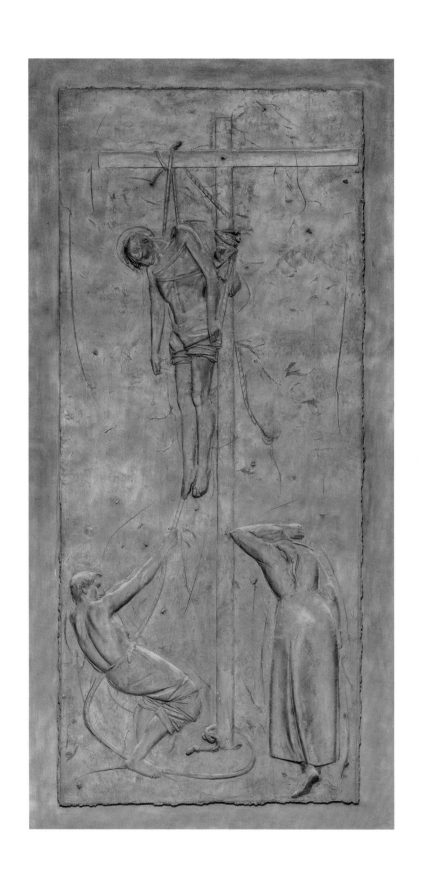

Death of Christ (1947–1964)

GIACOMO MANZÙ (ITALIAN, 1908–1991)

BRONZE | HEIGHT 9.8 FT. (3 M) (PANEL); 25.2 FT. (7.7 M) (OVERALL) | ST. PETER'S BASILICA, VATICAN CITY

Among the most compelling religious works of the twentieth century is the enormous *Doors of Death* for St. Peter's Basilica in the Vatican, created by the Italian master Giacomo Manzù (born Manzoni). Situated at the leftmost portal in the church's narthex (vestibule), the pair of doors leads directly into the church proper and takes its name from the fact that this was the primary exit used for funeral processions. Shortly after the end of World War II, the Vatican hosted a competition for the doors, which Manzù, then gaining critical acclaim in Italy and beyond, handily won. The original subject was to be a more traditional and allegorical one dedicated to the "Triumph of the Saints and Martyrs"; however, Manzù later convinced Pope John XXIII (now Saint Pope John XXIII) that "Doors of Death" would be more appropriate. In the end, the sculptor created one of the most provocative works in the history of Christian art. In relief form, he depicts the deaths of Abel, Saint Joseph, Saint Stephen, Saint Peter, Pope John XXIII, and Pope Gregory VII, among others. However, the largest featured images are oblong presentations of the death of Mary on the left door and the death of Christ on the right.

Although images of and related to the crucifixion and death of Christ abound and may, in fact, be the most populous of all Christian images, Manzù's representation—located in a vertical panel that fills nearly the whole top half of the right door—is unusual. Instead of portraying high drama or chaos, Manzù offers a quiet, sparsely populated scene. Only three figures are shown: a lifeless Christ at the upper center, suspended from a rope wrapped to the beams of the cross; a youthful male worker or servant at the bottom left, pulling on the rope and struggling with the weight of Christ; and a female figure, presumably Mary Magdalene, seen from behind at the bottom right, grievously leaning against the base of the cross. The artist has decided against background detail, and the forms are cast mainly in shallow relief, as with the cross, the rope, and much of the anatomy of the figures themselves, with

some carved slightly higher, such as the upper torso and head of Christ, the shoulder of the young man, and the extended left leg of the Magdalene.

The imagery is legible in situ from a distance below, even amid the bustling of the narthex, yet the compositional simplicity of Manzù's *Death of Christ* can be deceiving. At first glance, the viewer assumes the body of Christ is being lowered from the cross following his death, and therefore this could technically be described in Christian art as the Deposition. The suggested weight of the dangling corpse and protruding rib cage seem to support death by asphyxiation, but close inspection reveals no bodily evidence of limbs nailed or side pierced. One could question the timing, whether it depicts a moment immediately before or immediately after death—an ambiguity shared by most of the other holy figures featured across the *Doors of Death*. This considered, and aided by the simplicity of each scene, Manzù ultimately provides visual meditations on death itself.

Manzù was born to a large impoverished family in Bergamo, Italy. He left school at thirteen and found work with a carpenter, mastering stucco, gilding, and wood carving. Although largely self-taught as an artist, he was drawn to classical sculpture and the work of Michelangelo, and he was largely unaware of current trends in the art world. His focus was almost exclusively the human figure, which he defined in rather minimalist terms. His images, as evidenced in the *Death of Christ*, build up forms soundly but sparingly, and sketch-like details are common. Manzù gained initial fame in Italy during the 1930s, but it was following the Fascist period and World War II that his international reputation increased. He grew close to and became the official portraitist of Pope John XIII, who, although a generation older, also came from impoverished circumstances near Bergamo. Although Manzù won the commission for the *Doors of Death* in 1947, work was largely done in the early 1960s in the ambiance of and immediately following John's pontificate.

JAB

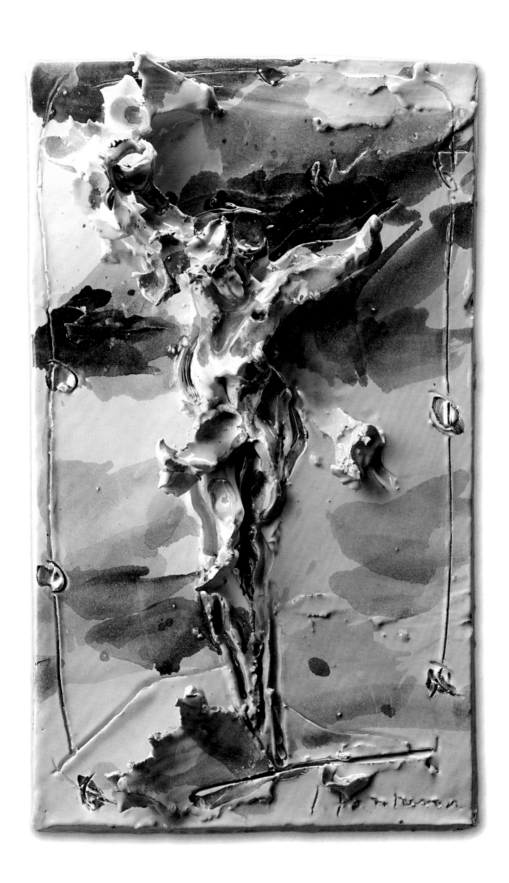

Christk on the Cross (ca. 1955)

LUCIO FONTANA (ITALIAN, 1899–1968)

GLAZED TERRACOTTA | 16¾ × 10¼ × 5 IN. (42.5 × 26 × 12.5 CM) | PRIVATE COLLECTION

Lucio Fontana is among the most influential and productive abstract artists of the mid-twentieth century. Born in Argentina to a family of Italian heritage, he spent most of his career living and working in Italy. Celebrated as a painter, sculptor, and theoretician, he was intimately associated with the avant-garde that flourished in and around postwar Milan. Although he initially worked with his father, who was a sculptor in Argentina, and spent much of the period of World War II there, he is generally considered an Italian artist. Always cutting-edge in his approach to art, he was nevertheless keenly aware of the history of art—especially centuries of tradition in Italy. In recent years his work has been the subject of a renewed focus, and the art market in general has heralded him as one of the leading masters of European abstraction.

Fontana was initially associated with Spatialism in the late 1940s and early 1950s, and he wrote extensively about new art that was made up of matter, color, and sound in motion. In the 1960s he was associated with the group Continuita. In many ways his work and ideas developed parallel to but distinct from those of Abstract Expressionism and its most vigorous exponent, action painting, in which texture and surfaces are extremely significant. As a painter and a sculptor, Fontana was highly experimental, often introducing materials and forms into each discipline that had not yet been considered. In painting, he was willing to affix a wide variety of materials to the surface to break down the traditional boundaries between painting and sculpture. Yet he is perhaps best known for violating the surfaces of his canvases with large slashes that break the uniformity of the picture plane and that have been proposed to recall the wounds of Christ in historical works of art.

Ceramics are integral to Fontana's repertoire and appear at different stages of his growth and development. In keeping with his interest in abstraction, most are nonrepresentational. However, in the 1950s and 1960s he created a highly important series of Crucifixion reliefs intended to be hung on the wall. Most are not measurably large like those intended for public display in a church or chapel, but intimate and personal. There is a decidedly domestic character to this series that calls to mind traditions of popular piety in which even the humblest of homes in Italy and other Catholic cultures feature a crucifix. Together with images of the Virgin Mary, such crucifixes were and still are a visual norm for the faithful and may have been the only works of art a family would have had on domestic display.

Certainly, images of the crucified Christ are central to the history of art, and innumerable examples by Italian masters have been produced over the centuries. Yet the tradition calls for a body of Christ to be featured atop a form of the cross itself. Flesh against wood, animate atop inanimate, is to be expected. However, with Fontana's images of Christ on the cross it is often difficult, if not impossible, to discern the human figure from the cross. Over and again, the artist would manipulate the unfired, highly malleable clay to create cruciform images that pulsate with energy and texture. Forms seem fluid and contours grow thin through the artist's fingers working their way across the surface of the clay. One final gesture is the bold, decorative use of color, which calls to mind the tradition of domestic Italian ceramics.

In Fontana's work, the highly visceral quality of the clay surfaces calls to mind flesh. In this instance, the flesh of Christ on the cross, but mystically the flesh of Christ in the form of the Eucharist as well. In this powerful series, the pierced and battered corpse and the standard of the cross completely merge. Artists— sculptors in particular—have long celebrated the visual and tactile similarities of clay and flesh, but rarely with a view toward transcendence like Fontana. Even more than the inseparable unity of body and cross, Fontana proposes a beauty of substance and form that rise above physical violence and death to become something precious and worthy of careful consideration.

JAB

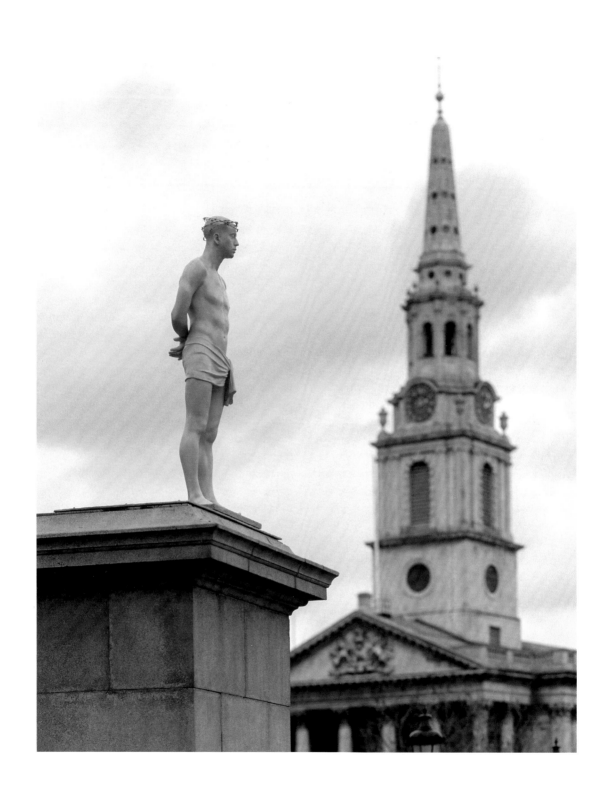

Ecce Homo (1999–2000)

MARK WALLINGER (BRITISH, BORN 1959)

WHITE MARBLEIZED RESIN, GOLD-PLATED BARBED WIRE | LIFE SIZE | INSTALLATION VIEW,
TRAFALGAR SQUARE, LONDON, UK, 1999

Ecce homo! Behold the man! These words of Pontius Pilate, as relayed in John 19:4–6, are among the most stirring in the entirety of the New Testament. Further, they are among the most visually suggestive in biblical tradition. Pilate, then Roman governor over Judea, has found no fault with Jesus, but he presents him, mocked and scourged, to the Jews gathered outside his judgment hall. It is easy to imagine the tortured figure of Christ, stripped and crowned with thorns, standing before the howling masses, alone in his mortal vulnerability. Despite Pilate's findings, public calls for crucifixion ensue, leading to the death of Christ on the cross on the infamous skull-hill, Golgotha. The Ecce homo subject is rare in early Christian and medieval art. From the Renaissance onward, it appears with increasing frequency as part of the narrative of Christ's passion, or as a standalone devotional image in both public and private contexts.

In July 1999, British artist Mark Wallinger unveiled one of the most stirring representations of Jesus in generations. Made of a pristine white marble resin, *Ecce Homo* shows a life-size, modestly athletic man conceivably in his late twenties or early thirties. The degree of realism over idealism suggests the figure was cast from life. Stripped bare save for a simple loincloth, he has his hands bound behind his back, and he stands motionless. His eyes remain closed, his visage surprisingly calm. Only an aggressive crown of barbed wire, a contemporary stand-in for the biblical crown of thorns, violates the suggested physical and psychological still of the moment. Nearly naked, unidealized, bound, and still, the figure appears vulnerable and resigned. Although Wallinger's sculpture has been shown effectively at ground level, its evocative power, even to the most casual of viewers, escalated during its temporary installation in London's Trafalgar Square, one of the most impressive public squares in the world.

Spanning the festivities surrounding the passing of the second millennium into the third, Wallinger's *Ecce Homo* remained atop a massive fourth plinth (pedestal base) in the square until February 2000. This was the first of the now legendary Fourth Plinth project in London, which utilizes an empty platform initially intended to hold a figurative sculpture of a subject from British history; while the other three plinths in the square were realized according to plan, the fourth is now the basis for annual sculpture installations by leading contemporary artists. In his installation, Wallinger accentuated both certain elements of his sculpture and the visual conditions of the site, recontextualizing a biblical event to the modern world. At human scale, *Ecce Homo* seems diminished but not defeated in comparison to the colossal size of the architectural platform. Further, the artist positioned the sculpture near the front edge to great effect in relation to the crowd below. Stark white against the background sky, this new Christ is presented to the jostling masses. The outer, public precincts of Pilate's historical chambers have been seemingly transported to one of the most dynamic public environments of our time.

Wallinger is known primarily as a conceptual and installation artist. Although sculptural projects have been and continue to be an important part of his practice, he is not only a sculptor. Born in Essex and trained at London's equally renowned Chelsea School of Art and Goldsmiths College, he won the coveted Turner Prize in 2007. He is associated with the YBA, or Young British Artists, a diverse but influential collective of artists working in Britain in the late twentieth cum twenty-first centuries. The concepts and forms of his work vary but frequently speak to social and political conditions. More than a strictly religious work of art, *Ecce Homo* addresses timeless themes of suffering, injustice, and man's ongoing inhumanity to man.

JAB

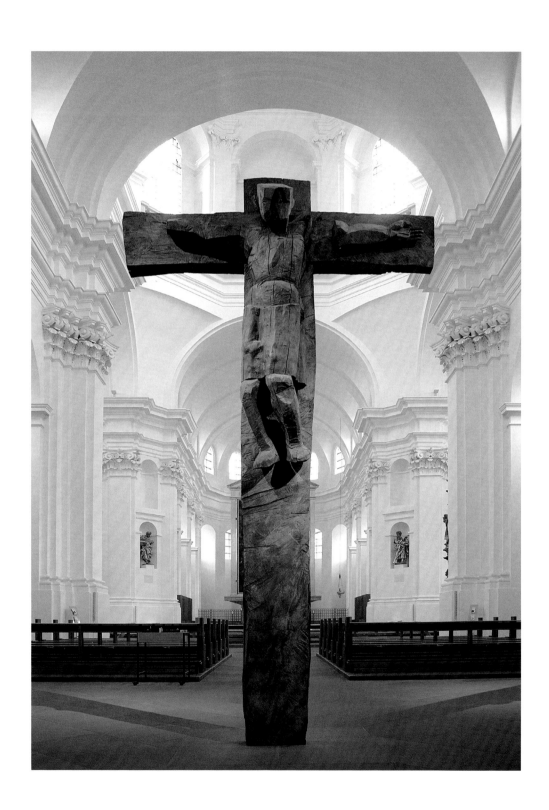

Crucifix (2003)

DIETRICH KLINGE (GERMAN, BORN 1954)

BRONZE | HEIGHT 14.2 FT. (4.3 M) | ST. JOHANNES IN STIFT HAUG, WÜRZBURG, GERMANY

In Germanic and eastern European cultures there is a strong tradition of large-scale, carved images of the crucified Christ featured in church or cathedral environments. Although such sculptures are commonly installed around and above the high altar, they are also frequently encountered in or near the narthex, the vestibule entrance preceding the main worship space. For contemporary sculptor Dietrich Klinge, an understanding of and sensitivity to cultural and artistic tradition has been foundational to his distinguished career. Although overtly Christian imagery is but a percentage of his expansive repertoire, his profound understanding of the past combines with the physicality of his highly innovative artistic process and his abiding effort to distill the human experience.

Klinge was born in Heiligenstadt, just inside the former eastern border of a then divided Germany, to a large extended Roman Catholic family. He and his immediate family emigrated to West Germany in 1958, eventually settling in Stuttgart. In their block housing project, Klinge was exposed to art for the first time, through reproductions in art books; images by Dürer and Rembrandt made a lifelong impression. He initially studied drawing and printmaking at Stuttgart's highly regarded art academy before entering the sculpture program. Although he initially worked in stone, critical acclaim came in the early 1990s with a series of roughly carved wooden sculptures, primarily of heads, which were painstakingly cast in bronze. Throughout the decade he solidified a highly personal approach to sculpture that involved long periods of quiet contemplation on a subject, direct carving in wood through the bold actions of chainsaws, and finally an exacting bronze cast. For the artist, the wood version is a transitional moment, and the work to be considered was the final bronze. Over the course of the next two decades, the scale of his work grew from life-size to monumental.

Although the sculptor's work is found in prominent public and private collections in Europe, Russia, and the United States, *Crucifix* is among Klinge's largest endeavors and one of his few commissioned works. Sited near the opening of the nave in the large, early Baroque church of Stift Haug in Würzburg, the totemic contemporary sculpture stands in poetic contrast to the vast whitewashed walls and layered architectural details of the historic interior. Commissioned in 2003 and installed two years following, the relationship between the sculpture and the church's interior is immediately striking upon entry into the worship space. Bold but reverent, the exacting placement of *Crucifix* at the precise median of the nave (central aisle) allows the apse and side aisles to frame the work in a perfectly symmetrical fashion. Further, the green and umber hues of the sculpture's patina visually resound within the luminous, white interior.

The height of the sculpture and the elevated corpus encourage the viewer to draw close. Marks from the original veining and cracking of wood abound, as do cuts from the chainsaw. The figure itself is not a single object attached to the cross but a series of individually carved and cast elements against intersecting beams. Therefore, there is an element of assemblage to the work, and the disjointed form suggests a body battered and torn. This effect is evident in the downcast head and moving down the central line of the torso, where the twisted stomach is attached to the waist, and in the uneven lower legs. One senses the pain of physical brokenness, but unlike traditional Germanic images of the Crucifixion, which vacillate between the expressive and the grotesque, Klinge's interpretation is remindful but not repelling, equally contemplative and emotional. Herein lies his great contribution to the history of Crucifixion art.

JAB

Untitled (2008)

MIMMO PALADINO (ITALIAN, BORN 1948)

PATINATED IRON | 69 × 83 × 8 IN. (175.3 × 210.8 × 20.3 CM) | PRIVATE COLLECTION

The Italian artist Mimmo Paladino is celebrated globally for his role in the revival of figurative art during the last quarter of the twentieth century. As a young artist, Paladino and his contemporaries were surrounded by an avant-garde in Europe and America that favored abstraction and nonrepresentational imagery over anything focused on the human form. However, as an Italian, he had firsthand exposure to millennia of figurative art spanning the Greco-Roman period, Middle Ages, Renaissance, Baroque era, and Fascist era. Paladino is recognized as a guiding light of the transavantgarde movement in Italy, which, beginning in the late 1970s and 1980s, brought a collective of young painters and sculptors together in search of ways to transcend the avant-garde and reinvigorate the figurative traditions of the past but in new and personally expressive ways. The impact and popularity of their work quickly spread across Italy and Germany to the rest of Europe, the United States, and parts of Asia and continues to the present day.

A truly well-rounded artist, Paladino is best known as a sculptor, although his works as a painter, printmaker, set designer, filmmaker, and installation artist have also merited widespread critical acclaim. The large floor sculpture *Untitled* from 2008 is among the master's most unique and powerful works. An elongated corpus representing the crucified Christ is depicted in rigid cruciform against the open expanse of a floor. Whereas most of Paladino's sculptures are realized in rounded, volumetric terms, this work is thin and flat. In truth, this sculpture is a kind of relief, even though most relief sculptures are viewed upright and are typically attached to walls as part of an architectural scheme. One exception to the significantly more common vertical reliefs is the abundant number of tomb sculptures of clergy and patrons that frequently line the floors of medieval cathedrals in geometric rows, serving as a type of figurative paver the faithful and tourists alike would encounter in Italy and, indeed, across most of western Europe. Although Paladino's sculpture is singular and shown diagonally rather than as part of a geometric framework, the historical implications are intact.

This sculpture contains many iconic elements associated with centuries of imagery of the crucified Christ. Tilted head and outstretched arms immediately register with the viewer, and close inspection also reveals a pronounced cut in the torso where the side of Christ was pierced and more subtle but numerous marks across the surface that suggest lacerations to the flesh from the notorious scourging prior to crucifixion. This considered, Paladino's visual interpretation is far from a historical pastiche and is uniquely his own. The entire figure is realized not as an anatomical study but as a stylized form in keeping with the rest of Paladino's figurative repertoire. The torso is not contorted, nor are the legs overlapping as anticipated; instead, the legs are straightforward counterparts to the arms, with a clear sense of geometry and rigidity. Corpus and cross become nearly interchangeable.

Unexpected symbolic details, like the thorny branch along the left arm and the dagger atop the left leg, suggest but do not illustrate physical pain. The inscribed number "3" could refer to the Trinity or to the number of days from death to resurrection; Paladino has never said. More mysterious still are elements like the small cup atop the cheek, the top hat on the right arm, and the little bird resting on the foot—all flung open to personal interpretation, as is common across the artist's work. Most striking is the dusky gray patina (surface coloration) of the overall sculpture. This combined with the aforementioned flatness and elongation of the figure and its placement across a floor calls to mind the enigmatic presence of cast shadows. In this work Paladino moves beyond the traditional figure of Christ crucified, providing a work of mystery and meditation.

JAB

Ash Jesus (2011)

ZHANG HUAN (CHINESE, BORN 1965)
ASH, STEEL, WOOD | HEIGHT 8.5 FT. (2.6 M) | COLLECTION OF THE ARTIST

This colossal sculpture of Jesus is among the most innovative realizations of the subject in recent memory. A masterwork by the Chinese artist Zhang Huan, it depicts an iconic Western subject through an Eastern lens. The general figure of Christ with head slightly lowered and arms outstretched is based on the central figure in Leonardo da Vinci's *Last Supper* painting from 1498. Arguably the most reproduced and copied image of all time, Leonardo's iconic subject has now been transformed into a massive three-dimensional form made largely of compressed ash over a wood and metal framework, which accounts for the gray, monochromatic palette and the stubbly surface texture. The ash is from burnt incense offerings that the artist and his assistants regularly collect from Buddhist temples and shrines in and around Shanghai.

Like many of the most profound artists of his generation, Zhang is an insightful contributor to the dynamic environment of a truly global contemporary art community. For him, origins and originality, past and present, and frequently, East and West combine to catalyze works that are aesthetically and spiritually engaging. Born in Anyang in Henan province, he showed an interest and ability in art at an early age. He studied art at Henan University and then the Central Academy of Fine Arts in Beijing, where he soon found himself at the center of the city's emerging avant-garde. His early work was largely performative, which continued when he moved to New York in 1998, capturing widespread critical acclaim. In 2005 he visited Tibet and connected deeply with Buddhist traditions and imagery. In the following year the pull of China's history and rapidly evolving culture drew him to Shanghai, where he opened a large studio on the outskirts of the city. A devoted Buddhist, Zhang frequently draws on the imagery and practices of Buddhism to create sculptures and paintings, which he views as more cultural than religious.

Fragmentary images based on Buddhist statuary began to appear in Zhang's repertoire shortly after his return to China, and so did his use of ash. The latter came in response to his astonishment that the fallen ash from burnt incense rods offered by the faithful at temples and shrines was simply gathered and discarded. The artist felt that such material—the remnants of offerings and prayers, abounding in symbolism and meaning—could be meaningfully repurposed. Zhang first used this unique material in sculptural form, either tightly compressed for temporary projects, which would eventually break down, or mixed with a binder for a more permanent form. He also meticulously constructed paintings with carefully selected shades of ash distributed to re-create the tonality of large black-and-white photographs. Although the material is seemingly lush and smooth, the ash mixture is actually quite variegated in texture, containing clumps and partially burnt incense rods.

Ash Jesus was created as part of one of two interrelated series in Zhang's repertoire. The first series revolves around images of the Buddha and fragments of Buddhist imagery. Again, intended more as a cultural rather than religious statement, his re-creations of the Buddha are large-scale, tending toward the colossal—anticipating and parallel to the scale of *Ash Jesus*. In essence, the namesake figure of Christianity, so embedded in Western cultures, is given the same physical scale and respect as the namesake figure of Buddhism, which is prevalent in so many Asian cultures. The second series deals with iconic images from the history of art, like Leonardo's Renaissance masterpiece, *The Last Supper*. For centuries the work has been so endlessly copied, studied, and parodied as to become emblematic of Western culture at large. Aware of his history and heritage as a Chinese artist but participating in a universal conversation through contemporary art, which until very recently was dominated by the West, Zhang Huan's art examines artistic and religious legacies in highly inventive ways that engage the present and future.

JAB

Together (2014)

JAUME PLENSA (SPANISH, BORN 1955)
STAINLESS STEEL | HEIGHT 14 FT. (4.2 M) (HAND) | PRIVATE COLLECTION

Contemporary artists often contemplate and expand upon Christian iconography from across the ages. The most compelling new work may convey the depth of spirit of, and converse gracefully with, historical precedents but emerge from a conceptual framework authentic to the time and place in which it is created. Working out of his studio in Barcelona, Jaume Plensa is among the most poetic and critically acclaimed sculptors working today, with major public and private projects installed in museums, parks, gardens, and city centers across the globe.

Together is the name of both a singular work and a monumental temporary installation inside the majestic sixteenth-century church and adjoining cloister of San Giorgio Maggiore in Venice. Designed by the Renaissance master Andrea Palladio, the church has long been admired for its soaring heights and luminous interior spaces. Engaging both the history and architecture of the site, Plensa created *Together* specifically for the 56th Venice Biennale in 2015—the most highly regarded event in contemporary art.

Plensa is known for his sculptures, installations, set designs, and drawings, but most of all, he is a conceptual artist. Ideas are foundational. His work emerges from a deeply considered understanding of a given topic and is guided by his intuition and insightful command of materials. Frequently but not exclusively, it is through the use of the human figure that Plensa is able to convey his ideas. As a whole or in part, through generalized forms or the specifics of portraiture, the artist uses the body as a vehicle to explore timeless questions and compelling aspects of the human condition. Nationality, age, gender, physical condition, and emotional range may initially appear as important, but ultimately Plensa remains endlessly committed to the universal and inclusive aspects of humanity. In addition, language and literature have been important sources of inspiration for Plensa, as they can unite and elevate as a means of communication, or alternatively, they can separate through a lack of understanding and appreciation.

The centerpiece of *Together* is a colossal stainless steel hand suspended from the ceiling near the high altar. Two fingers are raised in benediction—a gesture of Christ's blessing encountered in Western art from the early Christian and Byzantine periods onward. (Plensa cites Russian icons and Romanesque relief carvings as inspirations.) Building on historical Christian art, the sculpture is immediately noticeable upon entering the church, as it floats with authority above the viewer's head in a site traditionally occupied by sculptures of the crucified Christ in the Middle Ages and Renaissance. However, in *Together*, the hand is not a solid form but a diaphanous carapace formed of letters from eight different world alphabets. The letters merge into a silvery latticework of globalism that shimmers mystically in the light-filled upper register of Palladio's church. Although the disembodied form references Christian iconography, the melding of alphabets and, by extension, languages and cultures speaks to unity, universality.

Originally for Plensa, *Together* referenced the hand alone as a singular sculpture, but eventually the title also came to stand for the overall installation at San Giorgio Maggiore. In the main church the artist then placed a large head in the nave (main aisle), just inside the front doors. This colossus, too, is a carapace, but in stainless rod. Facing toward the altar, it joins in a narrative with the suspended hand sculpture. Notions of earthly and heavenly realms, the mortal and divine, and even mystical encounter are available to even the most casual of viewers. Ideas of individuality were then encountered in a series of carved portrait heads presented in the neighboring cloister. Following the temporary installation, the individual pieces were dispersed, and *Together* once again resumed its role as a singular sculpture. Although it clearly calls upon art historical representations of Christ and appeals to Christian audiences, it also unfolds more widely as a message of divine blessing and grace that embraces all of humanity.

JAB

Reference Catalog

1. *The Good Shepherd (ca. 280–90 CE)* 19
 Unrecorded artist (Eastern Mediterranean, likely Phrygia)
 Cleveland Museum of Art, Cleveland, Ohio | John L. Severence Fund 1965.241

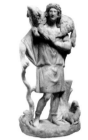

Spier, Jeffrey, ed. *Picturing the Bible: The Earliest Christian Art.* New Haven, CT:
 Yale University Press, 2007. Exhibition catalog. Pages 190–91.
Weitzmann, Kurt, ed. *The Age of Spirituality: Late Antique and Early Christian
 Art.* New York: Metropolitan Museum of Art, 1977. Exhibition catalog. Pages
 406–11.
Wixom, William. "Early Christian Sculpture at Cleveland." *Bulletin of the Cleve-
 land Museum of Art* 54, no. 3 (March 1967): 67–88.

2. *Sarcophagus of Junius Bassus (359 CE)* 21
 Unrecorded artist (Rome)
 Treasury of St. Peter's Basilica, Vatican City | Scala / Art Resource, NY

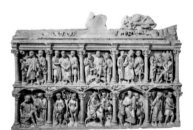

Christ, Alice. *The Sarcophagus of Junius Bassus: Patrons, Workshop, and Program.*
 3 vols. PhD diss., University of Chicago, 1992.
Malbon, Elizabeth Struthers. *The Iconography of the Sarcophagus of Junius Bassus.*
 Princeton, NJ: Princeton University Press, 1990.
Murray, Sister Mary Charles. *Rebirth and Afterlife: A Study of the Transmutation
 of Some Pagan Imagery in Early Christian Funerary Art.* Oxford: British Ar-
 chaeological Reports, 1981.

3. *Gero Crucifix (ca. 970)* 23
 Unrecorded artist (Cologne)
 Kölner Dom, Cologne | photo: Matz and Schenk

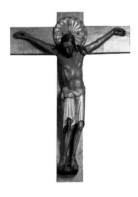

Diebold, William. *Word and Image: An Introduction to Early Medieval Art.* Boul-
 der, CO: Westview Press, 2000.
Fisher, Annika E. "Cross Altar and Crucifix in Ottonian Cologne—Past Narra-
 tive, Present Ritual, and Future Resurrection." In *Decorating the Lord's Table:
 On the Dynamics between Image and Altar in the Middle* Ages, edited by
 Søren Kaspersen and Erik Thunø, 43–62. Copenhagen: Museum Tuscula-
 num Press, 2006.
Fozi, Shirin, and Gerhard Lutz, eds. *Christ on the Cross: The Boston Crucifix and
 the Rise of Monumental Wood Sculpture, 970–1200.* Turnhout, Belgium: Bre-
 pols, 2020.

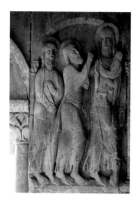

4. *Christ on the Road to Emmaus (ca. 1100)* 25
 Unrecorded artist (Castile, Spain)
 Santo Domingo de Silos, Spain | Bridgeman-Giraudon / Art Resource, NY

 Gerson, Paula, Annie Shaver-Crandell, Alison Stones, and Jeanne Krochalis. *The Pilgrim's Guide to Santiago de Compostela: A Critical Edition.* 2 vols. London: Harvey Miller, 1998.
 Schapiro, Meyer. "From Mozarabic to Romanesque in Silos." *Art Bulletin* 21 (1939): 313–74.
 Valdez del Álamo, Elizabeth. *Palace of the Mind: The Cloister of Silos and Spanish Sculpture of the Twelfth Century.* Turnhout, Belgium: Brepols, 2012.

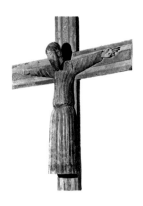

5. *Last Judgment (ca. 1130–40)* 27
 Unrecorded artist (Burgundy)
 Saint-Lazare, Autun, France | Scala / Art Resource, NY

 Denny, Don. "The Last Judgment Tympanum at Autun: Its Sources and Meaning." *Speculum* 57 (1982): 532–47.
 Sauerländer, Willibald. "Über die Komposition des Weltgerichts-Tympanons in Autun." *Zeitschrift für Kunstgeschichte* 29 (1966): 261–94.
 Seidel, Linda. *Legends in Limestone: Lazarus, Gislebertus, and the Cathedral of Autun.* Chicago: University of Chicago Press, 1999.

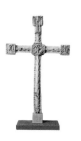

6. *Batlló Crucifix (ca. 1150)* 29
 Unrecorded artist (Girona, Catalonia)
 Museu Nacional d'Art Catalunya, Barcelona | Gift of Enric Batlló, 1914 |
 Album / Art Resource, NY

 Camps i Sòria, Jordi. "Majestat Batlló." In *Prefiguración del Museu Nacional d'Art de Catalunya*, 154–56. Barcelona: Lunwerg Editores, 1992.
 Mann, Janice. "Majestat Batlló." In *The Art of Medieval Spain, 500–1200*, edited by Jerrilyn L. Dodds, 322–24. New York: Metropolitan Museum of Art, 1993.

7. *The Cloisters Cross (ca. 1150–60)* 31
 Unrecorded artist (England)
 The Metropolitan Museum of Art, New York |
 The Cloisters Collection, 1963; 63.12

 Hoving, Thomas. "The Bury St. Edmunds Cross." *Metropolitan Museum of Art Bulletin* 22 (1964): 316–40.
 Nilgen, Ursula. "Das große Walroßbeinkruz in den 'Cloisters.'" *Zeitschrift für Kunstgeschichte* 48 (1985): 39–64.
 Parker, Elizabeth C., and Charles T. Little. *The Cloisters Cross: Its Art and Meaning.* New York: Metropolitan Museum of Art, 1994.
 Rowe, Nina. "Other." *Studies in Iconography* 33 (2012): 131–44.

8. *The Virgin and Child in Majesty (ca. 1175–1200)* 33
 Unrecorded artist (Auvergne, France)
 The Metropolitan Museum of Art, New York | The Cloisters Collection |
 gift of J. Pierpont Morgan | Art Resource, NY

 Forsyth, Ilene. "Magi and Majesty: A Study of Romanesque Sculpture and Litur-
 gical Drama." *Art Bulletin* 50 (1968): 215–22.
 ———. *The Throne of Wisdom: Wood Sculptures of the Madonna in Romanesque
 France.* Princeton, NJ: Princeton University Press, 1972.

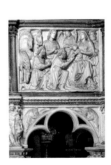

9. *Beau Dieu (ca. 1230–35)* 35
 Unrecorded artist (French)
 Trumeau of the central portal, west facade, Amiens Cathedral, Amiens, France |
 Godong / Alamy Stock Photo

 Murray, Stephen. *Notre-Dame, Cathedral of Amiens: The Power of Change in
 Gothic.* Cambridge: Cambridge University Press, 1996.
 Sauerländer, Willibald. *Gothic Sculpture in France: 1140–1270.* Translated by Janet
 Sondheimer. London: Thames & Hudson, 1972. (Originally published as
 Gotische Skulptur in Frankreich 1140–1270. Munich: Hirmer, 1970.) Pages
 460–66.
 Williamson, Paul. *Gothic Sculpture, 1140–1300.* New Haven, CT: Yale University
 Press, 1995. Pages 141–45.

10. *Crucifixion (ca. 1255)* 37
 Unrecorded artist (Saxony-Anhalt, Germany)
 Choir screen, Naumburg Cathedral, Naumburg, Germany |
 Scala / Art Resource, NY

 Jung, Jacqueline. *The Gothic Screen: Space, Sculpture, and Community in the
 Cathedrals of France and Germany, ca. 1200–1400.* Cambridge: Cambridge
 University Press, 2013.
 Williamson, Paul. *Gothic Sculpture, 1140–1300.* New Haven, CT: Yale University
 Press, 1995. Pages 181–84.

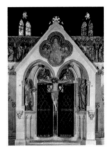

11. *Adoration of the Magi, from the Pisa Pulpit (1260)* 39
 Nicola Pisano (Italian, active 1258–1278)
 Pulpit relief, Cathedral Baptistery, Pisa, Italy | Scala / Art Resource, NY

 Bradshaw, Marilyn. *Italian Renaissance Art: A Sourcebook.* Upper Saddle River,
 NJ: Pearson, 2009.
 Cristiani, Maria Laura Testi. *Nicola Pisano: Architetto-Scultore.* Pisa, Italy: Pacini
 Editore, 1987.
 Pope-Hennessy, John. *Italian Renaissance Sculpture.* London: Phaidon, 1959.

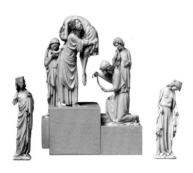

12. *Deposition from the Cross (ca. 1260–80)* 41
 Unrecorded artist (Paris)
 Musée du Louvre, Paris | dist. RMN-Grand Palais / (Philippe Fuzeau) /
 Art Resource, NY

Antoine-König, Élisabeth, and Juliette Levy-Hinstin, *La Descente de Croix au Musée du Louvre*. Paris: Louvre, 2013.

Barrett, Peter, ed. *Images in Ivory: Precious Objects of the Gothic Age*. Detroit: Detroit Institute of Arts, 1997. Exhibition catalog. Pages 138–40.

Gaborit-Chopin, Danielle. "Nicodème travesti: La *Descente de Croix* d'ivoire du Louvre." *Revue de l'art* 81 (1988): 31–44.

Williamson, Paul. *Gothic Sculpture, 1140–1300*. New Haven, CT: Yale University Press, 1995. Page 150.

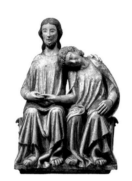

13. *Christ with the Sleeping John (ca. 1300–1320)* 43
 Unrecorded artist (Swabia, Germany)
 Cleveland Museum of Art, Cleveland, Ohio |
 purchase from the J. H. Wade Fund 1928.753

Hamburger, Jeffrey. *Nuns as Artists: The Visual Culture of a Medieval Convent*. Berkeley: University of California Press, 1997. Pages 160–63.

Haussherr, Reiner. "Über die Christus-Johannes-Gruppen: Zur Problem *Andachtsbilder* und deutsche Mystik." In *Beiträge zue Kunst des Mittelalters. Festschrift für Hans Wentzel zum 60. Geburtstag*, edited by Rüdiger Becksmann et al., 79–103. Berlin: Mann, 1975.

Jirousek, Carolyn. "Christ and St. John the Evangelist as a Model of Medieval Mysticism." *Cleveland Studies in the History of Art* 6 (2001): 6–27.

Wentzel, Hans. *Die Christus-Johannes-Gruppen des XIV. Jahrhunderts*. Stuttgart: Reclam, 1960.

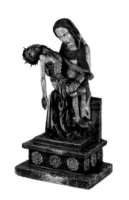

14. *Röttgen Madonna (ca. 1330–1360)* 45
 Unrecorded artist (Middle Rhineland, Germany)
 Rheinisches Landesmuseum Bonn, Bonn, Germany | Bachstraße 9, 53115 Bonn

Krönig, Wolfgang. *Rheinische Vesperbilder*. Mönchengladbach, Germany: Kuhlen, 1967.

Ziegler, Joanna. *Sculptures of Compassion: The Pietà and the Beguines in the Southern Low Countries, ca. 1300–1600*. Brussels: Peeters, 1992.

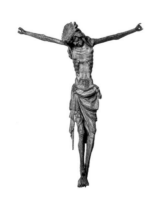

15. *Crucified Christ (ca. 1340–1350)* 47
 Unrecorded artist (Middle Rhineland)
 Cleveland Museum of Art, Cleveland, Ohio | Andrew R. and Martha Holden
 Jennings Fund 1981.52

De Winter, Patrick. "A Middle-Rhenish 'Crucifixus Dolorosus' of the Late Fourteenth Century." *Bulletin of the Cleveland Museum of Art* 69 (1982): 224–35.

Mühlberg, Fried. "Crucifixus dolorosus: Über Bedeutung und Herkunft des gotischen Gabelkruzifixes." *Wallruf-Richartz-Jahrbuch* 22 (1960): 69–86.

16. *Christ on a Donkey (15th cent.)* 49
 Unrecorded artist (Upper Franconia, Germany)
 The Metropolitan Museum of Art, New York |
 The Cloisters Collection, 1955; 55.24

 Lipsmeyer, Elizabeth. "Devotion and Decorum: Intention and Quality in Me-
 dieval German Sculpture." *Gesta* 34 (1995): 20–27.
 Ostoia, Vera K. "A Palmesel at the Cloisters." *Metropolitan Museum of Art Bul-
 letin* 14 (1956): 170–73.

17. *Crucifix (1444–1449)* 51
 Donatello (Italian, 1386–1466)
 Il Santo (Basilica di Sant'Antonio), Padua, Italy | Scala / Art Resource, NY

 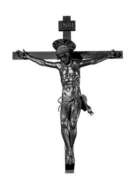

 Hartt, Frederick. *Donatello, Prophet of Modern Vision.* New York: Abrams, 1973.
 Janson, H. W. *The Sculpture of Donatello.* 2 vols. Princeton, NJ: Princeton Uni-
 versity Press, 1957.
 Pope-Hennessy, John. *Donatello.* New York: Abbeville Press, 1993.

18. *The Christ Child (ca. 1460)* 53
 Desiderio da Settignano (Italian, ca. 1429–1464)
 National Gallery of Art, Washington, DC | Samuel H. Kress Collection

 Coonin, Arnold Victor. "Portrait Busts of Children in Quattrocento Florence."
 Metropolitan Museum Journal 30 (1995): 61–71.
 Smyth, Francis, ed. *Sculpture: An Illustrated Catalogue.* Washington, DC: Na-
 tional Gallery of Art, 1994.
 Walker, John. *National Gallery of Art, Washington.* New York: Abrams, 1984.

19. *Christ and Saint Thomas (1467–1483)* 55
 Andrea del Verrocchio (Italian, 1435–1488)
 Orsanmichele, Florence, Italy | Scala / Art Resource, NY

 Butterfield, Andrew. *The Sculptures of Andrea del Verrocchio.* New Haven, CT:
 Yale University Press, 1997.
 Covi, Dario. *Andrea del Verrocchio: Life and Work.* Florence: L. S. Olschki, 2005.
 Pope-Hennessy, John. *Italian Renaissance Sculpture.* London: Phaidon, 1959.

20. *Madonna and Child (ca. 1475)* 57
 Benedetto da Maiano (Italian, 1442–1497)
 National Gallery of Art, Washington, DC | Samuel H. Kress Collection

 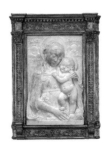

 Doris, Carl. *Benedetto da Maiano. A Florentine Sculptor at the Threshold of the
 High Renaissance.* 2 vols. Turnhout, Belgium: Brepols, 2006.
 Poeschke, Joachim. *Donatello and His World: Sculpture of the Italian Renaissance.*
 New York: Abrams, 1993.
 Smyth, Francis, ed. *Sculpture: An Illustrated Catalogue.* Washington, DC: Na-
 tional Gallery of Art, 1994.

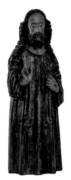

21. *Ascending Christ (1476)* 59
 Master Arnt of Kalkar and Zwolle (active ca. 1460–1491)
 Museum Kurhaus Kleve, Cleves, Germany | Ewald Mataré-Collection |
 photo by Annegret Gossens, Cleves

 Koch, Robert. "A Gothic Sculpture of the Ascending Christ." *Record of the Art
 Museum, Princeton University* 19 (1960): 37–43.
 Wert, Guido de, ed. *Heilige aus Holz—Niederrheinische Skulpturen des später
 Mittelalters*. Cleves, Germany: Museum Kurhaus Kleve, 1998. Exhibition
 catalog. Pages 12–18, 54–58.

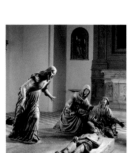

22. *Lamentation over the Dead Christ (1492)* 61
 Guido Mazzoni (Italian, 1445–1518)
 Sant'Anna dei Lombardi, Naples | Scala / Art Resource, NY

 Cole, Alison. *Art of the Italian Renaissance Courts*. Upper Saddle River, NJ: Pear-
 son / Prentice Hall, 1995.
 Lugli, Adalgisa. *Guido Mazzoni e la rinascita della terracotta del quattrocento*.
 Modena, Italy: U. Allemandi, 1991.
 Verdon, Timothy. *The Art of Guido Mazzoni*. New York: Garland Publications,
 1978.

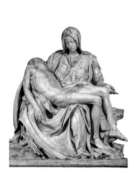

23. *Pietà (1498–1499)* 63
 Michelangelo Buonarroti (Italian, 1475–1564)
 St. Peter's Basilica, Vatican City | Peter Barritt / Alamy Stock Photo

 Hartt, Frederick. *Michelangelo: The Complete Sculpture*. London: Thames &
 Hudson, 1969.
 Pope-Hennessy, John. *Italian Renaissance Sculpture*. London: Phaidon, 1959.
 Zöllner, Frank, Christof Thoenes, and Thomas Pöpper. *Michelangelo: Complete
 Works*. Cologne: Taschen, 2014.

24. *Schreyer-Landauer Funerary Monument (1499–1505)* 65
 Adam Kraft (German, ca. 1460–1509)
 Sebalduskirche, Nuremberg, Germany | detail: Grablegung Christi

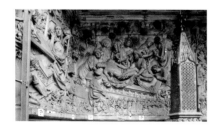

 Baxandall, Michael. *The Limewood Sculptors of Renaissance Germany*. New Ha-
 ven, CT: Yale University Press, 1980. Page 288.
 Kahsnitz, Rainer. "Sculpture in Stone, Terracotta, and Wood." In *Gothic and
 Renaissance Art in Nuremberg, 1300–1550*, edited by Ellen Schultz, 61–74.
 New York: Metropolitan Museum of Art, 1986. Exhibition catalog.
 Schleif, Corrine. "Nicodemus and Sculptors: Self-Reflexivity in the Work of
 Adam Kraft and Tilman Riemenschneider." *Art Bulletin* 75 (1993): 599–626.
 Schwemmer, Wilhelm. *Adam Kraft*. Nuremberg: Verlag Hans Carl, 1958.
 Weilandt, Gerhard. *Die Sebalduskirche in Nürnberg: Bild und Gesellschaft im Zeit-
 alter der Gotik und Renaissance*. Petersberg, Hesse, Germany: Imhof, 2007.

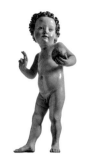

Baxandall, Michael. *The Limewood Sculptors of Renaissance Germany*. New Haven, CT: Yale University Press, 1980. Pages 127–35.

Os, Henk van, ed. *The Art of Devotion 1300–1500*. Amsterdam: Rijksmuseum, 1994. Exhibition catalog. Pages 100–101.

Scholten, Frits, ed. *Small Wonders: Late Gothic Boxwood Microcarvings from the Low Countries*. Amsterdam: Rijksmuseum, 2016. Exhibition catalog.

Scholten, Frits, and Reindert Falkenburg, eds. *A Sense of Heaven: 16th-Century Boxwood Carvings for Private Devotion*. Leeds, England: Henry Moore Institute, 1999. Exhibition catalog.

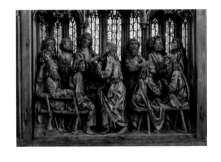

Baxandall, Michael. *The Limewood Sculptors of Renaissance Germany*. New Haven, CT: Yale University Press, 1980. Pages 172–90.

Boivin, Katherine. *Riemenschneider in Rothenburg: Sacred Space and Civic Identity in the Late Medieval City*. University Park: Pennsylvania State University Press, 2021.

Chapuis, Julien, ed. *Tilman Riemenschneider: Master Sculptor of the Late Middle Ages*. Washington, DC: National Gallery of Art, 1999. Exhibition catalog.

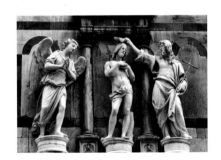

Huntley, George Haydn. *Andrea Sansovino, Sculptor and Architect of the Italian Renaissance*. Westport, CT: Greenwood Press, 1971.

Pope-Hennessy, John. *Italian Renaissance Sculpture*. London: Phaidon, 1959.

Radcliffe, Anthony, and Nicholas Penny. *Art of the Renaissance Bronze*. London: Phillip Wilson, 2004.

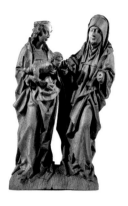

29. *Anna-te-Drieën (ca. 1520)* 75

Master of Elsloo (Dutch, active 1510–1530)

Rijksmuseum, Amsterdam

Nixon, Virginia. *Mary's Mother: Saint Anne in Late Medieval Europe.* University Park: Pennsylvania State University Press, 2004.

Os, Hank van, et al. *Netherlandish Art in the Rijksmuseum.* Zwolle: Waanders, 2000. Pages 98–99.

Peters, Famke, and Christina Ceulemans, eds. *A Masterly Hand: Interdisciplinary Research on the Late-Medieval Sculptor(s) Master of Elsloo in an International Perspective.* Turnhout, Belgium: Brepols, 2014.

Timmer, Jan Joseph Marie. "Een onbekend beeldsnijder der 16e eeuw: De Meester van Elsloo." *Oud Holland* 57 (1940): 75–78.

30. *Altarpiece of the Seven Sorrows of the Virgin (1518–1524)* 77

Henrik Douwerman (German, ca. 1480–1543)

Nicolaikirche, Kalkar, Germany | ART Collection / Alamy Stock Photo | detail: Bildarchiv Monheim GmbH / Alamy Stock Photo

Jacobs, Lynn F. *Early Netherlandish Carved Altarpieces, 1380–1550: Medieval Tastes and Mass Marketing.* Cambridge: Cambridge University Press, 1998.

Rommé, Barbara. *Heinrich Douwerman und die niederrheinische Bildschnitzkunst an der Wende zur Neuzeit.* Bielefeld, Germany: Verlag für Regionalgeschichte, 1997.

Schuler, Carol. "The Seven Sorrows of the Virgin: Popular Culture and Cultic Imagery in Pre-Reformation Europe." *Simiolus* 16 (1986): 5–28.

Werd, Guido de. *Die St. Nicolaikirche zu Kalkar.* Munich: Deutscher Kunstverlag, 1986.

31. *Christ on the Cold Stone (also known as Christ in Distress) (ca. 1525)* 79

Hans Leinberger (German, ca. 1475–1531)

Staatliche Museen zu Berlin, Berlin | bpk Bildagentur / Skulpturensammlung und Museum für Byzantische Kunst / Antje Voigt / Art Resource, NY

Baxandall, Michael. *The Limewood Sculptors of Renaissance Germany.* New Haven, CT: Yale University Press, 1980. Pages 202–16.

Smith, Jeffrey Chipps. *German Sculpture of the Later Renaissance, c. 1520–1580: Art in an Age of Uncertainty.* Princeton, NJ: Princeton University Press, 1994. Pages 53–54.

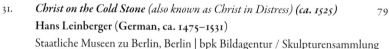

32. *Christ and the Canaanite Woman (1543)* 81
 Hans Vischer (German, ca. 1489–1550)
 Bayerisches Nationalmuseum, Munich | Inv.-Nr. R 555, Photo Nr. D82977 |
 photo: Dr. Matthias Weniger

Smith, Jeffrey Chipps. *German Sculpture of the Later Renaissance, c. 1520–1580:
 Art in an Age of Uncertainty*. Princeton, NJ: Princeton University Press, 1994.
 Pages 181–84.
Wixom, William. "The Art of Nuremberg Brass Work." In *Gothic and Renais-
 sance Art in Nuremberg, 1300–1550*, edited by Ellen Schultz. New York: Met-
 ropolitan Museum of Art, 1986. Exhibition catalog. Pages 75–80.

33. *Resurrection (1572)* 83
 Germain Pilon (French, 1525–1590)
 Musée du Louvre, Paris | Peter Horree / Alamy Stock Photo

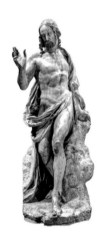

Béguin, Sylvie. "Le Primatice et Pilon." In *Germain Pilon et les sculpteurs français
 de la Renaissance: actes du colloque organisé au Musée du Louvre par le service
 culturel, les 26 et 27 octobre 1990*, edited by Geneviève Bresc-Bautier. Paris:
 Documentation française, 1993.
Blunt, Anthony. *Art and Architecture in France, 1500–1700*. 5th rev. ed. New Ha-
 ven, CT: Yale University Press, 1999.

34. *Crucifix (ca. 1600–1800)* 85
 Unrecorded artist (Kongo)
 Snite Museum of Art, University of Notre Dame, Notre Dame, Indiana | gift of
 Mr. Raymond E. Britt Jr., 1980.013.012

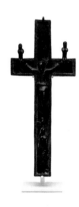

Blier, Suzanne. *The Royal Arts of Africa: The Majesty of Form*. Upper Saddle River,
 NJ: Prentice Hall, 1998.
Bradley, Douglas. *Christian Imagery in African Art: The Britt Family Collection*.
 Notre Dame, IN: Snite Museum of Art, 1980.
Fromont, Cécile. *The Art of Conversion: Christian Visual Culture in the Kingdom
 of Kongo*. Chapel Hill: University of North Carolina Press, 2014.
Morton, Elizabeth Gron. *Dimensions of Power*. Notre Dame, IN: Snite Museum
 of Art, 2018.
Thompson, Robert Farris, and Joseph Cornet. *Four Moments of the Sun: Kongo
 Art in Two Worlds*. Washington, DC: National Gallery of Art, 1981.
Thornton, John. "Afro-Christian Syncretism in the Kingdom of Kongo." *Journal
 of African History* 54 (2013): 53–77.

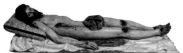

35. *Dead Christ (ca. 1625–1630)* 87
Gregorio Fernández (Spanish, 1576–1636)
S. Martin, Valladolid, Spain | Scala / Art Resource, NY

Bray, Xavier, ed. *The Sacred Made Real: Spanish Painting and Sculpture, 1600–1700*. New Haven, CT: Yale University Press, 2009.
Gómez Moreno, María Elena. *Gregorio Fernandez*. Madrid: Instituto Diego Velázquez, del Consejo Superior de Investigaciónes Científicas, 1953.
Martín González, J. J. *El escultor Gregorio Fernandez*. Madrid: Ministerio de Cultura, Dirección General del Patrimonio Artistico, Archivos y Museos, Patronato Nacional de Museos, 1980.

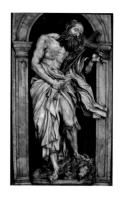

36. *Saint Jerome with Crucifix (1661–1663)* 89
Gian Lorenzo Bernini (Italian, 1598–1680)
Chigi Chapel, Cathedral of Siena, Italy | Opera della Metropolitana, Aut. No. 413 / 2020

Avery, Charles. *Bernini: Genius of the Baroque*. Boston: Bulfinch Press, 1997.
Pope-Hennessy, John. *Italian Renaissance Sculpture*. London: Phaidon, 1959.
Wittkower, Rudolf. *Bernini: The Sculptor of the Roman Baroque*. London: Phaidon, 1997.

37. *Ecce Homo and Mater Dolorosa (1674–1685)* 91
Pedro da Mena (Spanish, 1628–1688)
The Metropolitan Museum of Art, New York | purchase, Lila Acheson Wallace gift, Mary Trumbell Adams Fund, and gift of Dr. Mortimer D. Sackler, Theresa Sackler and family, 2014 | Christ: 2014.275.1 | Mary: 2014.275.2

Anderson, Janet A. *Pedro de Mena: Seventeenth-Century Spanish Sculptor*. Lewiston, NY: Edwin Mellen Press, 1998.
Bray, Xavier, ed. *The Sacred Made Real: Spanish Painting and Sculpture, 1600–1700*. New Haven, CT: Yale University Press, 2009.
Medina, Lazaro Gila. *Pedro de Mena: Escultor, 1628–1688*. Madrid: Arco Libros, 2007.

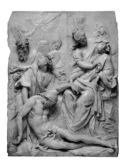

38. *The Virgin Mary Swooning over the Dead Body of Christ at the Foot of the Cross (1710)* 93
Pierre-Étienne Monnot (French, 1657–1733)
National Gallery of Art, Washington, DC

Haskell, Francis, and Nicholas Penny. *Taste and the Antique: The Lure of Classical Sculpture, 1500–1900*. New Haven, CT: Yale University Press, 1982.
Penny, Nicholas. "Pierre-Etienne Monot, *The Virgin Mary Swooning over the Body of Christ at the Foot of the Christ*." *National Gallery of Art Bulletin*, no. 32 (Fall 2004): 21–22.
Wittkower, Rudolf. *Art and Architecture in Rome: 1600–1700*. 6th rev. ed. 2 vols. New Haven, CT: Yale University Press, 1999.

39. *Veiled Christ (1753)* 95
Giuseppe Sanmartino (Italian, 1720–1793)
Museo Cappella Sansevero, Naples | akg-images / De Agostini Picture Lib. /
A. Dagli Orti

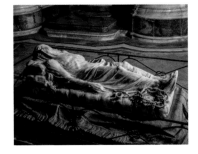

Catello, Elio. *Giuseppe Sanmartino (1720–1793)*. Naples: Electa, 2004.
———. *Giuseppe Sanmartino (Bibloteca di storia, arte e ambiente)*. Naples: Sergio
Civita Editore, 1988.
Macci, Fazio. *Museo Capella Sansevero*. Naples: Museo Capella Sansevero, 2006.

40. *Christ at the Column (1754)* 97
Franz Ignaz Günther (German, 1725–1775)
Detroit Institute of Arts, Detroit, Michigan | Founders Society purchase,
Acquisitions Fund, 1983.13

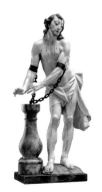

Harries, Karsten. *The Bavarian Rococo Church: Between Faith and Aestheticism*.
New Haven, CT: Yale University Press, 1983.
Hertel, Christiane. *Pygmalion in Bavaria: The Sculptor Ignaz Günther and
Eighteenth-Century Aesthetic Art Theory*. University Park: Pennsylvania State
University Press, 2011.
Volk, Peter. "Franz Ignaz Günther's 'Christ at the Column.'" *Bulletin of the Detroit
Institute of Arts* 63 (1988): 4–13.

41. *Presentation of the Christ Child in the Temple (1820–1822)* 99
Antonio Canova (Italian, 1757–1822)
Gallerie dell'Accademia, Venice | archivio fotografico G.A.VE; photo Matteo
De Fina, 2018; used by permission of the Ministry of Cultural Heritage and
Activities and Tourism—Gallerie dell'Accademia di Venezia

Janson, H. W. *19th-Century Sculpture*. New York: Abrams, 1985.
Licht, F. *Canova*. New York: Abbeville Press, 1983.
Pavanello, G., and G. Romanelli, eds. *Canova*. Venice: Museo Correr, 1992.

42. *Christus (modeled 1821, completed 1827–1828)* 101
Bertel Thorvaldsen (Danish, 1768/1770–1844)
Church of Our Lady, Copenhagen | Bjanka Kadic / Alamy Stock Photo

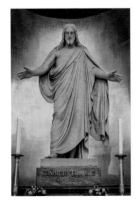

Grandesso, Stefano. *Bertel Thorvaldsen (1770–1844)*. Milan: Silvana Editoriale,
2015.
Jornaes, Bjarne. *Thorvaldsen Museum: Comprehensive Guide*. Copenhagen: Thor-
valdsens Museum, 1995.
Rosenblum, Robert, and H. W. Janson. *19th-Century Art*. Upper Saddle River,
NJ: Pearson Education, 2005.

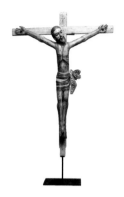

43. *Christ Crucified (ca. 1835)* 103
José Aragón (New Mexico, 1796–1850)
Snite Museum of Art, University of Notre Dame, Notre Dame, Indiana | gift of
Mr. Raymond E. Britt Jr., 2001.045

Bradley, Douglas E. In *Selected Works: Snite Museum of Art*. Notre Dame, IN:
University of Notre Dame, 2005.
Frank, Larry. *New Kingdom of the Saints: Religious Art of New Mexico, 1780–1907*.
Santa Fe: Museum of New Mexico Press, 2004.
Rosenak, Chuck, and Jan Rosenak. *The Saint Makers: Contemporary Santeras y
Santeros*. Flagstaff, AZ: Northland Publishing, 1998.

44. *The Reunion (Christ and Thomas) (1926)* 105
Ernst Barlach (German, 1870–1938)
Ernst Barlach House, Hamburg, Germany | Munson-Williams-Proctor Arts
Institute / Art Resource, NY

Ernst Barlach . . . "as wird bis Übermorgen gelten?" Eine Retrospective. Dresden:
Sandstein Verlag, 2020.
Kurth, Willy. *Ernst Barlach*. Stuttgart: Kohlhammer, 1985.
Paret, Peter. *An Artist Against the Third Reich: Ernst Barlach, 1933–1938*. Cam-
bridge: Cambridge University Press, 2003.

45. *Northampton Madonna and Child (1943–1944)* 107
Henry Moore (British, 1898–1986)
St. Matthew's Church, Northampton, England | Henry Moore Archive;
reproduced by permission of the Henry Moore Foundation

Lichtenstern, Christa. *Henry Moore: Work—Theory—Impact*. London: Royal
Academy of Arts, 2008.
Mitchinson, David, ed. *Celebrating Moore: Works from the Collection of the Henry
Moore Foundation*. Berkeley: University of California Press, 1998.
Sylvester, David, ed. *Henry Moore: Complete Sculptures*. Vol. 1, *1921–1948*. Lon-
don: Lund Humphries, 1988.

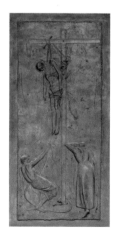

46. *Death of Christ, from the Doors of Death (1947–1964)* 109
Giacomo Manzù (Italian, 1908–1991)
St. Peter's Basilica, Vatican City | courtesy of Fabbrica di San Pietro in Vaticano

Manzù: Le Porte. Milan: Silvana Editoriale, 1989.
Pepper, Curtis Bill. *An Artist and the Pope*. London: Peter Davies, 1968.
Rewald, John. *Giacomo Manzù*. London: Thames & Hudson, 1973.

47. *Christ on the Cross (ca. 1955)* 111
 Lucio Fontana (Italian, 1899–1968)
 Private collection | courtesy of Galerie Karsten Greve Köln Paris St. Moritz

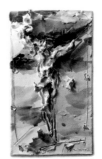

Crispolti, Enrico. *Fontana: Catalogo Generale*. 2 vols. Paris: La Bibliothèque des Arts, 1986.

Syson, Luke, Sheena Wagstaff, et al. *Like Life: Sculpture, Color and the Body*. New York: Metropolitan Museum of Art, 2018.

Whitfield, Sarah. *Lucio Fontana*. Berkeley: University of California Press, 1999.

48. *Ecce Homo (1999–2000)* 113
 Mark Wallinger (British, born 1959)
 Installation view, Trafalgar Square, London, UK | © Mark Wallinger,
 courtesy of the artist and Hauser & Wirth

Herbert, Martin. *Mark Wallinger*. London: Thames & Hudson, 2011.

Mark Wallinger: British Pavilian—The 49th Venice Biennale 2001. London: The British Council, 2001.

O'Reilly, Sally. *Mark Wallinger*. London: Tate Publishing, 2015.

49. *Crucifix (2003)* 115
 Dietrich Klinge (German, born 1954)
 St. Johannes in Stift Haug, Würzburg, Germany | Peter Gauditz, Hannover

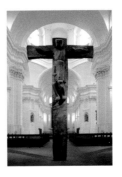

Becherer, Joseph Antenucci. *Between Silence and Strength: The Sculpture of Dietrich Klinge*. Grand Rapids, MI: Frederik Meijer Gardens and Sculpture Park, 2005.

Dietrich Klinge im Kloster Eberbach. Fellbach, Germany: Freshup, 2013.

Zimmermann, Axel, ed. *Dietrich Klinge, Brüche und Kontinuitäten, Arbeiten 2002–2004*. Munich: Galerie von Braunbehrens, 2004.

50. *Untitled (2008)* 117
 Mimmo Paladino (Italian, born 1948)
 Private collection | photo by Peppe Avallone

Arensi, Flavio. *"Paladino at Palazzo Reale,"* with essays by Arthur Danto and Germano Celant. Firenze: Giunti, 2011.

Celant, Germano. *Mimmo Paladino*. Milan: Skira, 2017.

Di Martino, Enzo. *Mimmo Paladino: Sculpture, 1980–2008*. Milan: Skira, 2010.

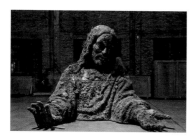

51. *Ash Jesus (2011)* 119
Zhang Huan (Chinese, born 1965)
Collection of the artist | © Zhang Huan Studio, courtesy of Pace Gallery

Yilmaz, Dziewor, RoseLee Goldberg, and Robert Storr. *Zhang Huan*. London: Phaidon, 2009.
Zhang Huan: Altered States. New York: Charta and Asia Society, 2007.
Zhang Huan: Evoking Tradition. New Windsor, NY: Storm King Art Center, 2014.

52. *Together (2014)* 121
Jaume Plensa (Spanish, born 1955)
Private collection | Jonty Wilde © Plensa Studio Barcelona

Becherer, Joseph Antenucci. *Jaume Plensa*. Grand Rapids, MI: Frederik Meijer Gardens & Sculpture Park, 2008.
McMillan, Jennifer Rohr. *Jaume Plensa: One Thought Fills Immensity*. Milan: Skira, 2018.
Sommer, Achim, ed. *Jaume Plensa: Inner Sight*. Brühl, Germany: Max Ernst Museum, 2016.